JAMES **CASEBERE**

JAMES CASEBERE

THE SPATIAL UNCANNY

CHARTA

SEAN KELLY GALLERY

Design
Gabriele Nason
with Daniela Meda

Editorial coordination
Debbie Bibo
Elena Carotti

Press office
Silvia Palombi Arte & Mostre,
Milano

Cover
Pink Hallway #3, *2000*

Back cover
Sing Sing, *1992*

Photo credits
Copyright James Casebere,
Courtesy the artist and Sean
Kelly Gallery, New York

unless otherwise specified

Sean Kelly Gallery has also
produced a deluxe edition of this
book, which includes an original
8x10-inch black and white
photograph. The edition is
limited to 26, numbered A to Z,
with 10 artist proofs numbered
I/X to X/X. Both the book and
the photograph are numbered
and signed by the artist, and
encased in a gray linen slipcase.

© 2001
Edizioni Charta, Milano

© James Casebere for his works

© 2001 Authors for their texts

ISBN 88-8158-315-1

All Rights Reserved

Edizioni Charta
via della Moscova, 27
20121 Milano
tel. +39-026598098/026598200
fax +39-026598577
e-mail: edcharta@tin.it
www.chartaartbooks.it

Printed in Italy

Sean Kelly Gallery
528 West 29th Street
New York, NY 10001
tel. +1-212 239-1181
fax +1-212 239-2467
e-mail: info@skny.com
www.skny.com

Acknowledgements

This publication could not have been realized without the vision, commitment and extraordinary support of Sean Kelly and his colleagues at Sean Kelly Gallery, New York, co-publishers with Charta of this book. I particularly want to thank Sean, Cécile Panzieri, the gifted and tireless director of the gallery, Susan Kelly, the gallery archivist and April DeLaney, gallery assistant.

Giuseppe Liverani, publisher, Debbie Bibo, editorial coordination and Daniela Meda, graphic designer, of Edizioni Charta, Milan, have worked with great dedication to ensure that this beautiful book accurately represents my work. David Frankel has done an exemplary job of editing the book's three outstanding texts. My work has been complemented by the support of a number of studio assistants over the years, particularly Kelley Bush, Michael Vahrenwald and Joe McKay to whom I am very grateful. I wish to thank Philippe Laumont, Esteban Mauchi, Willie Vera, Debra Villen and Marie Woarsh of Laumont Photographics who have printed and mounted my color work for many years. The same exacting attention to detail and quality of printing has been applied to my black and white photographs, in the past by Gary Schneider and John Erdman, and recently by Charles Griffin and Charles Richardson.

I am represented by a number of outstanding galleries internationally, in addition to Sean Kelly Gallery, New York, I would like to acknowledge Nicholas Logsdail and his colleagues at Lisson Gallery, London, Jean Bernier and Marina Eliades of the Bernier/Eliades Gallery, Athens, Naila Kunigk and Walter Mollier of Gallery Tanit, Munich, Christine Ayoub at Windows Gallery, Brussels and Marc Selwyn in Los Angeles, to all of whom I extend my thanks for their involvement over the years. Fortunately, my work has been collected extensively by museums and private patrons worldwide and supported by many friends and associates within the art world, not least of which are my peers, other artists. Without their support, I would not have been able to pursue my vision for the work in such a sustained manner. My thanks to you all. Adam Weinberg, director of the Addison Gallery of American Art, Phillips Academy, Andover, Massachusetts, deserves particular recognition for having commissioned a group of works including *Pink Hallway* which is on the cover of this book, and for his steady support of the work over the years.

Finally my heartfelt appreciation goes to the three outstanding writers, Christopher Chang, Jeffrey Eugenides and Professor Anthony Vidler. Each one has made an insightful and invaluable contribution to this publication which extends the understanding and reading of my work in a unique and remarkable fashion. Thank you.

This book is dedicated to Lorna and Zora.

CONTENTS

Staging Lived Space: James Casebere's Photographic Unconscious
Anthony Vidler

Panopticon

The image is, at first glance, apparently unambiguous: an obviously circular structure; four stories of regularly spaced half-round windows; a wall topped by rolled barbed wire; and a caption to seal the meaning—*Panopticon Prison #3* (1993). No doubt this is a photograph of a panopticon prison, modeled on Jeremy Bentham's original of 1792 and probably constructed in the United States around the mid-nineteenth century. After thirty years of post-Foucauldian criticism, the implications of such a photograph seem equally clear, especially when the image is situated in a series of "institutional" photographs entitled variously *Sing Sing*, *Prison at Cherry Hill*, *Georgian Jail Cages*, *Prison Cell with Skylight*, *Cell with Toilet*, and the like. The photographer is evidently constructing a visual critique of imprisonment, along the lines of Michel Foucault's book *Discipline and Punish*, a meditation on solitary confinement along the lines of his earlier study *Madness and Civilization*. *Panopticon Prison #3* establishes itself with all the confidence of Theodor Adorno and Max Horkheimer's critique of the Enlightenment; the panopticon, archetype of optical optimism, an architecture designed to machine bodies and souls by the pervasive presence of an all-seeing eye, is now displayed as the sign of Enlightenment's failure, symbol of the demise of utopian transparency revealed in the architectural form of the bourgeois disciplinary episteme.

Closer inspection, however, reveals troubling inconsistencies in this message. First, the photograph is not of a real panopticon but of a model of "Panopticon." Constructed in white cardboard and artificially lit, it resembles an architectural project for a panopticon—one not yet built. Which might signify a certain optimism as to its potential social effects, but such a project for a new building would surely not have included the small lean-to shed at its base, which would indicate that the model is of a real prison, somewhere—a "reality" that is then immediately denied by the abstract and generalized caption. Most disturbing is that out of the nineteen visible windows, all but one are dark voids, sinister reminders of the complicated system of natural lighting designed by Bentham so that the prisoners might be seen by the otherwise invisible Director at the center of the complex. One, however, is brilliantly lit, seemingly casting its glow on the scene outside. Which would imply that the prison, save for a single prisoner, has been abandoned, in the manner of the Bastille on the eve of the Revolution. It is an empty symbol; or perhaps, alternatively, a symbol of former oppression from which a ray of light emanates—the last hope of Enlightenment.

These ambiguities and more are compounded by the photographic medium itself, one purporting to reveal the real yet here overtly subverting its own power by revealing the artifice of the model. And the more so since this is a model of architecture, a profession in which the model has

developed a precise and determined role over centuries as a simulacrum of the real, future building, and in which photographs of the model strive to give the illusion of that reality accomplished. For while the architectural model is to scale, a miniature of the real, the photograph occludes this scale, allowing potential users and clients a vision from their "point of view" of what the building will look like when built. Many such model photographs—such as those for Mies van der Rohe's Seagram

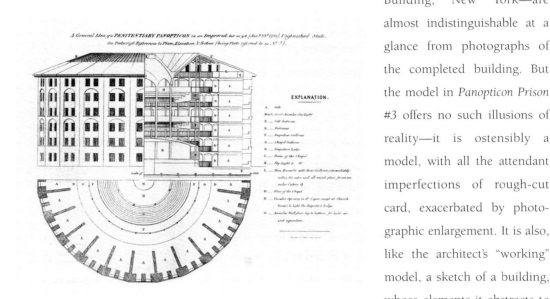

Building, New York—are almost indistinguishable at a glance from photographs of the completed building. But the model in *Panopticon Prison #3* offers no such illusions of reality—it is ostensibly a model, with all the attendant imperfections of rough-cut card, exacerbated by photographic enlargement. It is also, like the architect's "working" model, a sketch of a building, whose elements it abstracts to the point of geometrical reduction; it is less a model than a three-dimensional diagram.

Diagram of Jeremy Bentham panopticon, from Norman Bruce Johnson, *Forms of Constraint, History of Prison Architecture*, University of Illinois Press, 2000

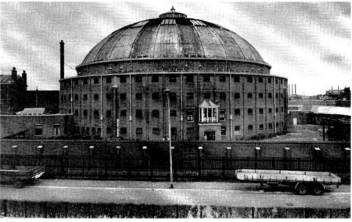

Panopticon Prison, the Netherlands, from Norman Bruce Johnson, *Forms of Constraint, History of Prison Architecture*, University of Illinois Press, 2000

Nor of course is this diagrammatic model the intended end result of the photographer; in the end the "art" is in the photograph itself, not as a representation of either a model or a building as a work

of art, but as a photograph. In this sense a first take would be that the photographer's model (of a building) performs a role not unlike the photographer's model (of a body). Even as the human model stages its body in space, so the photographer's "architectural" model stages space in space. Not as an end in itself but as a way of constructing a photograph.

Panopticon Prison #3 emerges in these terms as a profoundly ambiguous image: at once referring to an apparently endless string of associations from the Enlightenment to the present, associations evoked by the discourse on punishment and its spaces of confinement, and at the same time presenting itself as a scaleless vision of a toy-scale world of models. Further, in its actuality as "photograph," the image is formed almost entirely out of light and shade: light reflecting from white sur-

faces and projected from inside constructed space, revealing stark walls and hiding secrets in their shadows. Narratively, a host of stories could be told of this image; formally, its very glimmer seems to promise an architecture of white abstract volumes, translated not from plan to building, as in the modernisms of the 1920s, but from model to image, in such a way that the image now takes on the role of architecture itself.

Thus, in *Sing Sing* (1992) and *Prison at Cherry Hill* (1993), the grim and regular exteriors of actual prisons are represented in an unearthly nocturnal light, architectured only by the beams cast by the security floodlights around their periphery, with, in the latter, the only interior light shining from the control tower. These are places of absolute confinement, then, with a long history of incarceration buried in their walls, now silent and perhaps even unoccupied, but, as machines, they continue their implacable surveillance unaided. This would be in some way an image of the "afterlife" of incarceration—a sense, reinforced by *Georgian Jail Cages* (1993), that these historically obsolete spaces retain the memory of their terrible function as if frozen in time by the photographer's flash, with the striped clothing of their former inmates still hanging out to dry on the fence.

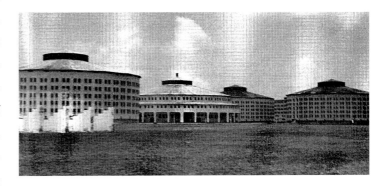

Uncanny Space

Such confinement, past in the present, is emphasized the more strongly as James Casebere enters into the cells and corridors of his panoptical engines. Here begins the long series of interiors of prisons and asylums that will imperceptibly merge with the later "Tunnels" and "Hallways" series—*Prison Cell with Skylight* (1993), *Cell with Toilet* (1993), *Asylum* (1994), *Empty Room* (1994), *Toilets* (1995), *Cell with Rubble* (1996), and *Two Bunk Cell* (1998)—all of which present us with the image of the "just abandoned," or per-

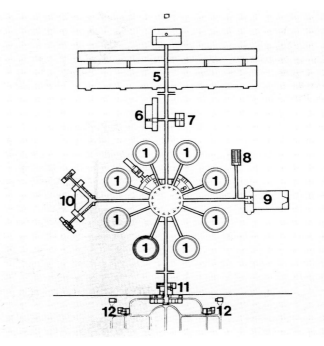

Panopticon Prison, Cuba, from Norman Bruce Johnson, *Forms of Constraint, History of Prison Architecture*, University of Illinois Press, 2000

Illinois Penitentiary at Stateville, 1919, from United Nations Social Defense Research Institute, *Prison Architecture*, The Architectural Press Ltd., London, 1975
Key: 1 cell houses; 5 workshops; 6 laundry/shower; 7 school; 8 special cell house; 9 chapels; 10 hospital; 11 administration; 12 warden's houses

haps also the "about to be inhabited," that is so characteristic a moment in the Caseberian uncanny. For if—as Freud, borrowing from Schelling, would define it—the uncanny is "the name for everything that ought to have remained . . . secret and hidden but has come to light," then Casebere has not only revealed the existence of these hidden cells but through their stripped and austere minimalism has rendered something of their double character, as both ascetic chambers of redemption and horrifying chambers of torture or of living death by isolation. No blood, no chains, no apparatus of bodily harm, no skeletons, no subjects in ruination or despair, but simply the pure geometries of conceptual architecture, as clearly defined and as potentially liberating as a modernist dwelling unit conceived by Le Corbusier or Gropius. The uncanny here consists of this double image, the one

haunting and giving the lie to the other, of a geometry conceived to cure, a space designed to heal, an architectural tabula rasa intended to erase memory and instill order, that is at the same time a machine for fabricating modernist souls.

Aura

These are photographs of constructed sites, then, where the sites themselves have no intrinsic artistic value. The focus on the site or "setting" is important here. In the French version of his celebrated essay "The Work of Art in the Age of Mechanical Reproduction," Walter Benjamin distinguished between a photograph of a painting—which was no more than a "mode of reproduction"—and a photograph of a fictional event in the studio:

In the first case, the thing reproduced is a work of art, its reproduction not at all. . . . It is different with the shot in the studio. Here, the thing reproduced is already no longer a work of art, and its reproduction is even less than in the first case. The work of art, properly speaking, is elaborated only in so far as the cutting allows.[1]

Benjamin is of course speaking of film, but in his earlier treatment of studio photography it is clear that he applies similar criteria. But where, for the film, art is produced by the act of cutting, in the photograph the atmosphere, the "aura," is produced by the studio setting itself, which, Benjamin writes, speaking of Franz Kafka's boyhood portrait, "occupied so ambiguous a place between execution and representation, between torture chamber and throne room," and even more by the qualities of the light, dependent on long exposures, and which more often than not "struggles out of the darkness."[2]

For Benjamin, such conditions were, of course, only a necessary preliminary to their inevitable supercession by the technological progress of modern photography and the definitive loss of aura. Subsequent theory of the "auratic" in art has done little more than repeat his conclusion that with the photograph, authenticity ceased to inhabit through the aura of its contents, but rested its only claim to authenticity on the shock effect of its ability "to capture fleeting and secret images" of the real, only to be identified and pinned down with a caption that inserted it into an easily absorbed narrative of everyday life for the masses. But, some seventy years later, we are presented with photographs, all as carefully and obviously staged as nineteenth-century studio assemblies, and all dependent for part of their effect on the struggle of light to escape from darkness. Perhaps we would be able to consign such works to the nostalgic attempt to restore aura to the photograph—much like the turn-of-the-century *Jugendstil* photographs that used "penumbral" tones to try to simulate the aura of an earlier time—were it not for the fact that a number of questions erupt from their spatial construction that refuse any absorption into any nostalgic "postmodern" program.

First in line, they are sets, settings, without characters—the human is entirely absent, signified by abandoned objects, rooms, and spaces. There is no interpenetration of the aura of the por-

trait and the aura of the setting, such as permeated mid-nineteenth-century images of clients "equipped with an aura" that had "seeped into the very folds" of their clothes, as Benjamin had it. Nor is there any indication that this abandonment means any more than just that—we are not invited to await a sudden return, nor, as in the genre of the uncanny, are we presented with a return in another guise. The spaces are abandoned *tout court*.

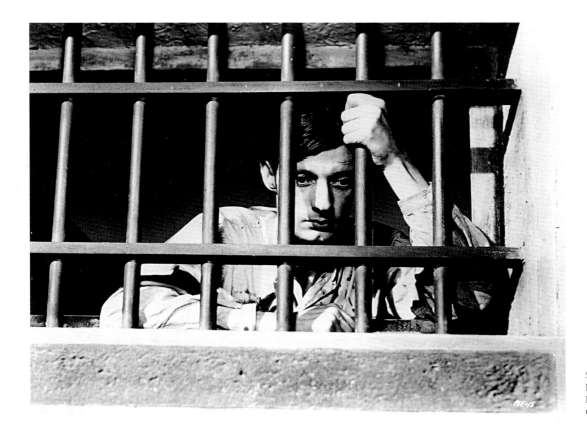

Still from *A Man Escaped*, 1956
Directed by Robert Bresson, starring
François Leterrier
Credit: Photofest

Second, the spaces constructed and photographed with such care are fundamentally "abstract" spaces. This does not mean that they are representative of abstract architecture, nor that they are perfect replicas of spaces formed out of pure geometry. They are spaces, rather, that ostentatiously flaunt their techniques of fabrication: they are obviously models, with the imperfections of jointing, gluing, cutting, entirely unmasked, even highlighted by enlargement.

Thirdly, and apparently paradoxically for so abstract a group of settings, these photographs are captioned; they are subject, as Benjamin would say, to "inscription." But whereas in the journalistic and often in the artistic photograph the caption generally serves to pinpoint meaning, to make signification less ambiguous, to remove the photograph from the realm of the "approximate," the captions to these works operate otherwise. They serve, indeed, to make meaning more ambiguous, to wrap associations around spaces and objects that might, in other viewing conditions, appear quite precise. Finally, the repeated statements of the photographer himself, often refusing any obvious characterization, and even refuting the apparently obvious messages of the captions, simply render these photographs more occluded than ever.

Spatial Unconscious

If we cannot ascribe "aura" in the traditional sense to these images, then their effect has to be sought elsewhere, perhaps in the unconscious associations they trigger, more than in any rational iconography. It was of course Benjamin who introduced the notion of an "optical unconscious" awakened by the camera's ability to capture moments of movement and change that were hidden to the unaided

David Octavius Hill, *Grayfriars Cemetery*, from "An Early Victorian Album, the Photographic masterpieces (1843-1847) of David Octavius Hill and Robert Adamson", published by Alfred Knopf, New York, 1976.

eye. He speaks, thinking of the time-and-motion photographs of Edgar Marey, of the instant when a body makes a move: "we have no idea at all what happens during the fraction of a second when a person actually takes a step. Photography, with its devices of slow motion and enlargement, reveals the secret."[3] This celebrated remark, to the effect that the new medium of the camera opens up the realm of the unconscious to representation, has generally been interpreted to refer to what he elsewhere termed the "optical unconscious." It is in this vein that commentators have expanded on his remarks, so that "unconscious optics" has become a commonplace of recent art criticism. Certainly, both in the essay on photographic history and in "The Work of Art in the Age of Mechanical Reproduction," Benjamin characterizes photography as a means by which "we first discover the existence of this optical unconscious, just as we discover the instinctual unconscious through psychoanalysis."[4] Rosalind Krauss has questioned Benjamin's initial assumption that there was indeed an "optical unconscious" connected to the work of the photograph: "What can we speak of in the visual field that will be an analogue of the "unconscious" itself, a structure that presupposes first a sentient being within which it operates, and second a structure that only makes sense insofar as it is in conflict with that being's consciousness? Can the optical field—the world of visual phenomena: clouds, sea, sky, forest—have an unconscious?"[5]

And yet, in qualifying this optical unconscious, Benjamin refers less to phenomena of a purely visual kind and more to spatial characteristics. Thus he speaks of the "space informed by human consciousness" replaced by the "space informed by the unconscious": "It is another nature that speaks to the camera than to the eye: 'other' above all in the sense that a space informed by human consciousness gives way to a space informed by the unconscious."[6] In characterizing photography as a mechanism for revealing spatial secrets, Benjamin is extending the traditional reach of psychoanalysis to comprise not simply the visual apprehension of space but, in his terms, its more phenomenological characteristics, including the experience of the body in space and the resulting "haptic" dimensions of spatial sensibility. His long crusade against the purely optical nature of modern social and cultural relations, inherited from Simmel and Riegl, had led him to speak of the need to experience space "blindly," as if space were in some way porous, open to the touch, but flattened by sight.

Thus Benjamin speaks of the "visual space" of photography, and reinforces his notion of "felt space" by the example of David Octavius Hill's early portraits taken in the Edinburgh Grayfriars

cemetery. He reflects on how much "at home" his subjects seem in this landscape: "And indeed the cemetery itself, in one of Hill's pictures, looks like an interior, a separate, closed-off space where the gravestones propped up against gable walls rise up from the grass, hollowed out like chimney-pieces with inscriptions inside instead of flames."[7] Here the combination of a spatial exterior, representing death, and a homely interior, reflecting the character of its inhabitants, acts like a psychoanalysis of space itself, a photograph now invested with all the power of the analyst. In this way the optical instrument (the photograph) reviews the spatial instrument (the setting) in order not simply to transmit, an "optical unconscious" but rather to reveal a spatial unconscious through optical means.

Now the idea of a spatial unconscious has not had a distinguished history in mainstream psychoanalytical thought. Freud himself had little to say about space in itself; in an era obsessed with space, and against a dominant psychology that founded itself on spatial apprehension and experience, Freud's etiologies were sexual and his cases set in a narrative and historical frame.[8] Where space intervened, as in the case of "Little Hans," it was meticulously described only to be immediately discounted. And yet Freud's own models of the mind, of the unconscious, were famously spatial, if not architectural, and his metaphors for the relations between memory and the psyche were drawn from the spatial discipline par excellence: archaeology. Certainly his dreams, if not interpreted through spatial psychology, were set in spatial scenes before being translated into symbols. In this sense space haunts Freud even as it is subjected to the regime of sexuality, a lacuna that was addressed by Ludwig Binswanger in the 1920s and '30s. Binswanger, whose interest in the visual and spatial dimensions of experience had been sharpened by his treatment of Aby Warburg in the early 1920s, was interested in his 1933 essay *Dream and Existence* in examining the topology of "rising" and "falling" with respect to mental states—the intersection of actual bodily states and the mental states that apparently take their cue from them. Here he argued, following Husserl and Heidegger, that there was something ontological in the "vectors of verticality," a kind of "matrix of meaning" that controls our feelings of existential instability. Far from simply drawing on bodily states to express these feelings as metaphors of falling or rising, language in fact draws on this ontological level in the same way as the body itself. From this it was a short step to deduce that such a spatial ontology was equally present in dreams.

When, in 1954, Foucault provided an introduction to the French translation of Binswanger's *Dream and Existence*, he seized on the concept of dream-space as crucial to the interpretation of the unconscious: "Much has been said about the temporal pulsations of the dream, its particular rhythms, the contradictions or paradoxes of its duration. Much less about dream space."[9] For Foucault, Binswanger's proposition allowed the dream to point to both meaning and "direction," in the sense of spatial direction, and it provided the key to an analysis of space itself that, as we know, became a central theme of Foucault's subsequent writing. For Foucault, the geometric space of science and the geographic space of mapping were secondary to the lived space of experience, and in some senses were dependent on this lived space. And lived space—like that of the dream, which was drawn from the same source—was simultaneous, at once distant and near, lost in the horizon or close-up in the familiar. Where geometric space indicates displacement and

change of position, lived space is a remembrance of past space and an anticipation of future spaces; its position with regard to the subject is ever shifting. Apparently articulated with reference to what is near and what is far—an articulation that ensures whatever security space can provide—lived space is notoriously unstable: "Far space can press upon near space, permeating it on all sides with a massive presence."[10] Near space, that of the familiar and the homely, is always "porous," susceptible to the sudden elimination of perspective, as in the Proustian dream, where distance and proximity are fused.

Here Minkowski and Foucault are especially interested in the form of space that is not apprehended visually, but entirely through the imagination and the other senses; what Minkowski called "dark space," where "envelopment" and fusion" replace division and distance. Foucault contrasts this "dark space," "no more than moving of shapes or sounds, coming and going according to the reflux of their apparition," to its opposite, "clear space," a space of "pure luminosity," where "all dimensions seem both to be realized and eliminated, where all things seem to find unity, not in a fusion of fleeting appearances but in the clarity if a presence completely open to our gaze."[11] In this opposition Foucault both anticipates his later characterization of "panoptical" space, one that establishes identity through transparent surveillance, and provides the mechanisms for its destabilization. Clear space, perspectively open and with a coordinate system based on pure geometry, can at any moment be collapsed through lived experience into dark space, the space of the dream, where no dimensions are secure, where, indeed, the very nature of spatiality shifts from the optical to the haptic. This model brings us close to Benjamin's own sense of the collapse of space and time in the photographic image, the unconscious opticality that is in fact spatial and experiential.

Casebere's photographs, then, would not be simply renditions of all the ambiguities inherent in the clear space of architectural geometry, but rather would dissolve or impact them in the collapsing of boundaries and distances, scales and forms, into an image that in some sense photographs "dark space." A photograph of dark space, however, would not simply render all in shadow, or analogically provide a metaphor for thinking darkly. Rather it would refer to that experiential ground common to all spatial vectors, both the space of the unconscious and lived space, blurring their distinction to reveal dimensions of our own unconscious spatiality.

The paradox in such a representational strategy, of course, is that such a spatial identification is rendered to us entirely visually; here the manipulation of actual spaces in model form, as if we had ourselves made the model, could even remake the shape, fabricate its alternatives, as if, finally, we were children again, inventing model spaces for our dolls and trains. This almost tactile accessibility enters us into the scene, a scene now of pregeometrical space: "Before being geometric or even geographic, space presents itself first and foremost as a scene or landscape: it gives itself originally as the distance of colored plenitudes or of reaches lost in the horizon, enveloped in the gathering distance; or, it is the space of things there, resistant to my touch; it is to my right or my left, behind me, opaque or transparent to my gaze."[12] By way of the mechanism of projection and identification, then, Casebere allows us to fill the empty space of his spatial stage, which produces the effect of a primordially experienced landscape, at once close enough to be touched and distant enough for reflection.

Underground

The underground world offers an infinite field of operations no less interesting than the earthly surface.
Nadar[13]

Casebere's stage is infinitely increased in its potential for revealing the spatial unconscious by its extension from the traditional institutions of surveillance and social control to an underground realm

entitled "Tunnels." This is less a result of the obvious metaphorical relationship between the vertical axis of the underground and the unconscious in general—an allegorical relationship exploited by Freud and Binswanger, and by Benjamin himself in his reveries on the Parisian métro—than a function of the uncertain status of the "tunnels" themselves. For Casebere's tunnels, as in *Tunnels* (1995) and *Two Tunnels from the Left (Vertical)*, *Two Tunnels from the Right (Vertical)*, *Two Tunnels from the Left (Horizontal)*, *Two Tunnels from the Right (Horizontal)*, *Tunnel with Bright Hole*, and *Tunnel with Dark Hole* (all 1998), all seem set in a realm that is "underground" according to their titles, and certainly in the affect of their dark and arched spaces, but that, often lit from above or the side, seems to have direct access to an outside. Such tunnels, then, might well be subbasements, or even tubes above ground. They are, moreover, joined in their abstraction and "neoclassical" style to the institutions represented in the earlier photographs, so that they could serve as their extensions, their "below-ground" as it were, joining in an infinite network, all species of incarceration and isolation spaces.

But equally, and as the photographer has noted, the tunnels might be inspired by the sewers of a metropolis like Berlin—

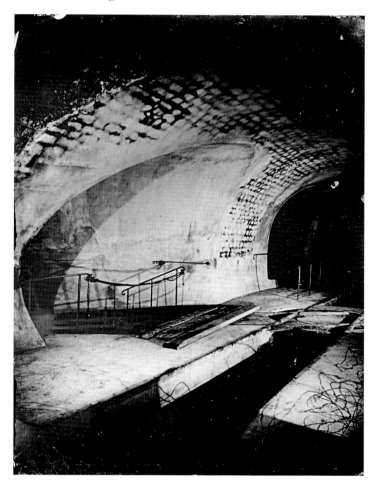

Nadar, *Égouts de Paris, écluse no. 1*, 1864-65
Modern print from glass collodian negative
Caisse nationale des Monuments historiques et des sites, Paris

a late-twentieth-century reprise of the earliest attempts at underground photography by Nadar in his experiments in the sewers of Paris. Nadar, beginning in 1858, tried a series of experiments in photographing Paris, shifting from his usual portrait genre to capture the urban landscape, but not in the sense practiced by his contemporary Marville. Nadar, a fervent amateur balloonist as well as an explorer of the catacombs, was drawn to depict, as he wrote, "the city from above and from below," catching the Arc de Triomphe from the air and the sewers from underground. The sewers were an especially intransigent subject, given the primitive nature of artificial illumination by magnesium flares, and the problem of transporting photographic equipment along the narrow, flooded, and smelly, passages of the drainage system installed by Haussmann. Nadar described the underground world as if it were some modern Hades designed by Piranesi: up to his waist in mud, the photographer plunged through the tunnels, drenched by the sudden overflows from bath- and

wash-houses, through intersections with vast domed roofs that seemed so many amphitheaters, "secret colosseums."[14]

Nadar's descriptions of these expeditions, were, on the one hand couched in the Romantic tropes of the labyrinth, the fantastic, and the Orphic; but on the other, as Benjamin noted, he was in a sense and consciously enough, exploring the underbelly of what, on the surface, manifested itself as the splen-

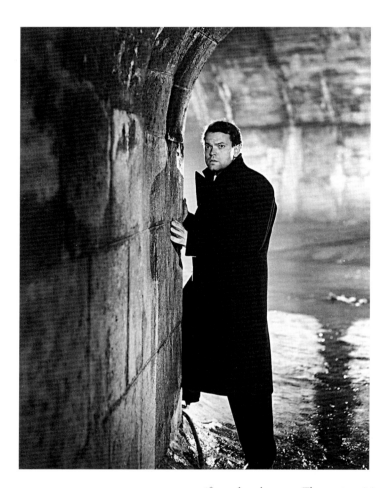

did, modernizing, boulevards and improvements of Haussmann; the dark side of transparent modernity. For Casebere, tunnels of this kind were silently present beneath the crust of all modern cities—we remember the sewers of Vienna, retreat of Harry Lime, the "Third Man." Those of Berlin, in particular, hid more than the simple overflow of the modern city, stained with the entire history of fascism, from the underground movement of the 1920s to the triumphant secret power of the 1930s and '40s. Nadar's "dark meeting-place of the immense void,"[15] is here given an attribution of evil that enhances the terror already implied in the claustrophobic tunnels and institutional spaces of Casebere's photographs from the early 90s.

The horror of this "darkened Enlightenment" was increased when, in a series of photographs from 1998, the interiors of Casebere's model spaces began to be partially flooded, in *Flooded Hallway* (1998-99), *Flooded Hallway from Right* (1999), *Four Flooded Arches from Left* (1999), *Four Flooded Arches from Right* (1999), *Four Flooded Arches from Right with Fog* (1999), *Untitled* (1999), and *Four Flooded Arches from Center with Fog* (1999). The first spaces to be flooded were hallways—hotel-like corridors with their floors entirely submerged (to ankle depth?). These were followed by flooded arches or arcades, now to a depth that seemingly would leave little

Still from *The Third Man*, 1950
Directed by Carol Reed
Credit: Photofest

if any head room. The water rising, the "fog" that then is introduced to inculcate a sense of doom, all combine to give the sense of abandonment present in the earlier photographs a deathly edge, as if the catacombs and sewers had overflowed, drowning the spaces of the everyday, and, like a watery equivalent to the lava and ashes of Pompeii, had put an end to a civilization already burying itself in institutional control and spatial order. Even the early asylum spaces are not immune, as in the *Untitled* of 1999, where the cells and wards, with their abandoned beds are similarly under water. This intimation is confirmed by the most recent photographs, where even the sacrosanct spaces of the private school and the art gallery are flooded, in the "Blue" and "Pink" hallways from the Phillips Academy and in the flooded entry hall of "Monticello" numbers 2 and 3 respectively. Finally, and as an appropriate coda to this series of catastrophic settings, the "Nevisian Underground" series of 2001, numbers 1 through 3, delineates arcades and porticoes that seem almost natural in their flooded state—like the arcades of a Saint Mark's Square in Venice, long accustomed to the ebb and flow of the high tides.

In these last photographs, the revelation of an implied future for architectural space, a space at once of our unconscious and our lived reality, describes the fragile treaty between the two. For why else would such spaces form the ontology of our existential being, if they did not, at the same time and for that reason, contain all the spaces of our inner fears and the predictions of our potential destinies? Or, as Lacan might have put it, the spaces of our desires, unseen in the everyday because of their replacement by symbolic inversions, are now sharply depicted in the mirror surfaces of photograph and water alike.

It is, in the end, the special quality of this "water" that condenses all the significance of these photographs of unconscious space into a single image: that of a viscous, opaque, glazed surface that, in its fixed and mucous ripples, reflects nothing more than the anamorphic shapes of geometrical space. The "water," then, would be no more than a depiction of space before geometry, primordial and *informe*, an ever creeping and enveloping bloblike space that images the landscape of dreams and forms the materiality of anxiety. Casebere's "spatial unconscious" is in photographic representation an opening through vision into the psychopathology of lived space, a space that blurs all the traditional distinctions between the space perceived and the space represented.

1. Walter Benjamin, *Ecrits français*, ed. Jean-Maurice Monnoyer (Paris: Gallimard, 1991), p.153. My translation. This citation, from the French version of "The Work of Art in the Age of Mechanical Reproduction" prepared by Benjamin, differs slightly from the German original.

2. Benjamin, "Little History of Photography," in Michael W. Jennings, Howard Eiland, Gary Smith, eds., *Selected Writings* (Cambridge: Belknap Press of Harvard University Press, 1999), 2:516–17.

3. Ibid., p. 510.

4. Ibid., p. 512.

5. Rosalind E. Krauss, *The Optical Unconscious* (Cambridge, Mass.: The MIT Press, 1993), pp. 179 sgg.

6. Benjamin, "Little History of Photography," p. 510.

7. Ibid., pp. 512–13.

8. Space has had a chequered history in psychoanalytical thought; Freud was for the most part uneasy with spatial formulations of mental states, being concerned to counter early assumptions that phobias and neuroses should be seen as stemming from urban or architectural conditions, and instead to return them to sexual etiologies. Space was left to the phenomenologically inclined, like Ludwig Binswanger and Eugene Minkowski. Lacan's topological models were less related to actual than to analogical "spaces"—developments of Freud's own spatial models of the unconscious. A few recent critics, like Victor Burgin in his *In/Different Spaces* (Berkeley: University of California Press, 1996), have begun to redress the balance.

9. Michel Foucault, "Dream, Imagination, and Existence," trans. Forrest Williams, in Foucault and Ludwig Binswanger, *Dream and Existence*, ed. Keith Hoeller (Seattle: *Review of Existential Psychology and Psychiatry*, 1986 [1984–85]), p. 60. This article was originally the introduction to Binswanger, *Le Rêve et l'existence*, trans. J. Verdeaux (Paris: Desclée de Brouwer, 1954), pp. 9–128.

10. Ibid., p. 61.

11. Ibid.

12. Ibid., p. 60.

13. Nadar, "Paris souterrain aux catacombes et égouts: Premiers essais de photographie aux lumières artificielles," in *Quand j'étais photographe*, 1900, reprinted with preface and notes by Jean-François Bory (Paris: Seuil, 1994), p. 143.

14. Ibid., p. 151.

15. Ibid., p. 151.

Grand Illusion
Chris Chang

Introduction by Means of an Eighteenth-Century Painting

Socrates, in a fundamental sense, is a figment of the imagination. He is known only through interpretation. Plato writes the book. Aristophanes provides anecdotal evidence. And, much later, Jacques-Louis David paints the pivotal picture. In *The Death of Socrates* (1787) the figment achieves visibility. Holding forth on his deathbed, surrounded by his followers, he grasps the fated chalice of hemlock. If Socrates could see the painting he would not be amused. Artistic endeavors are secondhand news. *The Republic*, Book X: "Mimetic art produces a product that is far removed from truth in the accomplishment of its task, and associates with the part in us that is remote from intelligence, and is its companion and friend for no sound or true purpose." Gods create ideals; craftsmen do their best job at replication; and artists produce shadows derived from shadows. (Pragmatists grind their teeth.)

David paints a man known to him only by previous representations. That the subject of the painting concerned himself with peeling away layers of representation to grasp fundamental truth is a delicious irony. It's also an allegory for the work of James Casebere. Scanning through existing architectural images, or going into the world to shoot his own, he returns to the studio to make models from photographs that become the subjects of yet more photographs. (Occasionally, in the absence of an existing form, Casebere distills an image from his own "interior." Socrates, with his taste for things essential, would probably prefer these.) This is no feat "remote from intelligence." It's a carefully perpetrated dance between historical stability and self-reflective delirium. The closer you look, the further the images recede in a structurally codependent hall of mirrors. Are they forms internal, forms external, or forms defiantly indecisive? Deleuze and Guattari, with a little help from James Joyce, came up with the perfect word for the wavering exchange between milieus.

Jacques-Louis David, *The Death of Socrates, 1787*
Oil on canvas, 51 x 77¼."
Credit: The Metropolitan Museum of Art, New York (Catherine Lorillard Wolfe Collection, Wolfe Fund, 1931)

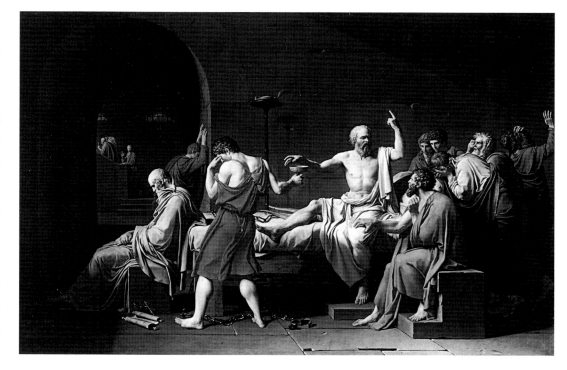

21

Chaosmos

To write about Casebere from the standpoint of a film critic poses a bit of a problem. A photograph, as it were, takes the motion out of motion pictures. Casebere's images contain no plot. There are no characters. A discussion of dialogue or soundtrack is fruitless. There's no movement or duration. But they are, on an elusive level, cinematic. Architectonic, but not architecture. Uninhabitable habitats

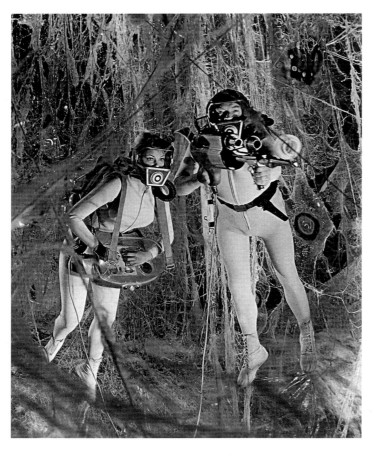

Still from *Fantastic Voyage*, 1966
Directed by Richard Fleischer
Credit: Photofest

that reside, somewhat peculiarly, in the home. You can't walk into them but you can, so to speak, walk around them. Peripatetic descriptions will hopefully tease various meanings, feelings, and values. At times it will appear as if this text doesn't address the artist at all. But to describe is to circumscribe.

Watching films or taking photographs is similar to a surgical act. Walter Benjamin states, "Magician and surgeon compare to painter and cameraman." In the sci-fi thriller *Fantastic Voyage* (1966), a miniaturized submarine, floating in an amniotic fluid in the interior of a hypodermic syringe, is injected into a patient. A surface integrity has been breached. We see the vessel navigate the needle, glide along the tubular inside, and finally plunge into the target bloodstream. The film, patently absurd, blatantly literalizes the body as temple. Both cinema and Casebere make great use of the same poetic of space.

Following Benjamin, the invisible picture plane makes an incision to reveal what lies within. Thankfully for the collector who displays the work on the walls of the extended body, i.e. at home, Casebere has cauterized the wound. The opening of the frame—the crop—has been sterilized. There is no blood; but it certainly slices deep.

Tunnel Vision

Art, along with its degeneration of Socratic truth, can provide liberation. To find it in a sewer is no mean feat. The great Polish director Andrzej Wajda knew where to look. In *Kanal* (1956) he borrowed a visual cue from Carol Reed's masterpiece *The Third Man* (1949). As Nazis obliterate the landscape of Warsaw, a small band of freedom fighters have no choice but to retreat underground to the sewers. They march through their own arterial infrastructure in the hopes of salvation. Just like the scientists of *Fantastic Voyage* they have become metaphors for the bloodstream's flow of life. The motivation of *The Third Man* is more dubious. He takes to the sewers to escape the punishment he deserves for dealing in deadly black-market drugs. This is high poetic justice: A man who pollutes the innocent blood of children meets his nemesis in the form of a gigantic industrial artery. With Casebere, we cannot identify with the personalities of Polish rebels or an American expatriate criminal on the run. But we can commiserate with like-minded space. Characters, temporalized by narrative, are fleeting inhabitants of an architecture larg-

er than their lives. They are phantoms on the walls of the cave. After they have come and gone, the structure remains primary. Their specificity, like legal precedent, makes them mortal. If law is the mere shadow of justice, and if we place the concept of character into the shadow position in the equation, what does that make architecture?

Films like *Kanal* and *The Third Man* mesh design and camera to suggest the existence of space beyond the image at hand. That the characters contained therein are purposively striving to attain that space only helps to heighten its existence. How is it that Casebere suggests the same thing? In painting and sculpture the viewer is met with a distinct border or limit to the object of perception. Both mediums are clearly delineated by their substance. A sculpture, if we can temporarily sidestep ideas like the "activation of space," simply stops. Likewise, in the case of painting, it makes little sense to ask, "What is outside the frame?" Photography functions in a completely different way. All photos are cropped. Cropping necessarily implies the existence of that which has been cropped out. A photograph of pedestrians on a sidewalk, for example, can imply the entire city surrounding them. Any single interior shot from Kubrick's *The Shining* (1980) implies the totality of the Overlook Hotel—patiently waiting along the edges to foment madness.

Still from *The Shining*, 1980
Directed by Stanley Kubrick
Credit: Photofest

To be precise, examples from photographic history exist in which the idea of cropping appears moot. The photograms of Man Ray, for example, allow no play for the continuation of the subject outside its frame. But here it gets interesting. What happens at the edge of a Casebere photograph? While there are sometimes several views of the same subject, none of them will show what lies behind the bend in the tunnel or doorway or window ahead. In this view the work is more akin to a photogram. But not exactly. Even though we know that the procedure of building a model, choosing a camera angle, and then fixing the image in space has taken place; we also know it doesn't make sense to ask what's outside the frame, because we already know the "real" answer: It's only the studio. However, I would like to suggest a more amorphous environment.

Still from *Yellow Submarine*, 1968
Directed by George Dunning
Credit: Photofest

Holey Space

In *Yellow Submarine* (1968), cartoon replicas of the Beatles find themselves in the Sea of Holes. Ringo manages to pry one loose from the background, plays with it for a moment, and then stuffs it in his pocket. "I have an hole in me pocket," he announces. It's an astonishing act of metaphysics. A black, circular void, an aperture, has been rendered palpable. More important, it's become *portable*. What does it mean when one takes an image of a hole and makes it mobile? A thing without substance, a thing defined by its necessary

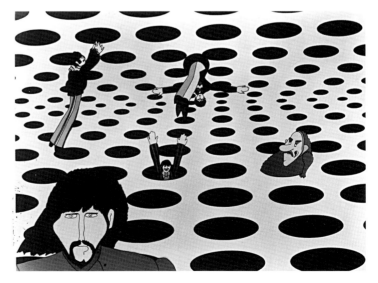

23

lack of substance, becomes substantive. Later in the film Ringo will retrieve the hole to free Sergeant Pepper's band from a trap set by the Blue Meanies. He places it on the crystal prison they've been entombed in and they are released. A fault or a flaw, like the hole in an argument, becomes redemptive.

Casebere's images are riddled with holes. To a large degree they are defined by holes. If you build architecture you must build holey space. Without the gaps—doorways, windows, passageways—the utilitarian function collapses. A room itself is a hole. (And *camera* is Latin for room.) Even prisons, the antitheses of the permeable, are perforated. This excites connoisseurs of the panoptic. The hole paradoxically defines the substance that surrounds it. By virtue of its nothingness it creates. When a Casebere exhibition is installed, isn't it, aside from the gallery's existing doorways and windows, an installation of holes in what was previously unholey space? And what happens when it moves to a different city? The Sea of Holes goes on tour; as the edge of the frame begins to waver.

The camera obscura is holey space a priori. A hole in the wall of a darkened chamber allows the external to reappear internally. Photography and visual perception (and perhaps God) are rooted in this. That the conception is evolutionary is addressed in Jonathan Crary's indispensable book *Techniques of the Observer* (1990). Crary outlines a turning point in the historically understood construct of sight. He sees it as a maneuver from the camera obscura's classic objectivity to a state of "autonomous" modernity. In reference to the still lifes of Chardin, Crary describes the "last great presentation of the classical object in all its plenitude, before it is sundered irrevocably into exchangeable and ungrounded signifiers or into the painterly traces of autonomous vision. The slow-burning glow of Chardin's late work, an effulgence inseparable from use values, is a light soon to be eclipsed in the nineteenth century, either by the synthetic aura of the commodity or by the radiance of an artwork whose very survival demanded a denial of its mere objectivity." The words unleash a prismatic array. On the one hand Casebere appears to be an exemplar of camera obscura classicism. But at this point we are dealing with a twenty-first-century artist. The classical object has been "sundered irrevocably." Or has it? Casebere uses a chamber with a hole (the camera) to take images of chambers with holes (the model). That, to me, seems fairly grounded. And, more to the point, fair ground for a new kind of "slow-burning glow."

The Great Escape
It's easy to view Casebere in light of the postmodern project. Thanks to photography the aura of art has evaporated (Benjamin). Reality has drifted out of view only to be replaced by images with no foundation (Baudrillard). Prisons aren't really that different from everything else around us (Foucault). Etc. We are now awash in Crary's sea of "ungrounded signifiers" and "the synthetic aura of the commodity." And if that's true it is apparently not much fun.

What I find missing in this well-trod ground is an awareness of the way critique can resemble fetishistic behavior. Although the aura may have left the building, Benjamin is still entranced by democratic technology. And that, of course, is his point: "Our taverns and our metropolitan streets, our offices and furnished rooms, our railroad stations and our factories appeared to have us locked up

hopelessly. Then came the film and burst this prison-world asunder by the dynamite of the tenth of a second, so that now, in the midst of its far-flung ruins and debris, we calmly and adventurously go traveling. With the close-up, space expands. . . . The enlargement of a snapshot does not simply render more precise what in any case was visible, though unclear: it reveals entirely new structural formations of the subject. . . . the camera intervenes with the resources of its lowerings and liftings, its interruptions and isolations, its extensions and accelerations, its enlargements and reductions. The camera introduces us to unconscious optics as does psychoanalysis to unconscious impulses."

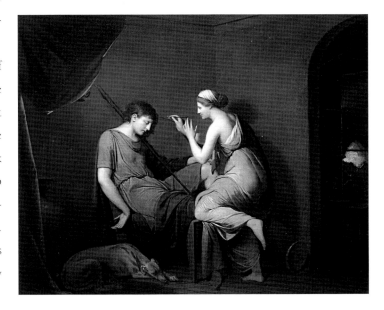

. There is no doubt Casebere can be seen within the sphere of postmodern discourse; I'm just hesitant to say that that's where the real power is located. It's helpful to recall that there's not one but at least two models for the advent of the image. Alongside Plato's Cave stands Pliny's Corinthian maid. The Corinthian maid was a lovestruck lass fretting over the departure of her boyfriend. To keep him close to home she propped him against her bedroom wall and drew the outline of his body. The image is thereby born out of desperate longing. (After simulation, Baudrillard claims, the only thing that remains is nostalgia.) How would you prefer to perceive the world? As shadowy deception or purposely structured Eros? What Is Cinema?

Joseph Wright, *The Corinthian Maid,*
1782-1784
Oil on canvas, 41⅞ x 51½"
Credit: National Gallery of Art,
Washington D.C. (Paul Mellon
Collection)

Casebere manipulates interior and exterior until they no longer exist. When we see from within his walls we sense and sometimes see the external world as void. In the exteriors the background landscape or sky is a void contained. The blackness does not stretch to infinity; it limits and confines. This seems especially true when examining the skies in any prison image. The endless depth of space becomes an impenetrable wall. It's a cruel logic akin to the travails that befall the freedom fighters in *Kanal*. At the end of their journey they find "salvation" in barred openings or portals that lead to firing squads. The struggle, nonetheless, remains cathartic. The dissolution between inside and out, both corporeal and mental, is part of a grand tradition in film history—a history that relies heavily on the same practice of architecture in which Casebere revels.

Two examples that come to mind are Joseph Losey's *The Servant* (1963) and Michelangelo Antonioni's *The Passenger* (1961). I can't think of two films more stylistically different yet completely coterminous with Casebere's project. Both deal with character instability and transfer as a means to freedom. In *The Servant* Dirk Bogarde plays a class-bound underling who gradually mutates into the role of master. Losey's astonishing visual accomplishment is seen in an interior that evolves from nondescript skeletal outline into freakish domicile. The house performs like a character in its own right. The architecture has been rendered psychological. And in the absence of characters, as in Casebere's world, that performance becomes even more acute.

Still from *The Servant*, 1963
Directed by Joseph Losey, starring
Dirk Bogarde
Credit: Photofest

In *The Passenger*, Jack Nicholson, as a journalist adrift in the African desert, is given the opportunity to do what any ardent moviegoer aspires to do: exchange his life for someone else's.

Nicholson splices his own image into a dead man's passport, giving himself a new identity. Antonioni is an archon of the existential. His characters, fumbling in their connections with each other, stand out in stark contrast to the coldness and cruelty of their environs. In the climax of *The Passenger*, architecture and identity are taken to a new cinematic level. Architecture, at this nexus, destroys identity. Nicholson lies on a hotel room bed. The camera drifts away into a seemingly objective view of the room itself. It creeps toward a window that frames a variety of external activity. In a 7 1/2-minute single take it passes from interior to exterior while a crucial act occurs—*behind its back*. Once outside, after the act is completed, it swings around to view the aftermath. An evasive maneuver mirrors the activity of an evasive character. He is both severed from his past and (temporarily) severed from the camera that creates him.

Still from *The Passenger*, 1963
Directed by Michelangelo Antonioni,
starring Jack Nicholson
Credit: Photofest

Antonioni's alien landscapes turn characters into aliens. The architecture reifies as identities are made unfamiliar to themselves. Casebere explores a variation on this theme. We are made unfamiliar not in virtue of an alien land but by familiarity itself. We recognize the forms. The buildings, rooms, tunnels, hallways, etc., are all part of our inventory of architectural awareness. But Casebere estranges his imagery by stripping it down to a bare-bones architecture. Conversely, looking at the images can have a parallel effect on the viewer. As we come to terms with what we see, or what we think we see, our own perception becomes estranged. The objectivity of the lens shifts to the subjectivity of the viewer as soon as he or she understands that the image is both primary and fabrication. And this leads to a perennial subtext that preoccupies a small army of trembling thinkers.

Holy Space

In *Jurassic Park* (1993), Jeff Goldblum proclaims, "God creates dinosaurs. God destroys dinosaurs. God creates man. Man destroys God. Man creates dinosaurs." "Dinosaurs eat man. Woman inherits the Earth," replies Laura Dern. Interestingly enough, Spielberg, the crown prince of simulation, uses his most overtly simulationist scenario to muse on theology. What are the dinosaurs of *Jurassic Park* but the ultimate and only move one can make when simulation, virtual reality, and their ilk come to full fruition? A nostalgic grasp toward prehistory, backed up by very plausible technology, allows the achievement of a new form of afterlife.

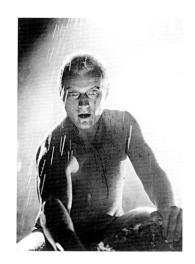

Still from *Blade Runner*, 1982
Directed by Ridley Scott
Credit: Photofest

Much science fiction is driven by this quest. Rutger Hauer, in Ridley Scott's *Blade Runner* (1982), sums up the sentiment succinctly as he prepares to kill the man who created him: "I want more life, FUCKER!" Hauer's character, in *Blade Runner*'s terminology, is a *replicant*. It is truly poignant that the film gives an android more lust for life than the merely living. Filmmakers like Spielberg and Scott create characters who play at being God. And so, by extension, are the filmmakers. (Not to mention a few photographers.) In his discussion of *Blade Runner*, in an essay titled "Realer than Real" (1987), Brian

Massumi nails it on the head: "Artists are replicants who have found the secret of their obsolescence."

The models of *Jurassic Park* take multiple forms. In a sense, the film is nothing but models. During preproduction, the animators took the act of modeling to a variety of extremes. Since they had no specimens to base dinosaur movement on, they first looked at nonextinct animals. And then, in a unique twist, they turned their research into autobiography. Armed with video cameras, they taped themselves prancing around a studio parking lot, moving in ways they imagined dinosaurs would move. The tapes became the models upon which the subsequent imagery was based. In lieu of the necessary reality, an artistic procedure, *a self-contained process of mimicry*, provides missing genetic information. And in a fit of ontological hysteria the film (of models) has spawned a variety of toys (models) in its wake.

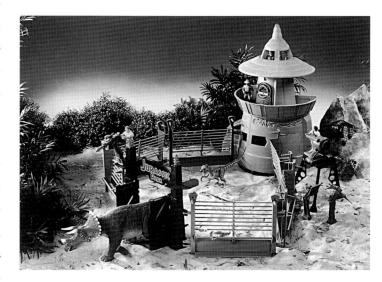

Model of *Jurassic Park*, 1993
Directed by Steven Spielberg
Credit: Photofest

Robert Bresson, perhaps the greatest filmmaker ever, preferred nonprofessional actors because he believed they were closer to reality. David Thomson, perhaps the greatest film critic ever, says Bresson's films "surpass beauty." (Imagine that.) Bresson didn't even like the word "actor." He preferred to call his cast "models." One would be hard-pressed to find one frame in Bresson that remotely resembles a Casebere image. However, any Bresson film can be seen as a structural analogue to the entire Casebere oeuvre. Bresson is a filmmaker of modalities. His work is austere, minimal, extremely Catholic, and obsessed with something I can only describe as transcendental rhythm. The circulation of his "models," their comings and goings, the opening and closings of doors (holes), the routines of daily life stripped down to essential patterns, are visible everywhere. It's a visual equivalent of musical theme and variation. In *A Man Escaped* (1956) the technique achieves mystic intensity. We see the prisoner in his cell methodically scratching, day by day, his hole of escape. He is periodically interrupted by the clockwork schedules of prison life—feeding time, exercise, bathing—and it all, of course, begins to resemble normal life. (Remember Foucault.) In art, the prison is nothing less than the human soul. What is incarceration but a deliberately implemented sense of finitude?

Bresson's single shots appear as simplicity itself. Taken together, the rhythms and repetitions coalesce in a fugal mass of the ineffable. I find the same thing happening with the compendium of images in this book. They form a continuum playing off each other, improvising, dividing and recombining in an ongoing modular genesis. In this way the seeming stasis of the Casebere image is activated. As an array they begin to sing.

In Bresson's *L'Argent* (1983), the circulation of a false image, i.e., a counterfeit bill, propels the narrative. As it passes from hand to hand it leaves a trail of human destruction in its wake. The themes of greed, human frivolity, and death occur throughout Bresson's films. But that's just surface. The process of circulation grinds away appearance to reveal internal structure. The human machinations, as destructive as they are, strip away the false realities to reveal a core—a primary essence.

Is it any wonder many of Casebere's images look like bones?

The final shot of Bresson's *Diary of a Country Priest* (1950) is a manifold image. In it one sees the sacrifice of Socrates, the passion of the Corinthian maid, the slow-burning object of Crary, and the archetype of Casebere. The film's story, adhering closely to the model of the Bernanos novel, is an unbearable study of religious perseverance. The face of Claude Layou, as the priest, is one of the most

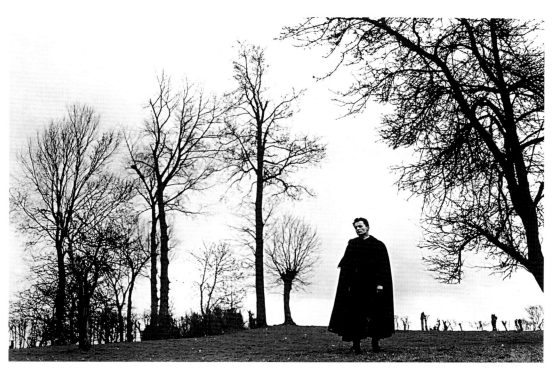

Still from *Diary of a Country Priest*, 1950
Directed by Robert Bresson
Credit: Photofest

pained ever committed to celluloid. The infinitely receding holes of his eyes are nothing if not spiritual wounds. Not only does his environment appear to conspire against him, but his own body, fueled by an ironic diet of bad wine and bread, has joined the fray. Two types of resignation torment Bresson's world. On the base level there's the resignation of suicide. And then there's resignation unto God.

At the film's end the priest succumbs to the unknown. His life, in passing, is replaced by the simplest architectonic structure imaginable. A crucifix radiates grace directly from the screen. The same phenomenon appears in many Casebere photos, especially the prison and asylum interiors. It's a rarefied glow of immanence. But to talk or write is to some degree to do away with it. In *The Poetics of Space* (1958), Gaston Bachelard states, "To verify images is to kill them." This is strange ground to travel—a place verging on the celestial. However, Casebere strategically sidesteps the divine. In his most recent work, in recognition of the affect of illumination, he has deliberately moved his light source from an external "above" to an internal inside. Immanence becomes earthbound. (Not unlike a light flickering within a cave.) This revives the paradox posed by Socrates. How does one overcome the prison of one's own representation? Through the act of artistic creation—which is nothing but further representation. Socrates, in a fundamental sense, is a figment of the imagination.

Sources/Influences

Bachelard, Gaston. *The Poetics of Space*. Beacon Press, 1958, reprint ed. 1994. "All small things must evolve slowly, and certainly a long period of leisure, in a quiet room, was needed to miniaturize the world."

Benjamin, Walter. *Reflections*. Schocken Books, 1986. "The work is the death mask of its conception."

Casati, Roberto, and Achille C. Varzi. *Holes and Other Superficialities*. The MIT Press, 1995. "A philosophical theory originates from astonishment and is judged from its ability to silence astonishment. A theory of holes is no exception."

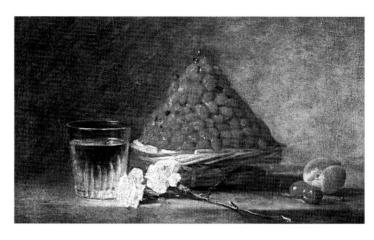

Crary, Jonathan. *Techniques of the Observer: On Vision and Modernity in the Nineteenth Century*. The MIT Press, 1992. "Take, for example, Chardin's *Basket of Wild Strawberries* from around 1761. His superb cone of stacked strawberries is a sign of how rational knowledge of geometrical form can coincide with a perceptual intuition of the multiplicity and perishability of life. For Chardin, sensory knowledge and rational knowledge are inseparable."

Jean-Baptiste-Siméon Chardin
Basket of Wild Strawberries, 1761
Detail
Oil on canvas
96½ x 116⅞"
Private collection
Credit: RMN - R.G. Ojeda

Deleuze, Gilles, and Felix Guattari. *A Thousand Plateaus: Capitalism and Schizophrenia*. University of Minnesota Press, 1988. "What chaos and rhythm have in common is the in-between—between two milieus, rhythm-chaos or the chaosmos."

Foucault, Michel. *Discipline and Punish: The Birth of the Prison*. Vintage Books, 1979. "Even if the compartments it assigns become purely ideal, the disciplinary space is always, basically, cellular. Solitude was necessary to both body and soul, according to a certain asceticism: they must, at certain moments at least, confront temptation and perhaps the severity of God alone."

Kubler, George. *The Shape of Time: Remarks on the History of Things*. Yale University Press, 1962. "The manuscript draft by the puzzle-maker is a prime object (which no one conserves); all the solutions in subways and on the desks of people who 'kill time' compose the replica-mass."

Plato. *Collected Dialogues*. Princeton University Press, 1978. "Then in every way such prisoners would deem reality to be nothing else than the shadows of the artificial objects."

Rabinow, Paul. *Essays on the Anthropology of Reason*. Princeton University Press, 1996. "We need to anthropologize the West."

Thomson, David. *A Biographical Dictionary of Film*. Knopf, 1994. "It might be said that watching Bresson is to risk conversion away from cinema."

The Ancient Myths
Jeffrey Eugenides

J. Logan, a product of suburbia, was doing what the legendary fathers did, the steerage patriarchs. He was preparing a place for his family in a strange new land. Logan's wife and daughter were still in Manhattan and he was here, in Berlin, setting up house. That was the plan, anyway. So far he didn't have much to show for his time. Aside from an expensive, virtually telepathic coffee-maker and a shoe rack (he was fastidious about footwear), the only furniture Logan had managed to acquire was a secondhand daybed. He was stretched out on it now, the better to contemplate his dislocation. Jet lag still dragged him down after a week. He'd been waking up at four in the morning. In the afternoons he had these on-Jupiter moments where it seemed the force of gravity tripled. He gave into them, lying flat. The daybed struck him as the right vehicle to nudge his way into Berlin on. It was heavy, formal, bordello-ish, Freudian. Stiff buttons pinioned the olive green fabric and fringe fell to the floor. There were stains and gnaw marks from some old, short, beloved pet, probably a dachshund. The cushions had a gravy smell. On this artifact of civilization you lay on your back and gazed out the windows. *Kitrin'll like the windows at least*, Logan considered now. *She'll hate the noise, the stairs, the trash situation, the screwy tap in the bathroom, the asbestos risk and the dungeon keys, but the lights she will love.* In German the word for bright, oddly enough, was *hell*. Right now the sky was a Prussian gouache, gray and opaque. Logan was elevated three stories above Hauptstrasse, with traffic noise below and the smell of meat from the *döner* restaurant rising, but he was thinking, as always, of Michigan, of his school at the end of the block years and years ago.

When he'd put his name on the buzzer (in the event he did buy something there would be deliveries) Logan had noticed that one of his fellow tenants was named Arndt. Mrs. Arndt had been his third-grade teacher back in 1968. On the daybed now with closed eyes he recalled her. She had worn loose brown dresses, belted at the waist like a Franciscan monk. Her glasses, too, were somehow churchy. *We still took naps in the third grade. Or it was called "quiet time." Mrs. Arndt made us lay our heads on our desks. They were still wood back then, not Formica, and smelled of pulp, sawdust. The blond, gouged, inked-up wood felt cool against your cheek as you rested, fetal, toes hooked around the desk legs. Whoever was quietest got a gumdrop. The bowl stood on Mrs. Arndt's desk. They were the multicolored kind, not just mint but sophisticated, in spice flavors. I used to stare at the jar longingly while learning to add and subtract.*

For some reason it had been Logan's father who had taken him to register at Trombley Elementary. They had moved back to Detroit from Maryland in July. The transition had been difficult. Their new house was a Frank Lloyd Wright knockoff and Logan, at eight, had been opposed to modernity. He missed their red brick Georgian in Potomac. *I was lonesome that first summer, before school started. Didn't know anybody on our block. Went out one day leaving a note for my mother: "I've gone out to find a friend." Melodramatic even back then.*

Maybe that was the summer his mother had had her hysterectomy. That would explain why his father had taken him to school alone. Somewhat mysteriously Logan's mother had left one day for the hospital, taking an overnight bag. Logan's grandmother had arrived to cook dinner. The next day, during visiting hours, Logan made his mother blush by asking what the operation had been for. "Woman's problems," she'd said, looking away. *Now your mom would draw a picture of her uterus for you and discuss estrogen replacement therapy.* In the hospital room Logan's mother looked pale without her makeup. She was not Greek but Irish, the freckled, burning type. She had a hillbilly gap between her front teeth and had studied English literature at night school, her favorite author being Defoe. Her handwriting was very beautiful. Logan's earthly existence had begun in the muscular organ, amphora shaped, that had been cut from her body and disposed of. Maybe she was thinking about that. Though it increased her pain, she let him play with the remote controls, lowering and raising her bed.

Or maybe that had been another summer altogether. But Logan remembered following his father down the block, silently, as boys followed their fathers in those days, or at least as he had always followed his. Harry Logan—Aristotle Logathetis, if you wanted to get technical about it, but the family surname had been changed at Ellis Island and Aristotle had taken Harry as a nickname—wasn't at his best with an eight-year-old kid, especially a boy. Sports were not Harry's thing. He couldn't throw a decent pass or hit a fly ball for you to catch. He didn't make a fool of himself trying, either. The most he would do was drive Logan out to Harper Sports Store and buy him a mitt. There was a formal agreement between them. *A business agreement. Here are my straight A's. Now where is my ten-speed?* In Berlin trucks were rattling past, and double-decker buses. Across the street beige Mercedes cabs waited in line, while under striped awnings Turks shouted and stacked oranges and sipped their fluted glasses of tea. But Logan only heard the solid sound of his father's Allen Edmonds wingtips against the sidewalk thirty-three years ago. With so many billions of people on earth now it was getting harder and harder to maintain a hallowed position for childhood. Logan painfully felt how overpopulation strained any feeling of uniqueness. He sometimes wondered if God remained interested in the prayers of the multitudes. *He must stop listening half the time. If He's got any brains at all.* Likewise Logan brought before rigorous review his own charmed memories, knowing that they were in their essentials like everyone else's. School, and cracked pavement, and your dad's big shoes—but here already he gave up his enforced objectivity and submitted (dropped, really, as if the daybed under him were a trap door) and plunged into the irresistible miracle of his own specific past. Two doors down from them stood a newer house, the cheapest on the block, where a Teamsters official lived. *Some thug who had worked his way up through the ranks.* It was split-level, with orangy brick and white siding. *One time the thug's wife dinged up somebody's car and fled the scene. The people she hit followed her home. There was a big argument out on the front lawn. My brother and I watched from a distance. The acoustics were perfect, the whole street our personal Epidaurus. The thug took a swing at the husband. His wife jumped in front to protect him. "Don't you hit my husband!" she shouted. Whereupon the thug smacked her. His Teamsters ring cut her face. I felt sick to my stomach. The violence seemed to carry through the air like a smell of bad meat.* Continuing down the block they next passed the iron gates of a Mafia mansion, "Black Bill" Tocco's house. There were plane trees in the front yard and terra-cotta tiles on the roof.

Lived on that street fifteen years and never saw anyone going in or out. Nothing like a crime syndicate to make a neighborhood peaceful. Still, contracts had gone out from that house, people's deaths had been ordered and slated, plus the action in drugs and prostitutes, kept in strict accounts. This was in Logan's old neighborhood in the supposedly deadly dull suburbs. It was the corner of the WASP paradise where they let the Italians and the Greeks and the labor crooks live. Standing on the corner, you could take any direction in thought and end up back in Sicily or Constantinople or at the Battle of the Overpass where Walter Reuther got his head beaten in. Meanwhile everything remained clean and leafy, with high-end mulch in the flower beds and the sprinklers going all night.

But they were headed for the end of the block and across the street where the schoolhouse stood. There was a hedge surrounding the school yard, thin in one spot where kids taking short cuts plunged straight through. A central walk led up to the big, black, peaked doors. *And during school there would always be two safety girls standing there, wearing white arm-bands. In winter their bare legs would get lobstery from the cold. I was impressed by their fortitude, and pitied them, too. It was like a biblical curse: you will suffer in childbirth and wear skirts on freezing days.* To the left of the doors was a greenhouse shaped like a carnival tent. Wire mesh protected the glass, obscuring the plant life within. Pressing your face to the metal grid, all you saw was steam. Inside, the school was cathedral-like, with a soaring ceiling the color of eggnog and a big, hanging brass clock, vaguely punitive. The floor was reddish and vulcanized, made of the same material as the desktops at GM. *The movies they showed us were always about mass production, too. Industrials full of conveyors and blast furnaces and shiny Fords rolling off the line.* Logan's father in his gray suit and Countess Mara tie had been obscurely connected to all this manufacturing. Logan didn't understand exactly how, but his father's moods rose and fell with the automotive economy. Now they reached the office. Logan's father opened the door and ushered him in. Behind a counter two secretaries were working summer hours. "I've got someone to meet you ladies," Logan's father had said smiling. It always surprised Logan how charming his father could be with other people. "This is Jack. He's going to be in the third grade."

Those old schoolhouses with their military lineups and pledges of allegiance, their indoctrinations, their medicine balls. The green stuff the janitors used to scatter on the floor to collect dust. The Thanksgiving turkeys you made by tracing your own hand. The books in the library scored with other kids' marginalia. A democracy of wisecracks and misspellings, of pen marks and saliva drips, snot and blood. All this happening in those Midwestern schoolrooms modeled on other, Arcadian rooms in eighteenth-century Virginia. The white cornices and the fanlights, the cupola on the roof with the wind vane. Behind the school, on the playground side, was a set of stairs leading down to a locked door. It was dark at the bottom and smelly, referred to as "the pee hole." When you fouled off a baseball there, it was your penalty to retrieve it. Kids frantically shagged their own pop-ups, trying to catch them before they bounced all the way down. Of course having to descend fully was a kind of enjoyment, too. You ran down screaming, holding your nose. Coming back up gave a sense of thrilling escape.

The reek of that abyss now brought back to Logan's recollection the school principal, Mr. Welcenbach. *Pit Willie, we called him.* He was tall, skeletal, Lincolnesque in dark, empty, floppy

trousers, and with sunken cheeks and pockmarked skin. His eyes lacked the soul warmth of Lincoln's, however, and his breath was bad. There was an undertaker air about him. Welcenbach, too, was a German name. *And now here I am in the Fatherland itself, where at dinner the other night my table partner insisted that there are more people of German ancestry in the United States than of any other nationality. Maybe it's true. They all taught at my old school.*

Logan shifted on the daybed, his attention returning to his present surroundings. The new apartment was a vast *Jugendstil* place, showy with etched glass and the bonus of a mythological theme. The head of Pan presided in silver grillwork over the building's front entrance. The leaf clusters and branches twining around his goat's head were worked throughout the interior, in the dead brown cage of the defunct elevator and in the newly painted plaster of Logan's own, eighteen-foot ceilings. *Pan! What more could a Greek guy ask for? Right over my head, here in 2001, a thyrsus.*

The flat was painted exclusively white, a very bright shade, almost painful to the eyes. Kitrin had told Logan to ask the people at the *Hausverwaltung* to paint the bedrooms a different shade, light green for their bedroom, light pink for their daughter's. Logan had delayed, however, and when he brought the subject up it was too late. Now everything was bright white. It was like living inside a wedding cake or the frozen palace in *Dr. Zhivago*. The building itself stood on a busy street in a semi-Turkish neighborhood. The sidewalk outside wasn't clean, the median muddy and flecked with exploded fireworks from New Year's. Alone in the apartment Logan had welcomed in the true millennium. At midnight, balconies all around had erupted with explosions, red rockets, spinning saucers of ice blue flame, Roman candles. Listening to the detonations Logan had had the feeling that Berlin was being bombed again. The city was busy rebuilding itself and making claims of world status but there was something defeated about it still. It was way out in the middle of nowhere, too, built on a sandy swamp. But the air was famously healthful, stirring to thought.

The Second World War wasn't a piece of history when Logan was a kid. It was still close in many respects. Logan's father had fought in it. He'd been in charge of the post office on Iwo Jima, a plum job as it turned out. The smoked hams and chocolate bars sent from families stateside were often undeliverable. The intended recipients had been transferred, or taken to the hospital, or killed. So Harry Logan ended up with the delicacies, which he sold and traded. That was how he'd come to have the Japanese sword. *Dad's prize possession. The old samurai sword.* The ornamental saber had been displayed on their living room bookshelves. Every so often Logan would climb up and get the weapon down. The blade was long and curved, engraved with a *Katakana* character near the hilt. The black ribbon around the handle was coming loose and the scabbard was moldering. *It was just tourist junk. Harry didn't strip it off a fallen enemy. He got it in exchange for a fruitcake or some cigarettes. Still, it held a power over him and who am I to make fun of it? Those old guys had done something that we would never do, they had completed the hero's journey, going off to war. This you could still see in the way they parted their hair in the morning.* Logan's father had also had a scrapbook from Iwo Jima. Logan had been forbidden to look through it but secretly often had. The back pages contained snapshots of dead Japanese soldiers. Their bodies were strewn and twisted on sand, faces burned off or innards exposed, spilling.

The sound of battle, of guns and cries, the dragon roar of flame-throwers, was unrecorded, however. In the scrapbook death worked in silence. One corpse was just a torso, headless, with a machete sticking straight up. Ghoulishly Logan had studied the photos, feeling no horror.

It was strange how the past attached itself to you through your parents. Logan had been born long after the war had ended, and yet shreds of it, as of a bygone America itself, were tangled up in his magpie self. For instance he knew certain Tommy Dorsey songs from his father's habit of whistling them. And somehow he had a preference in hat styles no one wore anymore. In fact Logan had an extensive knowledge of Detroit back in the '30s and '40s, long before the riots. He knew where the old Electric Park had been and could cite details about the trial of Dr. Ossian Sweet. But this was a peculiarity about Logan himself. He overran his personal timeline. He was a historian of the purely local, not good for much other than this voluntary dropsy on this used chaise. He had the old, dreaming, swooning look of a monk, some candle-faced, Greek hermit in a cave, but his visions bodied forth only the sunken hydroplanes and red, tongue-burning candies of Detroit's old East Side. *Remember those old street lamps they used to have when we were kids?* They were open at the bottom, to facilitate repair. But birds built nests in them, darkening the light. Finally they got rid of them. *I used to love looking up to see the motion of the nestlings against the big yellow bulbs.* The warmth probably helped the eggs hatch, too.

Logan's father, on the other hand, had always been big on venerating the authorized American shrines. With foreign-born parents and a mother who spoke no English, Harry Logan was eager to perform the stations of the national cross. Out in Maryland on the weekends they had made frequent trips to historic sites. Gettysburg, Appomattox, the marble memorials in D.C. Logan's parents had worn matching London Fog raincoats and sunglasses. Stalking around battlefields and cannons they resembled Boris and Natasha. The car motoring them from site to site was a black Fleetwood Cadillac with fins. They were in Colonial America but Detroit went with them. Whenever Logan and his brother fought they were ordered to put down the arm rest. The white leather bolster pulled out from the big back seat like a Murphy bed, separating them, ending hostilities. They visited the great presidents' houses, Mount Vernon and Monticello. The tour of the latter in those days didn't mention Sally Hemmings. Instead the guide pointed out Jefferson's inventions and gadgets. There was a device that enabled the founding father to sign two signatures at once. A kind of harness fit over the writing hand, duplicating movements of Jefferson's quill in another pen rigged across the secretary. Jefferson had also devised a dumb waiter to bring wine bottles up from the cellar. *And so I, as a kid, took away from Monticello the impression that the essential thing about being an American was ingenuity coupled with learning (there were books all over the place at Monticello). Whereas now the visiting schoolchild must imbibe a strong draught of hypocrisy, hearing that the author of "The Declaration of Independence" had also kept slaves.* But why hide the truth? Was it necessary to rear children in purity, however false? Did a country, a national culture, require these myths? Logan's father had been brought up on them. Logan, too. Maybe they would have been better off being disabused of a simplistic patriotism at the outset. Maybe the young nowadays were getting a better lesson altogether. What would it have been like for Logan to learn, in the second grade, that Thomas Jefferson had been to bed with an African lady? It would have shut his father up, at least. So there was that.

Through the double-paned windows a sound reached him now: church bells. Was it Sunday? Was it, in fact, morning? Logan had been pretty confident that it was afternoon. But maybe he'd slept through yesterday afternoon and the night following as well. The puny light outside didn't give much clue. The bells were quite insistent, pealing away. If it was Sunday all the stores would be closed. They still honored the Sabbath here. *Meanwhile Americans consider themselves religious but keep no day sacred. How could they? It would interfere with the shopping.*

This started his mind along another track altogether. He remembered a fact about his grandfather, George Logan. All his life in America he had been the one who did the grocery shopping. Logan's grandmother wasn't up to the linguistic requirements. Logan now realized that *this* pattern would be repeated, too. Kitrin knew no German. Logan did. So he would be dispatched to haggle over melons and cuts of beef. He asked himself if this was maybe why he'd come to Berlin—to repeat his grandparents' immigrant saga. *If that's the case I'm doing it in style.* His grandparents had arrived in shock, grief, counting their dead, and sick and hungry, too. They hadn't found an apartment in the *Morgenpost* but had squeezed into a crowded frame house, in a smoky city full of the hell-bent clatter of factories, the river already poisonous and the winters fiendishly cold. No place for a human being to live. Logan's *yia yia* had seen that right away. Half a century didn't alter her view.

One of the few people Logan knew in Berlin was of Greek extraction too. Stelios Garofalidis was Swedish by birth, his father Greek and his mother Austrian. On discovering that Logan had been Logathetis, he had asked the details. "My grandparents came to the States," Logan had filled him in. "From Asia Minor in 1922. During what everyone calls the 'catastrophe.'"

Garofalidis, urbane, in a shark-colored Belgian suit, with attractive De Niro wrinkling in his cheeks, smiled and said, "Yes, those national myths."

Logan had wanted to object. No illusion had murdered his grandparents' parents or burned down their house and warehouse. A million and a half Greeks had fled Anatolia in 1922. No myth, either. But on the other hand he understood what Garofalidis meant. The attachment to disaster was becoming the chief ingredient in ethnic identity. *Tell me your Holocaust and I'll tell you your name.* His grandmother had been rich in Turkey, a merchant's daughter who had known Onassis as a boy. The next thing she knew she was in Detroit, living in a basement. There was no place to dry her sausages so she hung them over the heating pipes. In a corner of the room she kept her vigil light. By the time Logan was born, that was gone too.

Logan had not had a religious upbringing. He had been baptized Greek Orthodox but then had been let off. Now and then, however, if he slept over at his friend Martin's on a Saturday night, he would go with Martin to church the following Sunday morning. Mr. Palmer, Martin's dad, was a different kind of father. He looked down as you walked beside him. He smiled and spoke. That was because he believed in God. He was something of a fanatic, actually. Logan had been aware of this. One winter Mr. Palmer had hurt his shoulder skiing. Dislocated it, probably. But he sought no medical help. For months in the front yard as his right arm threw spirals to the boys, Mr. Palmer's left arm hung motionless at his side. He winced when you tackled him. Whenever Jack said "God!" Mr. Palmer

gently explained that it wasn't right to take the Lord's name in vain. Two minutes later Jack would forget and shout "God!" again. But Mr. Palmer remained mild.

And now, three decades later, a father himself, suffering his own bodily pains (though not opposed to medicine), lying with his feet hanging off the end of the daybed—his feet that Kitrin always made fun of, saying they sloped like the Citicorp building—now Logan remembered the Sunday morning when he had been humiliated in Sunday School.

The church was Christian Scientist, in that denomination's neoclassical style. Doric columns soared out front, chalk white. *In modern times, religion, dying, wanted infusions of life from any connection to the scientific. So first you had Mary Baker Eddy with her Christian Science and then L. Ron Hubbard with his Scientology. But now science, too, is losing esteem, and many people are falling back on pagan ideas. I hear there's a Druid temple out in Oyster Bay.* Logan had had expectations about Christian Scientists. He was already sold on the empirical method. He expected to see loony people inside the church, perhaps visibly afflicted, but they looked as hale and sober as Presbyterians. Mr. Palmer went to church alone. His wife was not a believer. They kept separate bedrooms, too. Mrs. Palmer was often in hers during the day, suffering headaches. She wore sunglasses inside and was frantic about her hydration. She carried a water glass with her everywhere, tinkling ice. Family trips couldn't begin until the glass was in the car. *I thought it was booze even then. But I never smelled anything.* The glasses were plastic, unbreakable, foggy with citrus slices, lemons and oranges, laminated inside.

While Mr. Palmer attended the service, Logan followed his friend Martin down to the basement for Sunday school. Ten or twelve kids waited, Bibles in front of them. Bits of scripture adhered to the walls, along with Holy Land pictures. At the room's far end, window wells let in gray winter light. You could tell the basement flooded in the summer. There was a drain in the center of the floor and despite scrubbing, a high-water mark discolored the walls. Now in February the radiators steamed, smelling of rust. Mittens lay drying on them, going stiff and crinkly. The kids sat at a bland table, in hacked-up chairs. In such surroundings Logan immediately felt like a heathen. He didn't believe in God. He was surprised anyone still did. He was under the impression that the world had gotten over that. *Who needs religion as a kid, anyway? You've already got the kingdom of heaven inside of you. Jesus said so.* The teacher told them to open their Bibles to Luke. Seeing Logan paging around helplessly, Martin found his place for him. Then they went around the room, each reading a chapter. Logan was typically a good reader in class. Once they got to him he began in a loud voice.

"On the way to Jerusalem Jesus was going through the region between Samaria and Galilee. As he entered a village, ten lepers approached him."

The class burst into laughter, a sharp, derisory sound. A game-show buzzer, signaling failure and stupidity. Logan had pronounced lepers as leapers. What did he know? The children screamed. "Leapers!" they shouted, laughing and jiggling. "Leapers!" Even the Sunday school teacher was smiling. Logan's face burned.

Now, however, in Berlin, he smiled to himself, thinking about his mistake thirty years ago. He saw himself again in that basement room, florid faced, trying to smile, and dying of embarrassment.

He pictured that church basement, and his friend Martin in his clip-on necktie. Years later they would look at *Playboys* together, exhibiting the state of their arousal like clinicians sharing data. *You don't make friends like that anymore.* Fondly smiling upon the daybed, Logan remembered his old best friend's face, but even as he did he was aware of that line of scum on the basement's walls. With the spring rains basements all over the East Side would flood again. They always did. The basements in Detroit were still flooding now, in the houses of whoever lived there, in that city where no one he knew was left. And now in Europe, in Germany for no good reason, abandoned by his family but in hope of reunion, Logan saw in his mind the drain of that church basement brimming with water. He saw the water rise up between the legs of the table. And it seemed to him that this water was rising over all the places of his childhood. The waters were rising up the steps of Monticello, where his father had taken him to learn about America, and they were flowing and coursing into Mrs. Arndt's old classroom where the desks stood in rows. He could see words on the blackboard reflected in the rising waters and he could see the pee hole filling with water, too. His was the last generation to know about that old-time America with its civic pride and flag folding, and he hadn't really known about it at all. He had only caught the tail end. They had built it for him, to last, and it had lasted to the extent that he could remember it. But even now the waters were rising and old school desks were floating away.

WORKS

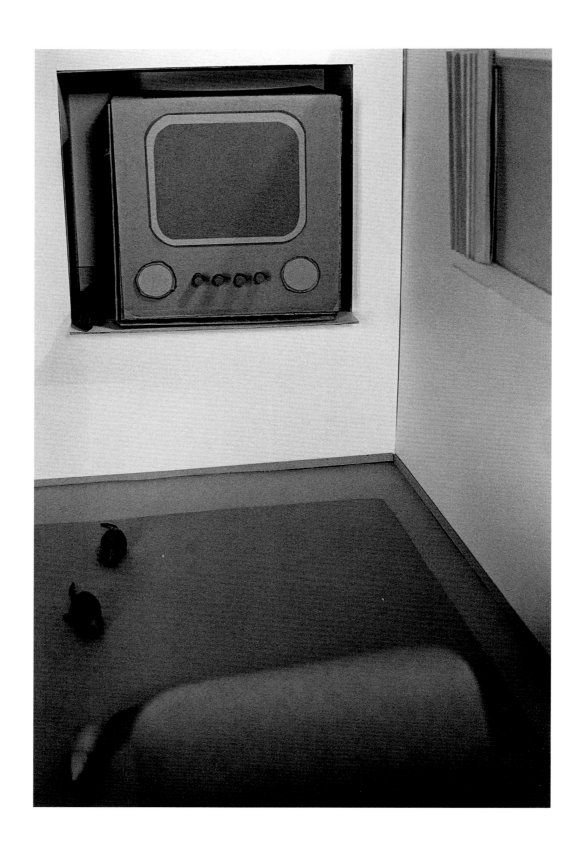

Bacillus Pestis (to be looked at while listening to "Scenes from Childhood," section 3 "Catch me" by Robert Schumann) *1976*

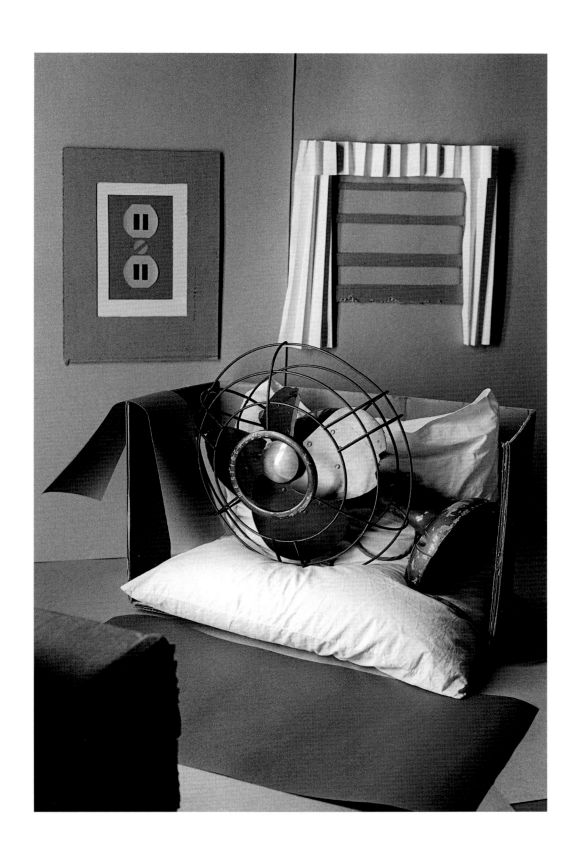

Fan as Eudemonist: Relaxing after an Exhausting Day at the Beach *1975*

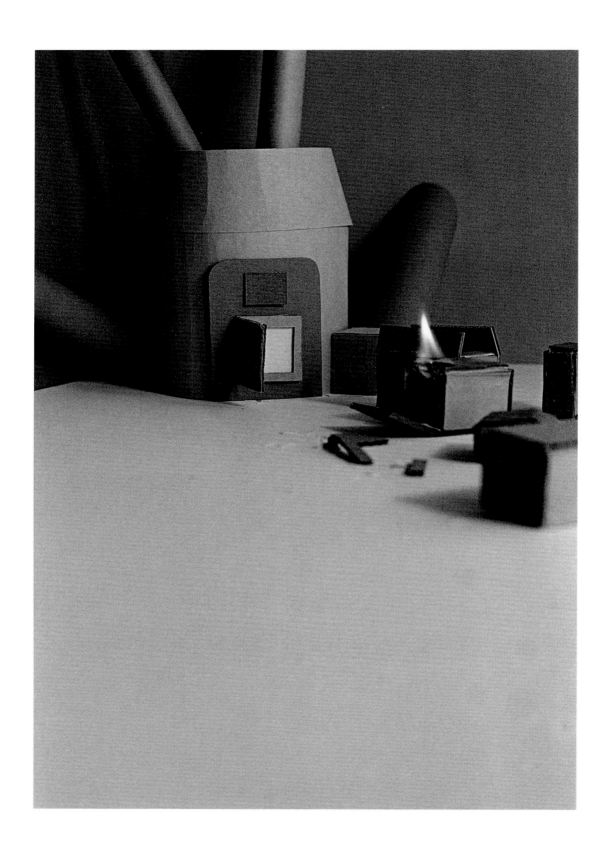

Furnace With Flame *1976*

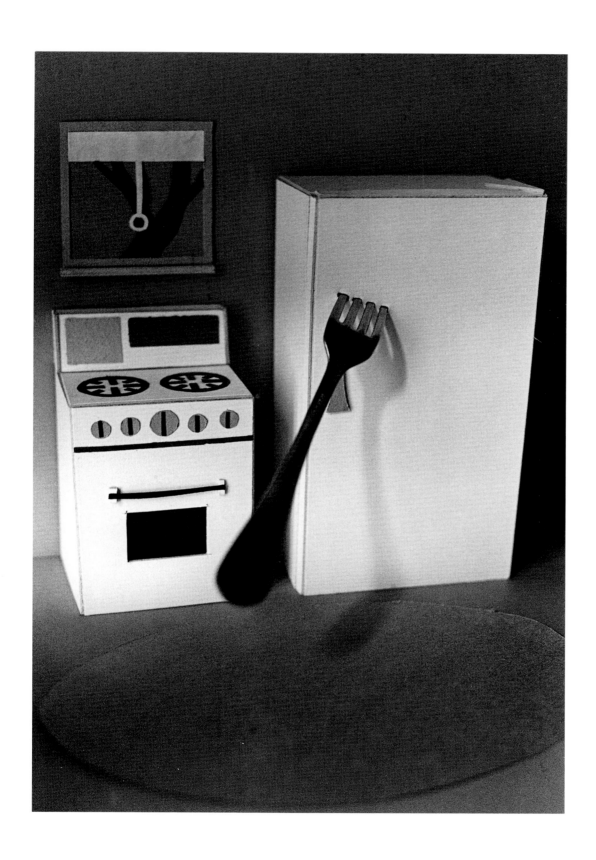

Fork in the Refrigerator *1975*

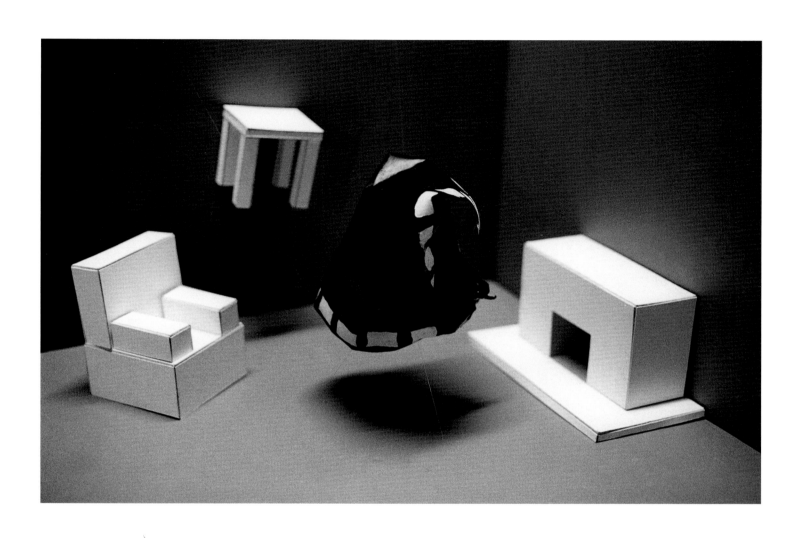

Finding a Shiny New Copy of my Father's circa 1933 Boy Scout Scarf in a New Jersey Dormitory Lobby *1976-77*

Bed Upturning its Belly at Dawn *1977*

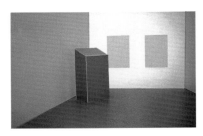

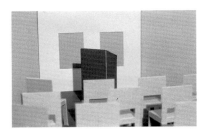

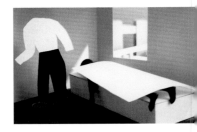

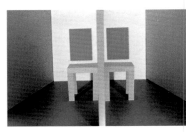

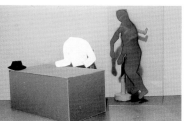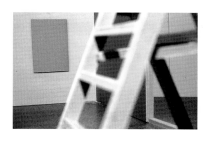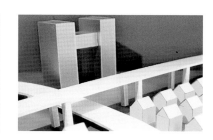

Storyboard for a Film 1979, Casebebere *1979*

A Film 1979 Casebebere	Needs	horizontal → desires
→ withdrawl rehearsal	affecting → performance	being → affected conscious/ consciousness
holding on pulling at one anothers' clothes inter-personal → conflict	→ letting go play	tension → work

Storyboard (Sketch) *1979*

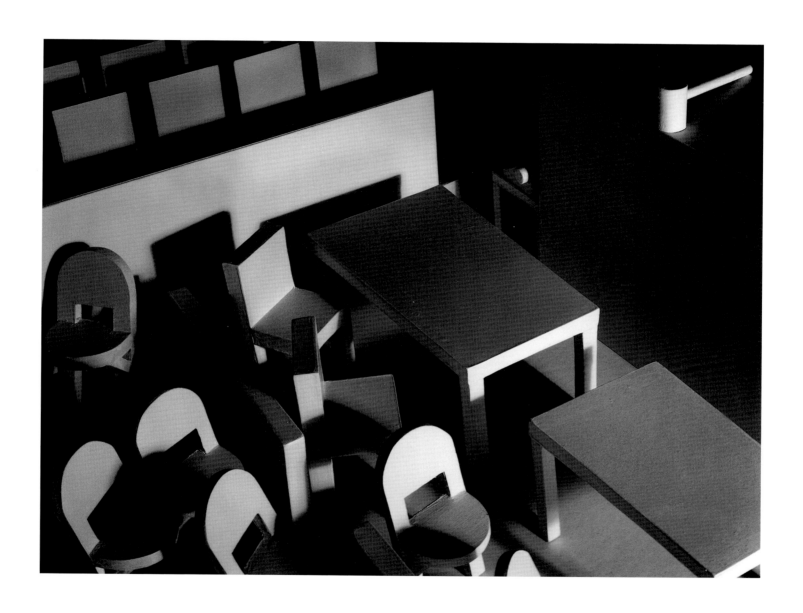

Courtroom *1979-80*

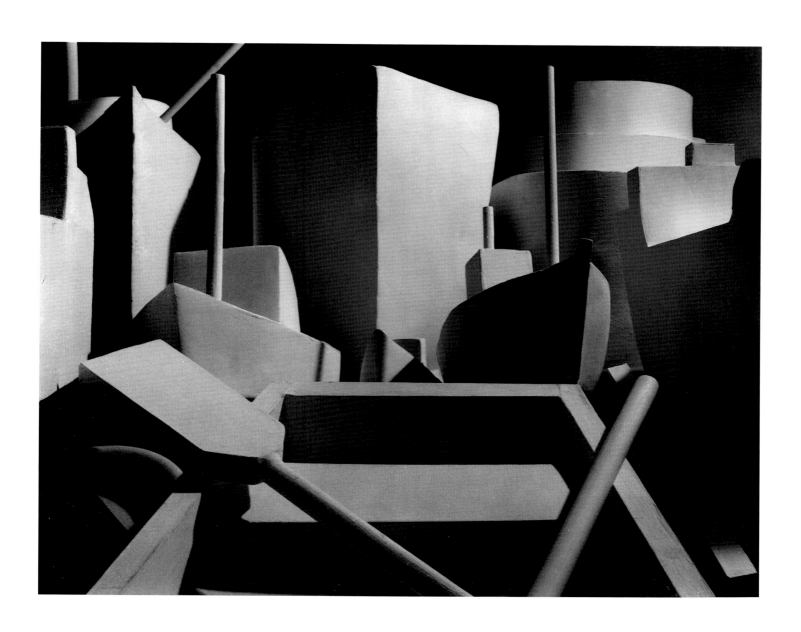

Boats *1980*

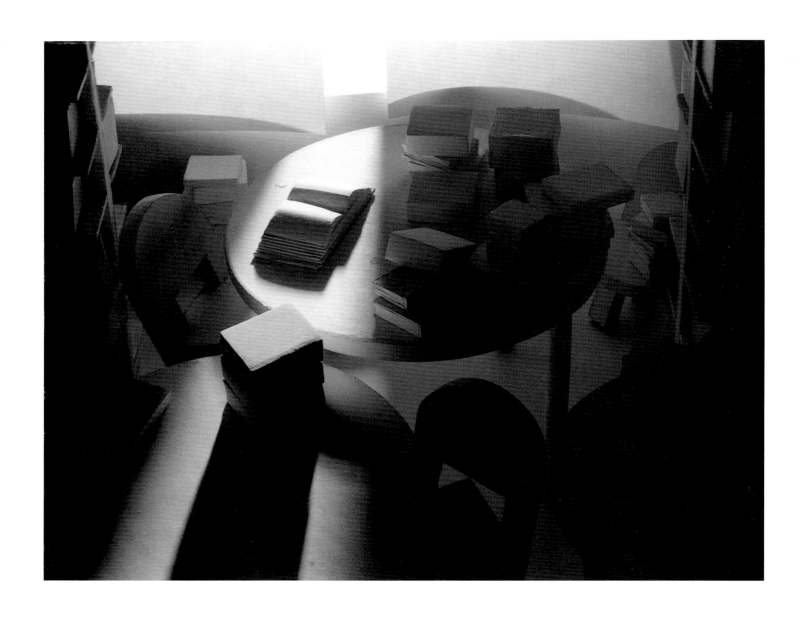

Library I *1980*

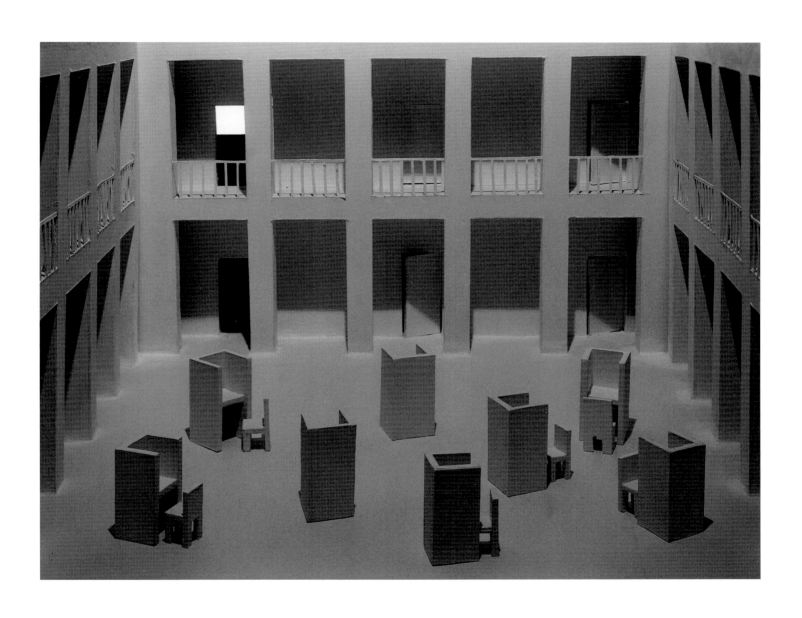

Library II *1980*

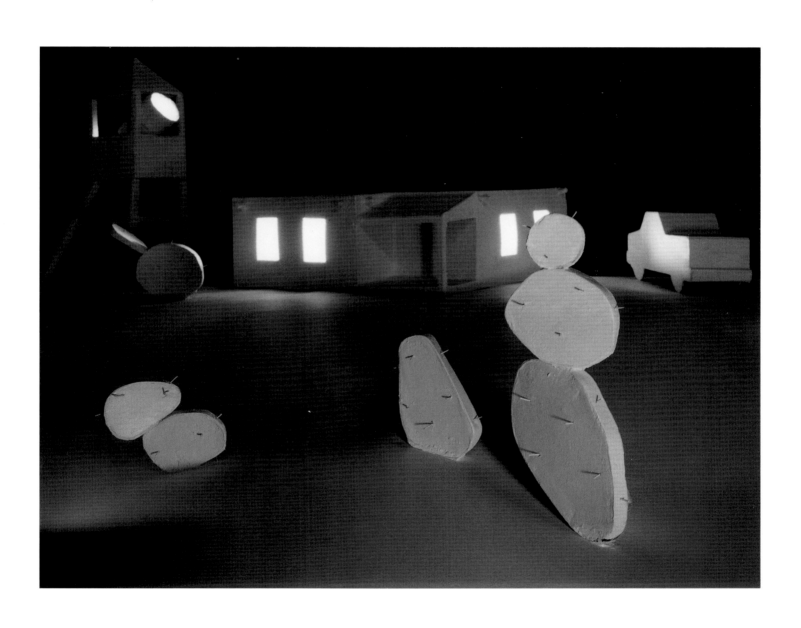

Desert House with Cactus *1980*

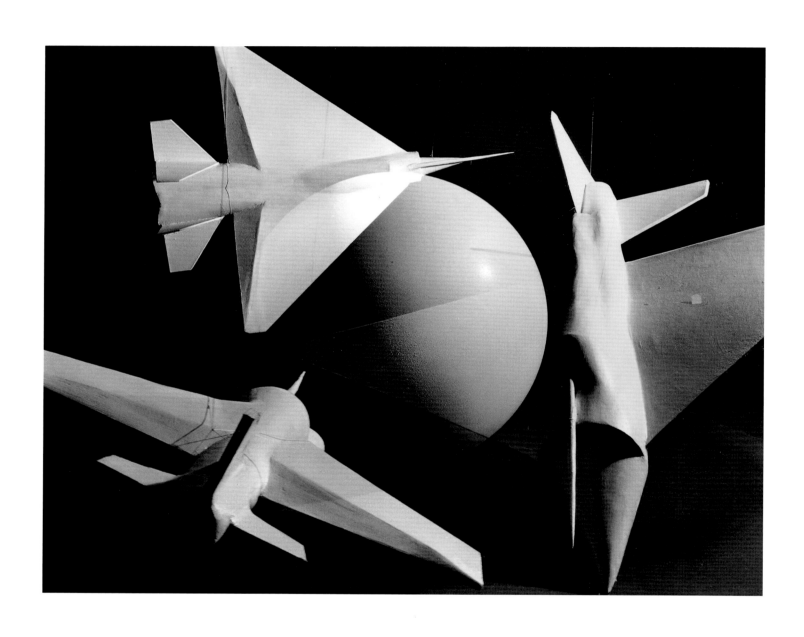

Three Planes *1982*

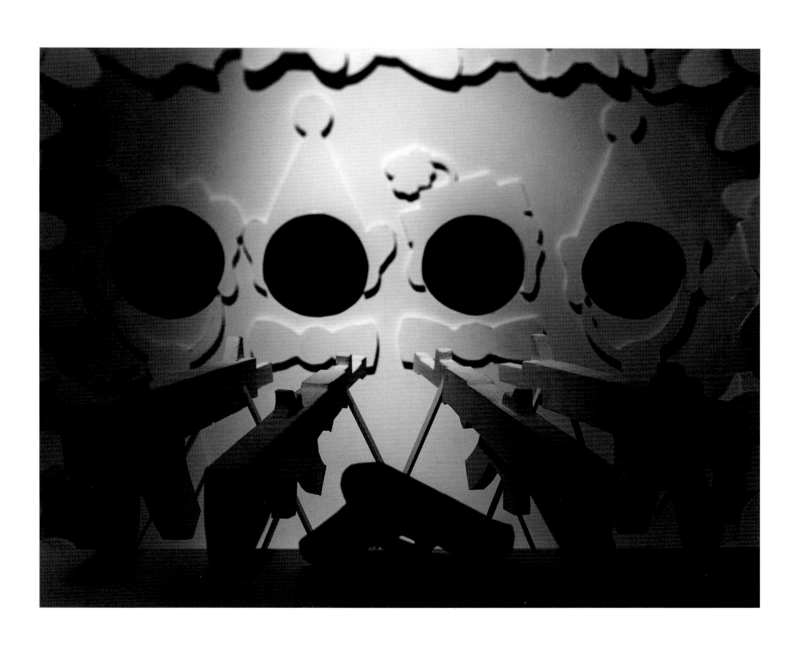

Shooting Gallery *1981*

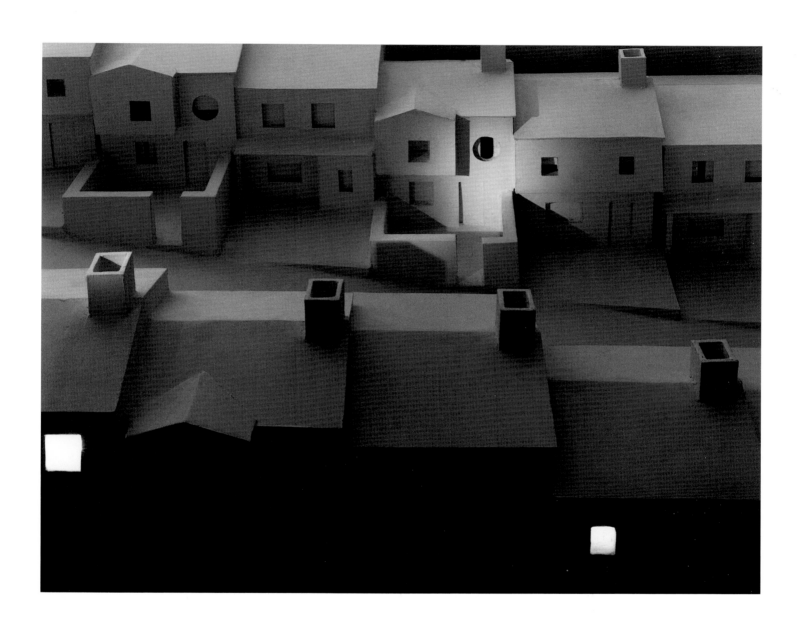

Subdivision with Spotlight *1982*

Kitchen Table *1982*

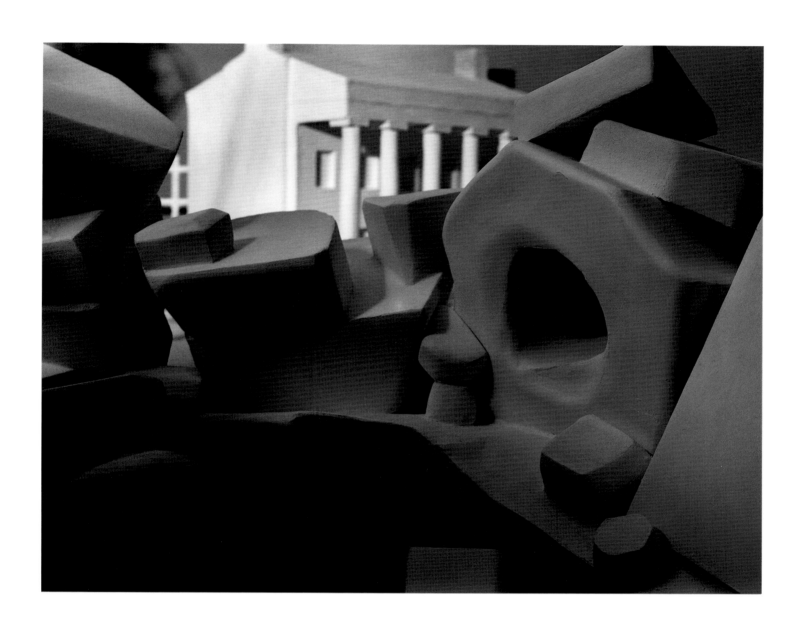

Sutpen's Cave *1982*

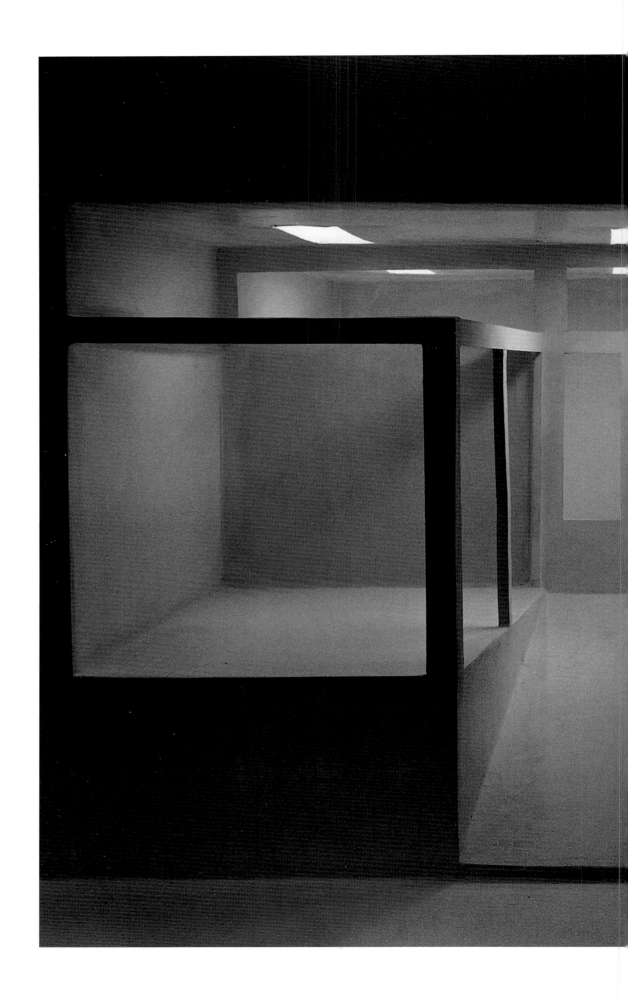

Storefront *1982*

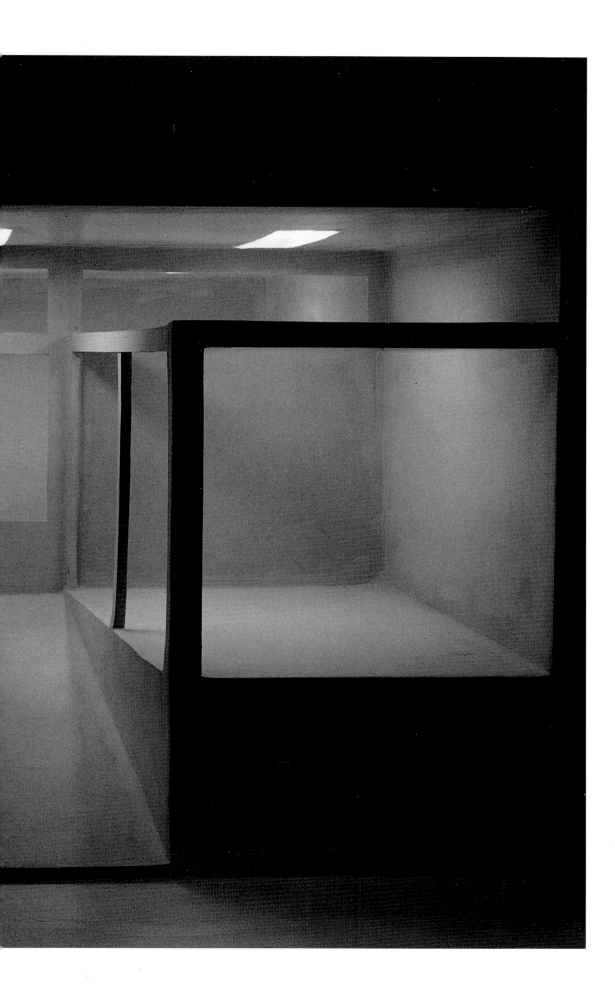

Street with Pots *1983-84*

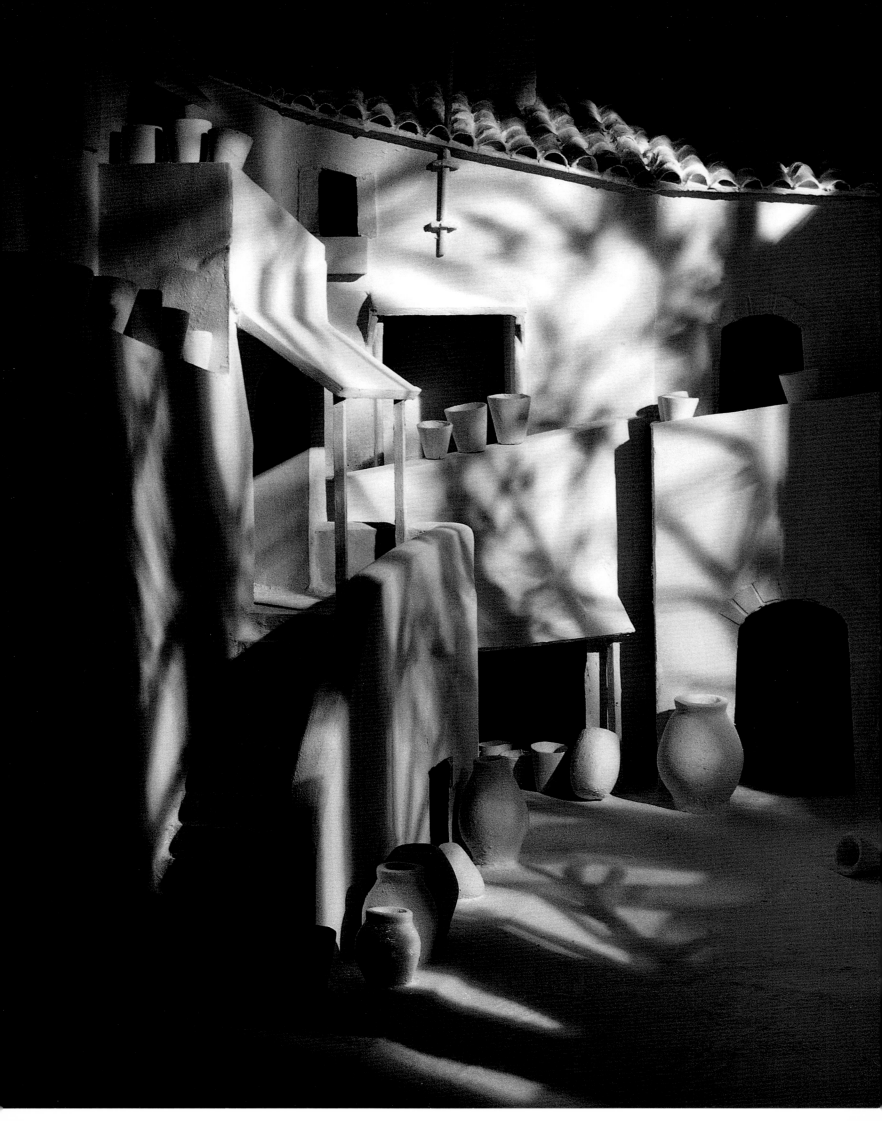

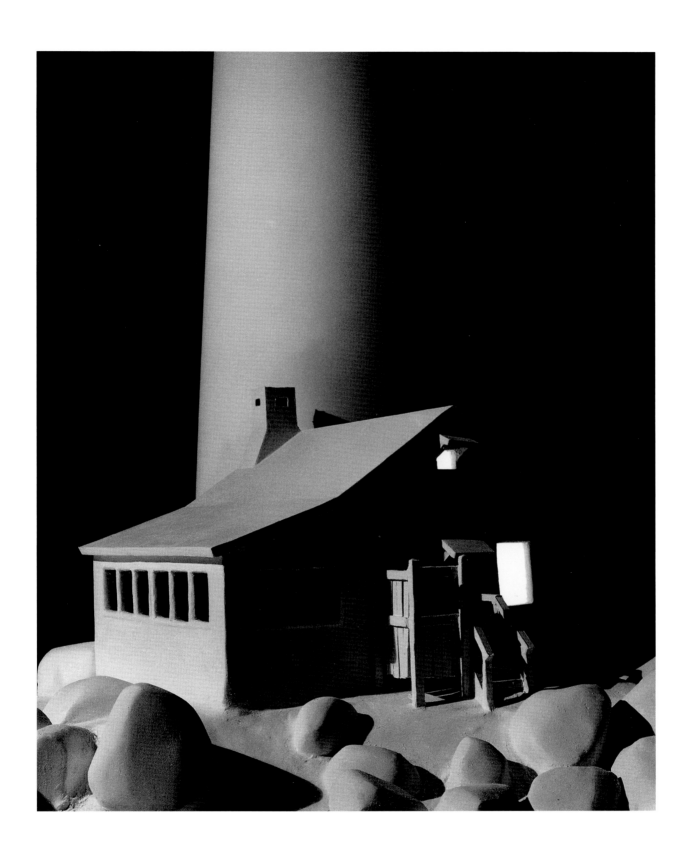

Lighthouse *1983*

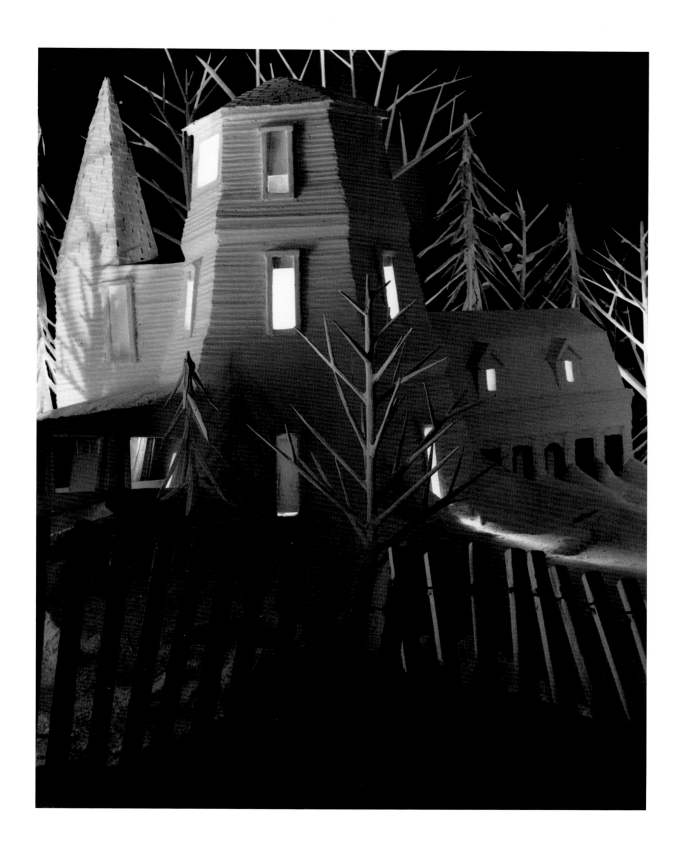

Winterhouse *1984*

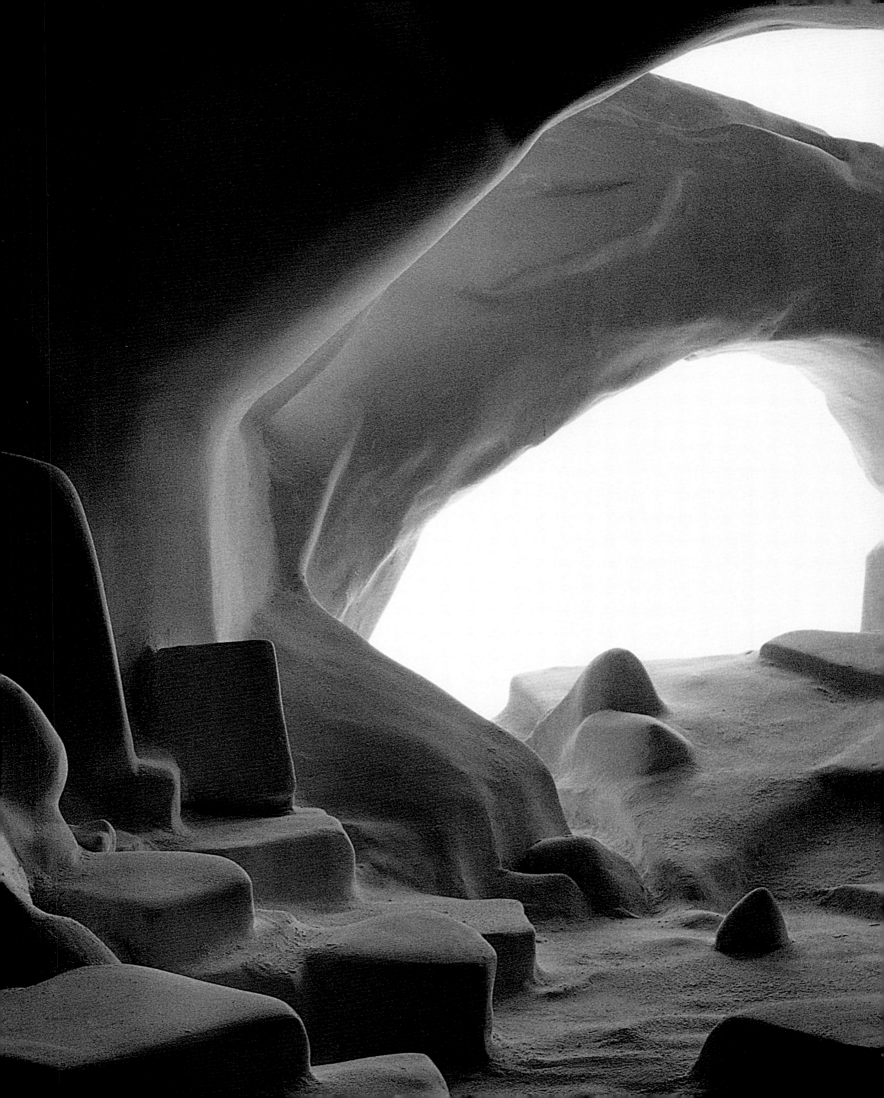

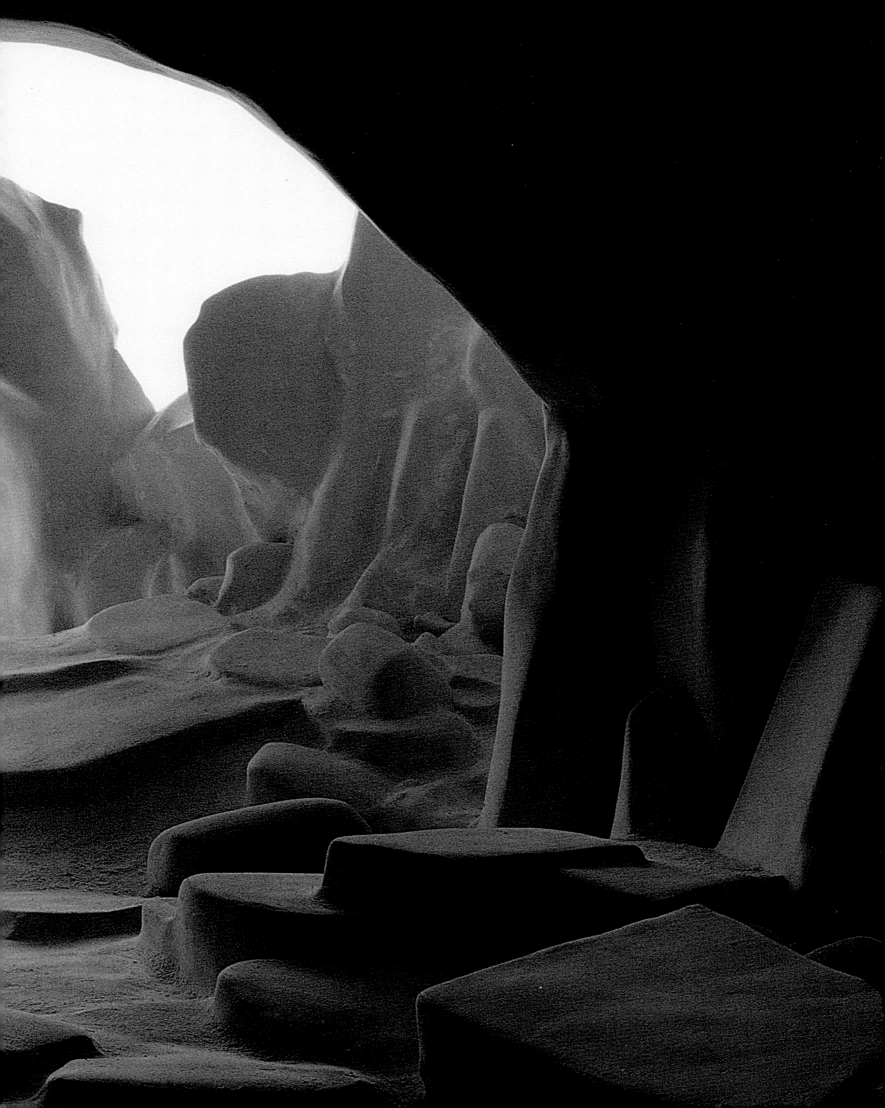

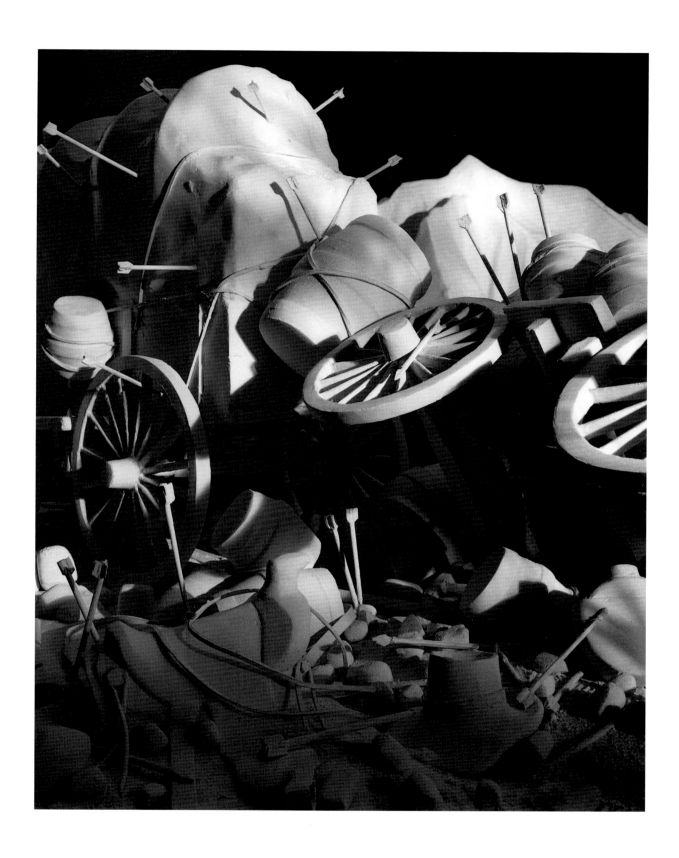

Covered Wagons *1985*

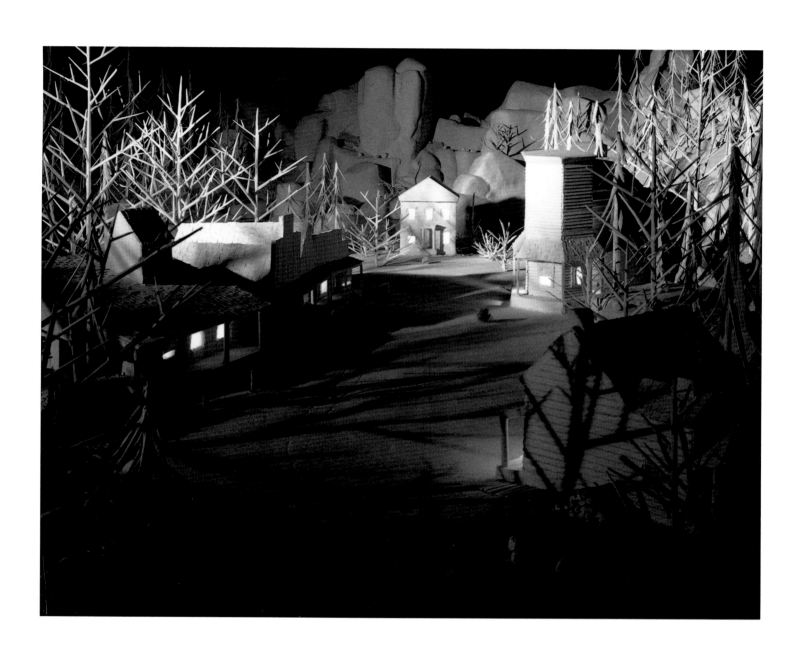

Western Street *1985-86*

Needles *1985*

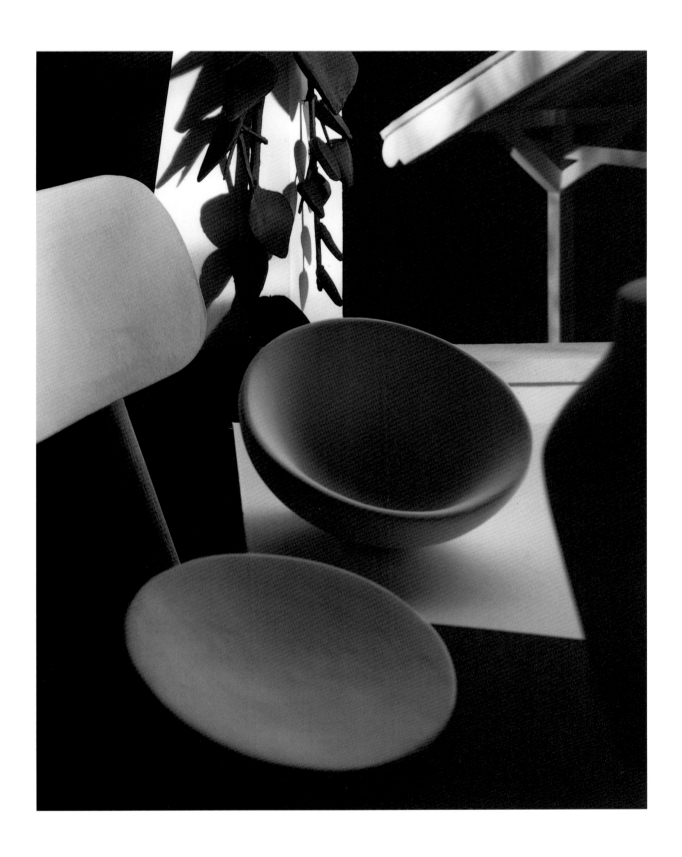

Empty Bowl with Canopy *1989*

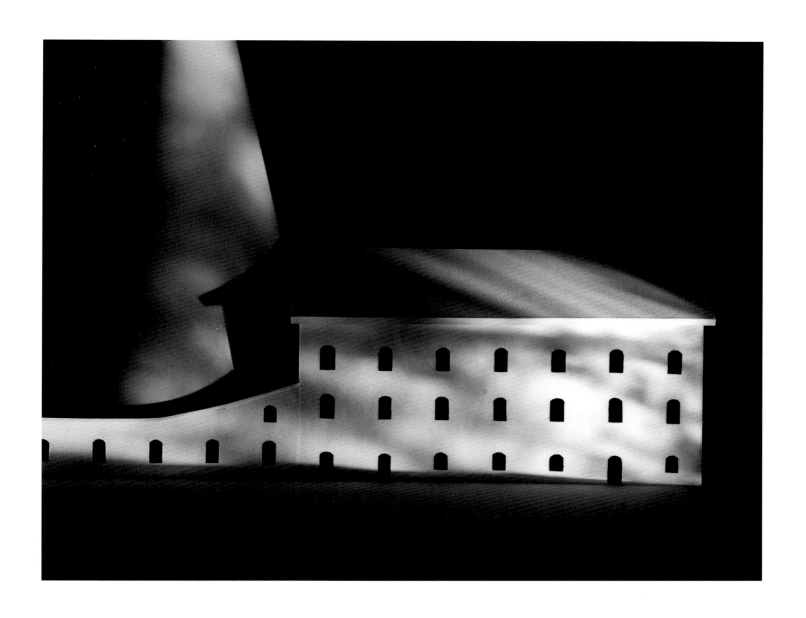

Industry *1990*

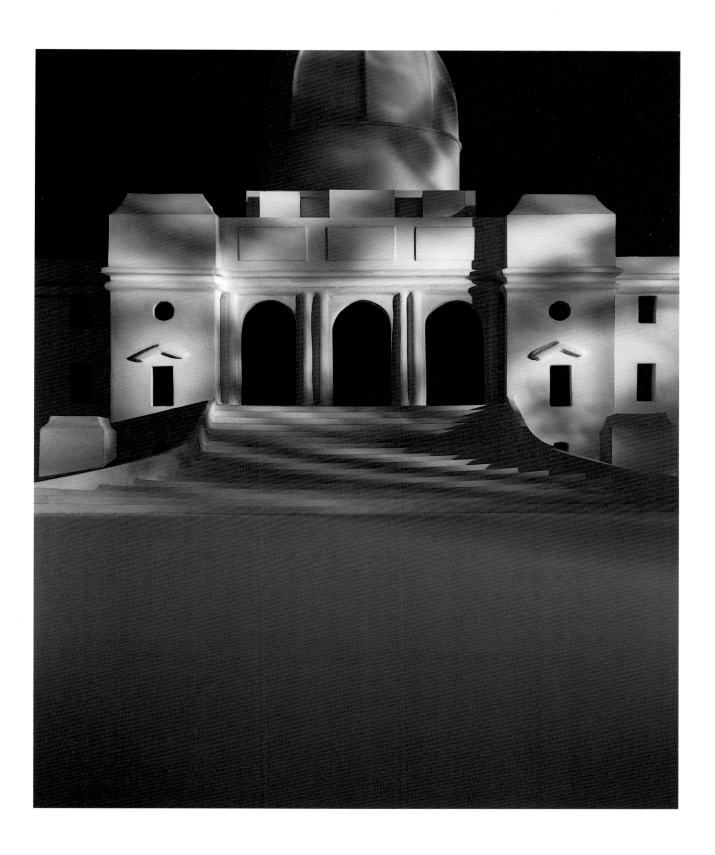

Capitol Facade *1990*

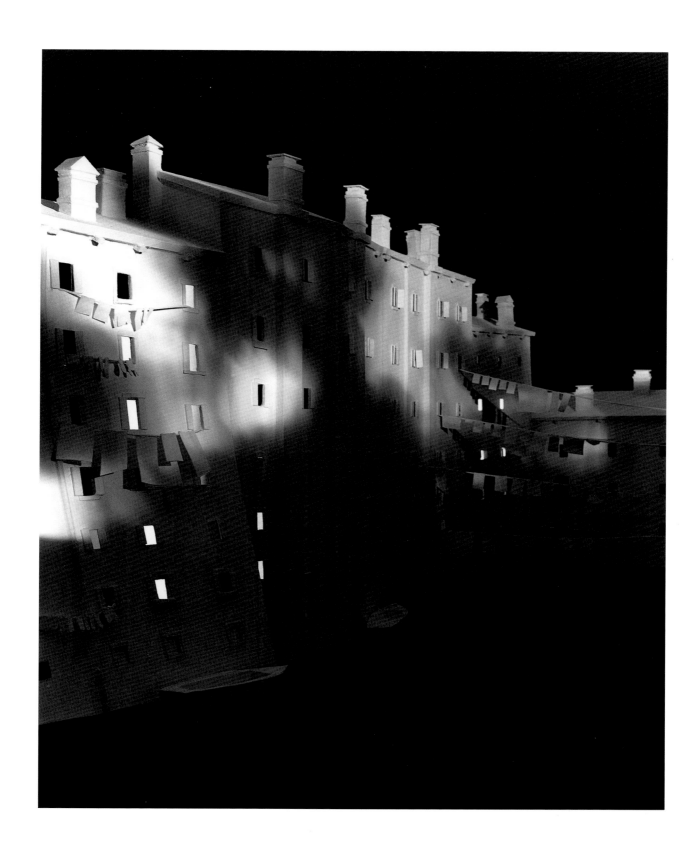

Venice Ghetto *1991*

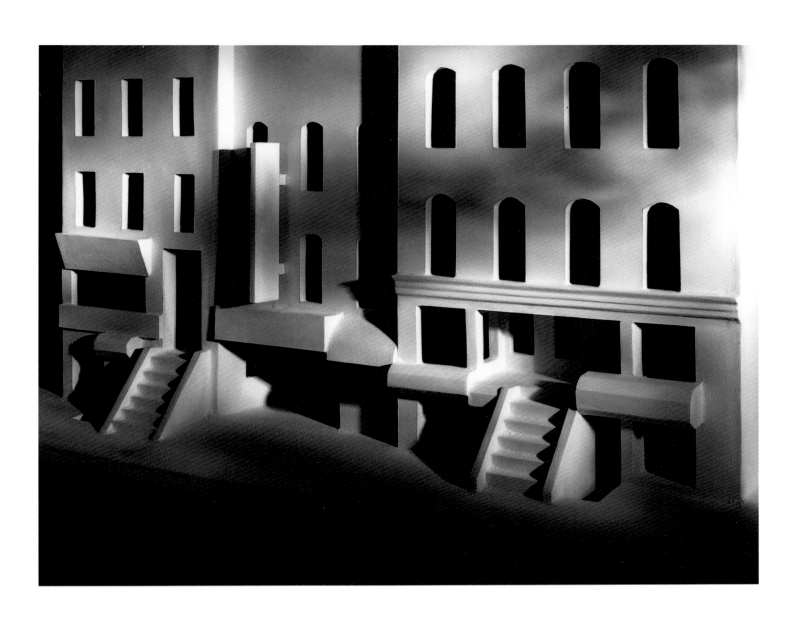

Tenement/Market Place 1992

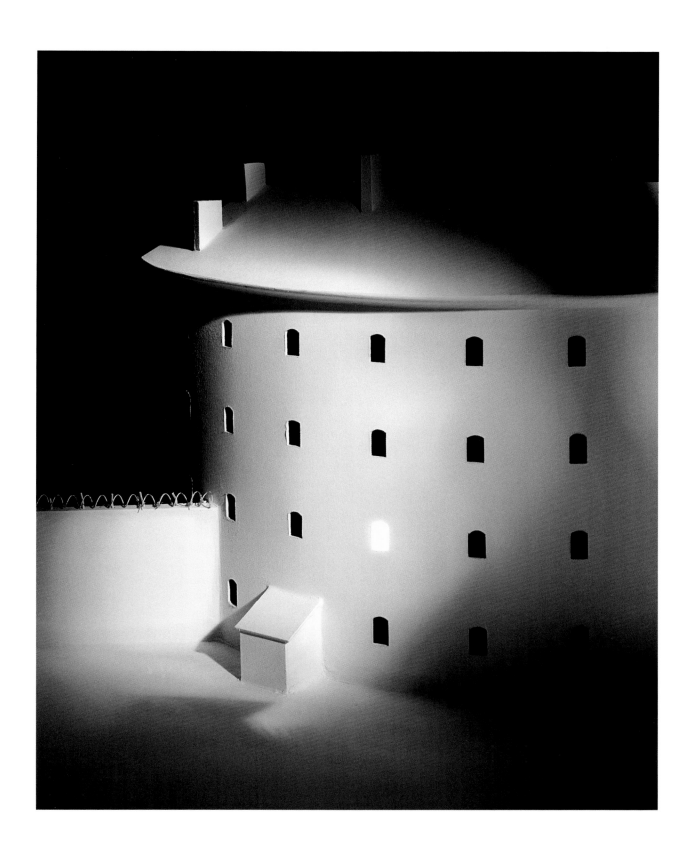

Panopticon Prison #3 *1993*

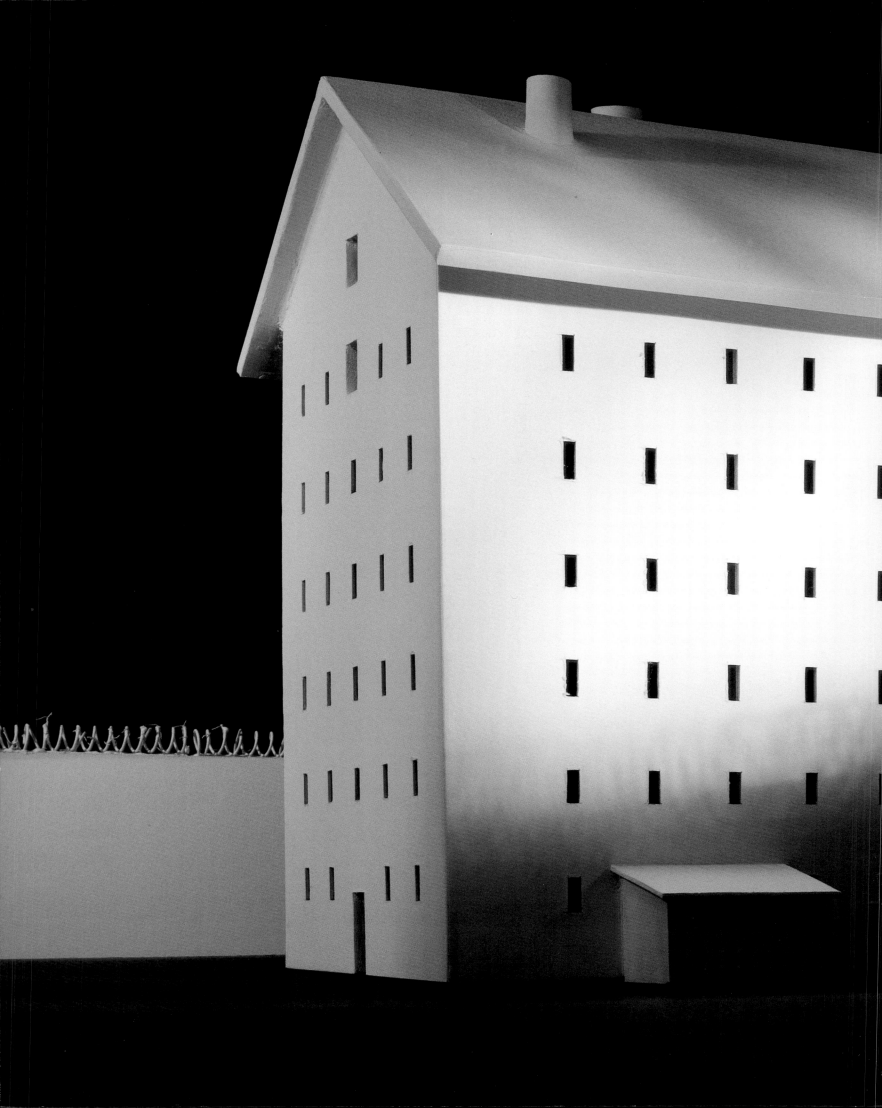

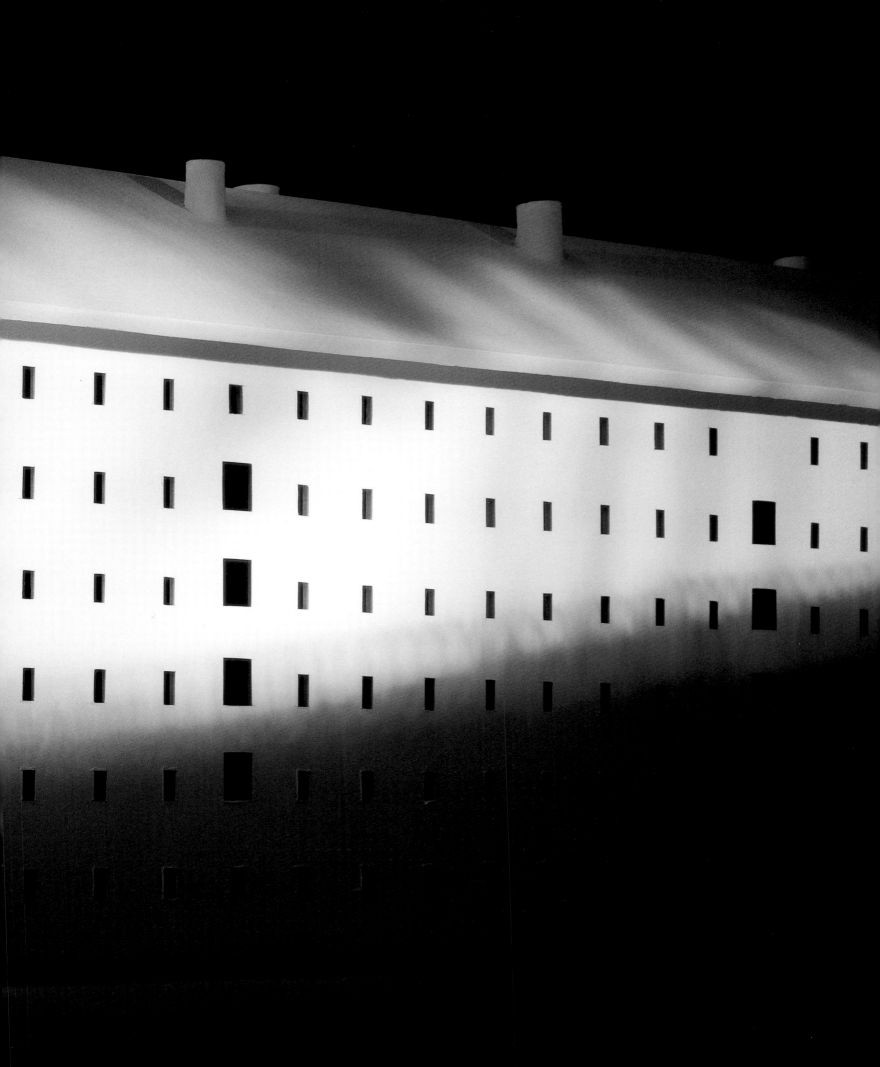

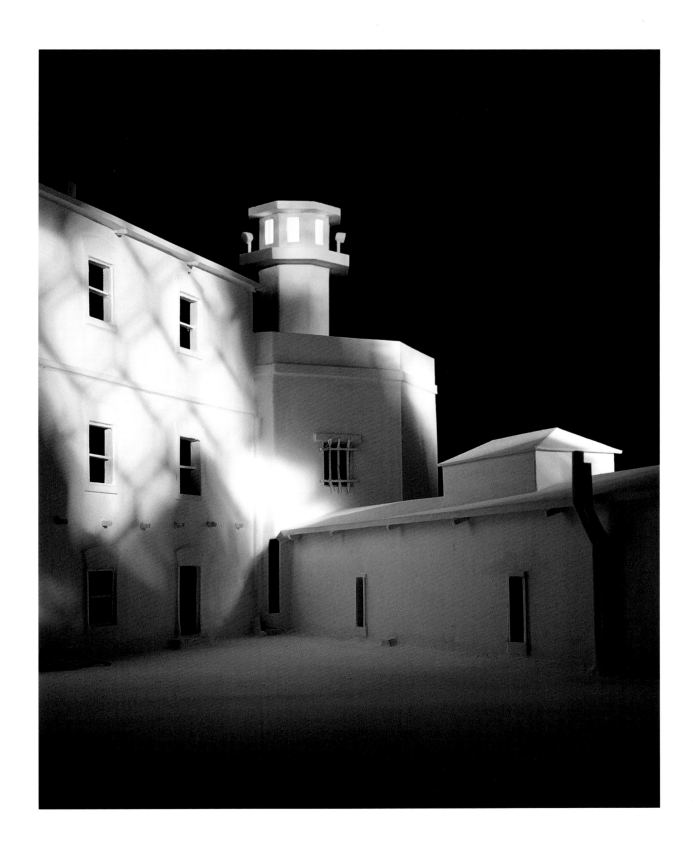

Prison at Cherry Hill *1993*

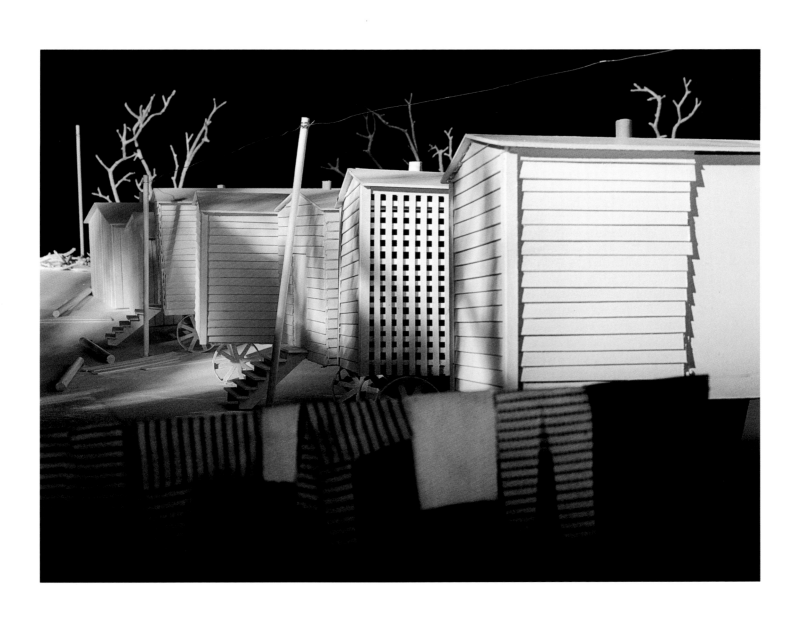

Georgian Jail Cages (Horizontal) *1993*

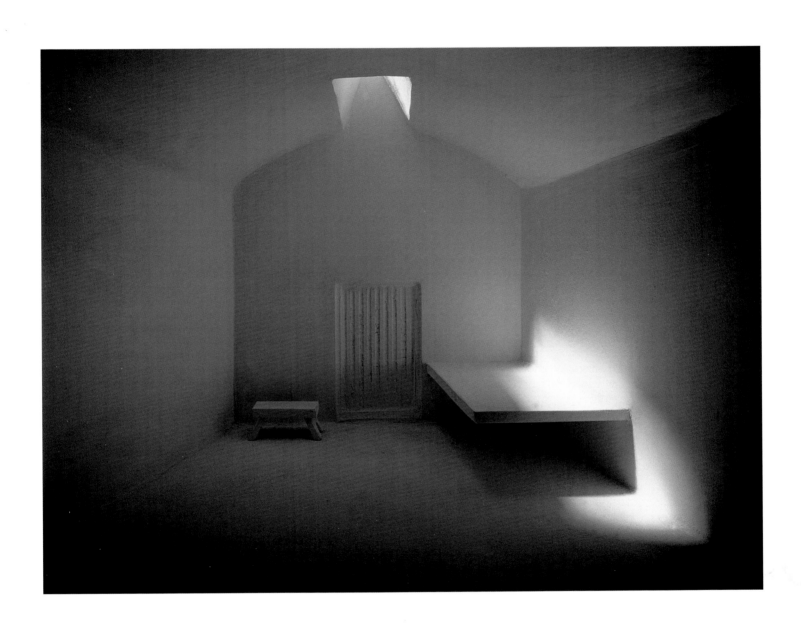

Prison Cell with Skylight *1993*

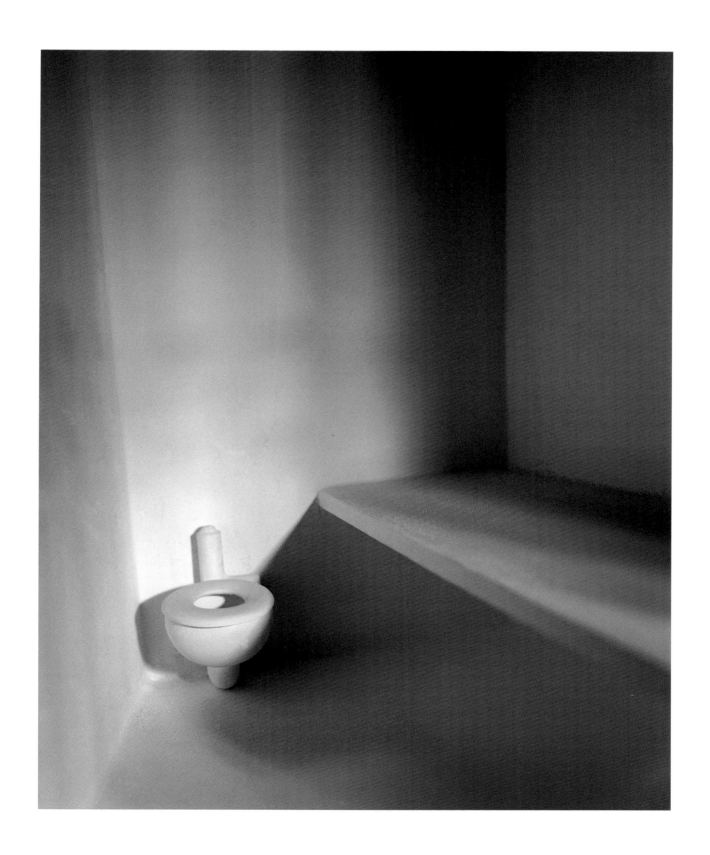

Cell with Toilet *1993*

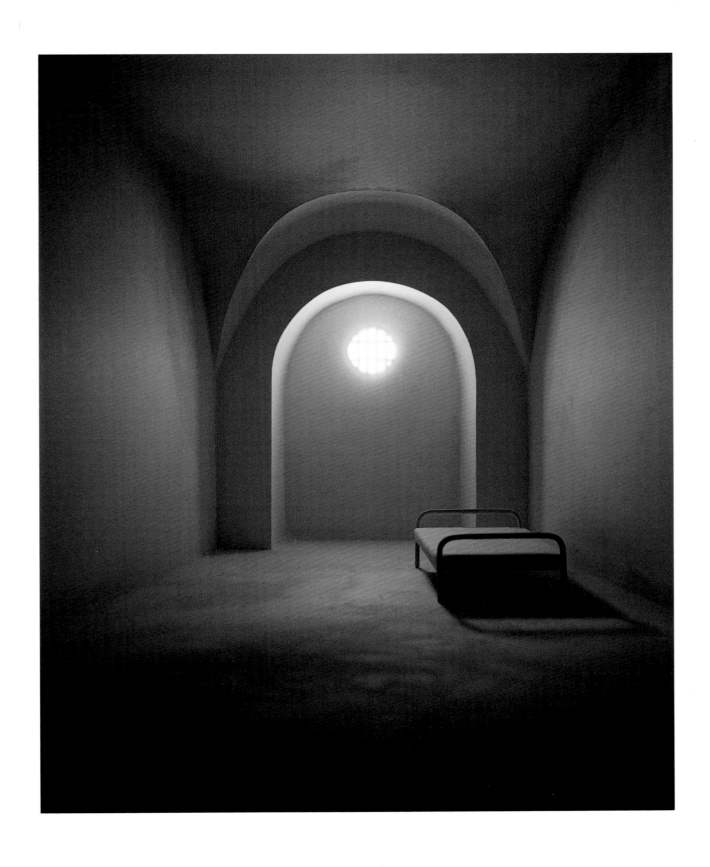

A Barrel Vaulted Room *1994*

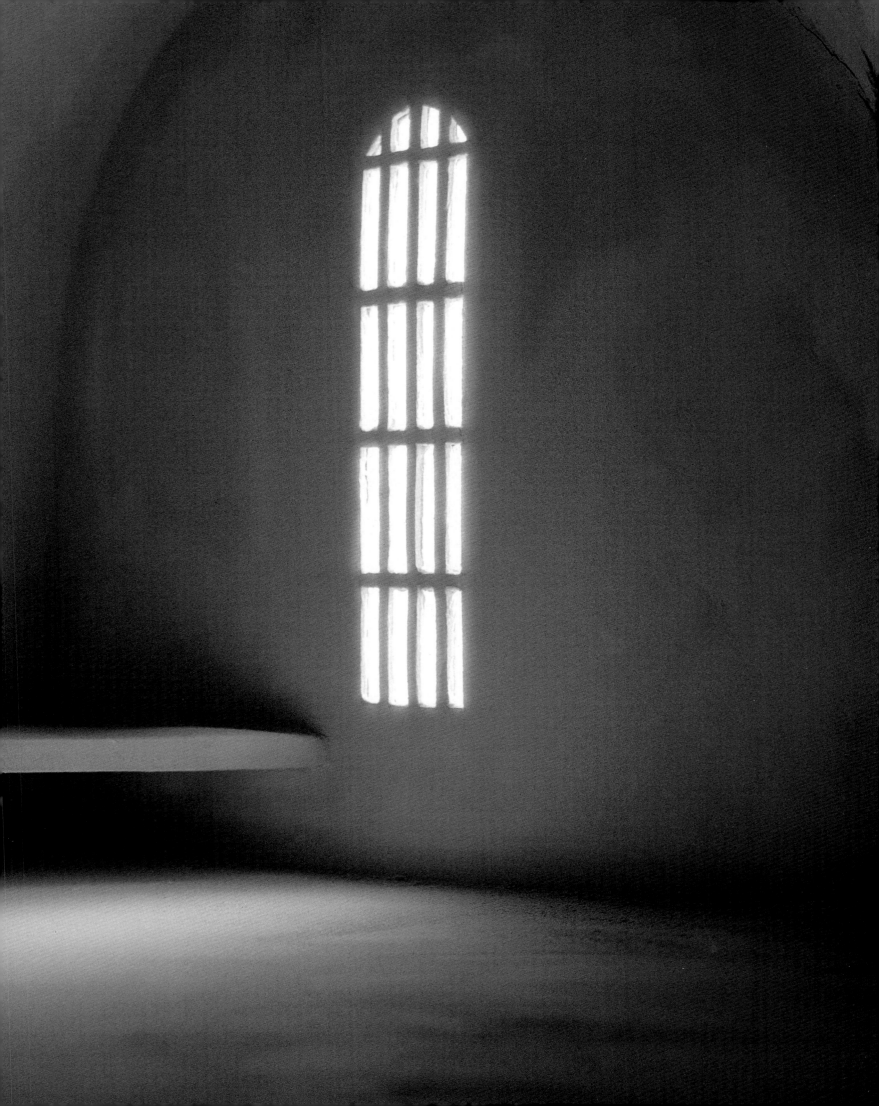

pp. 110-111
Asylum *1994*

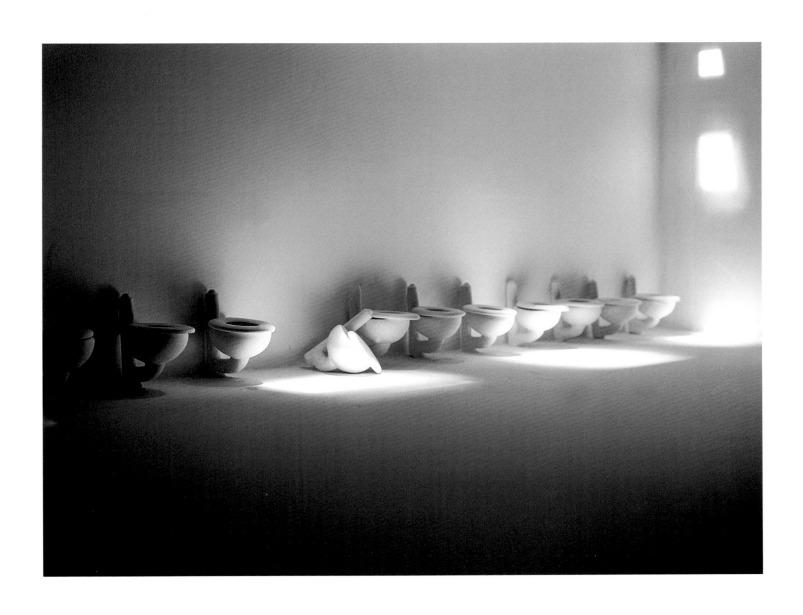

Toilets *1995*

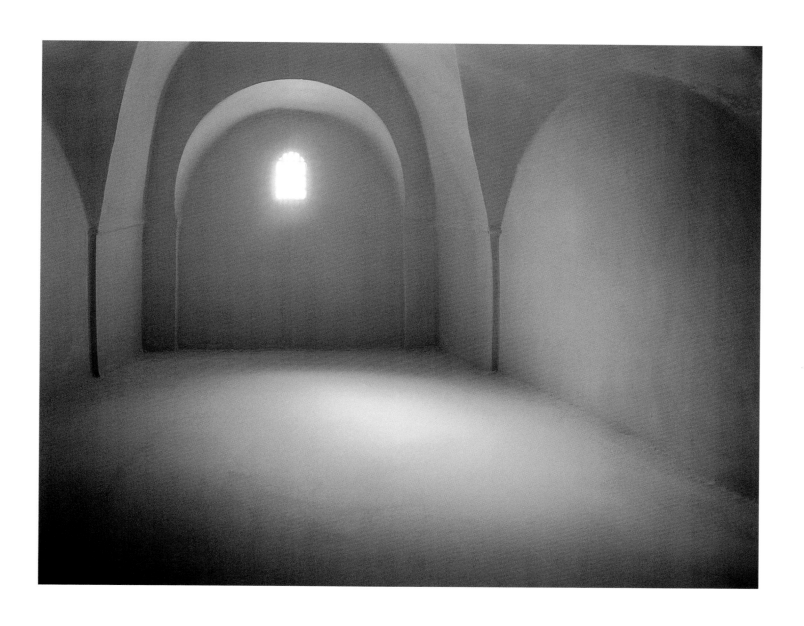

Empty Room *1994*

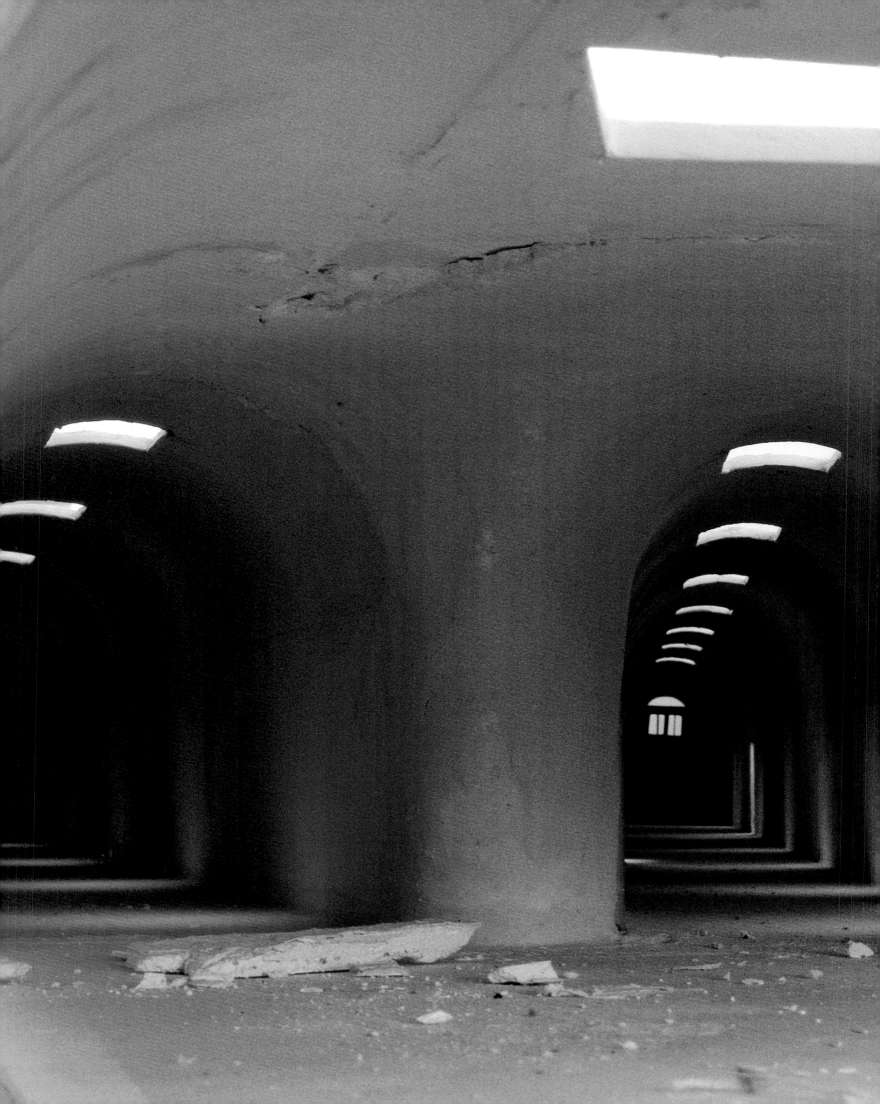

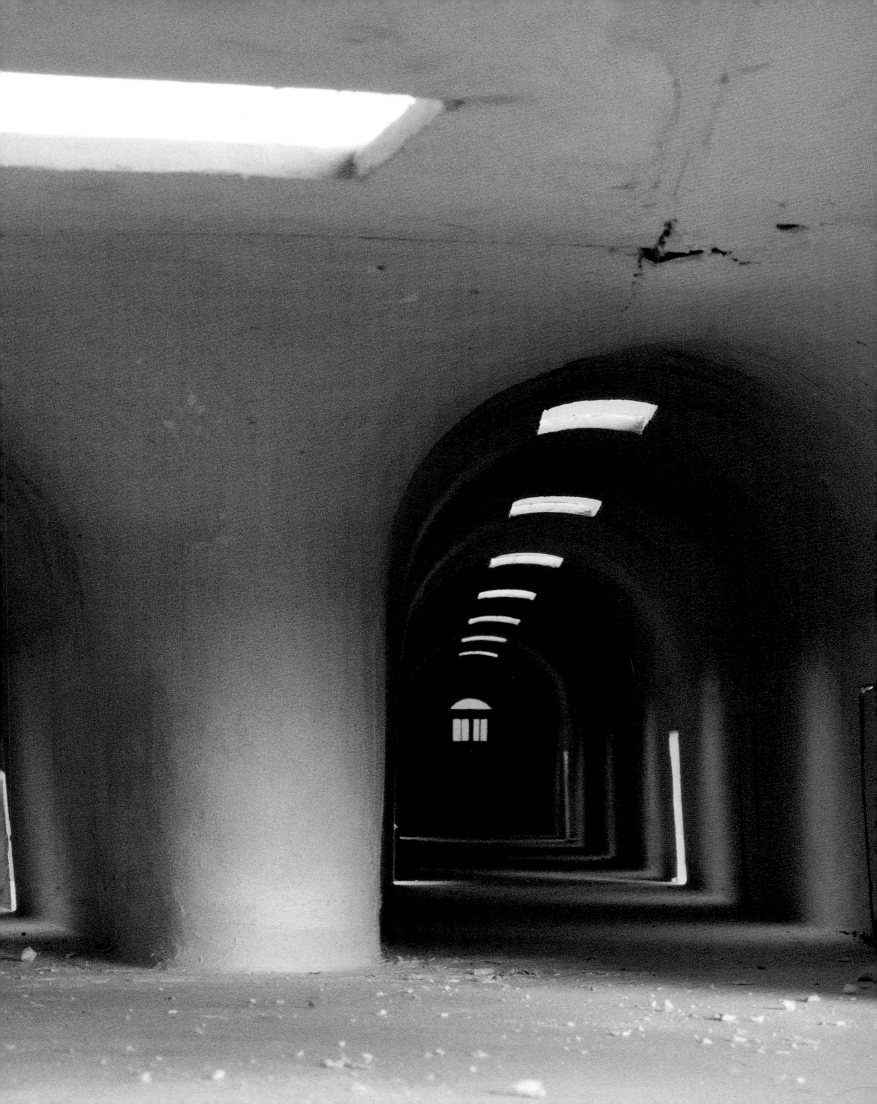

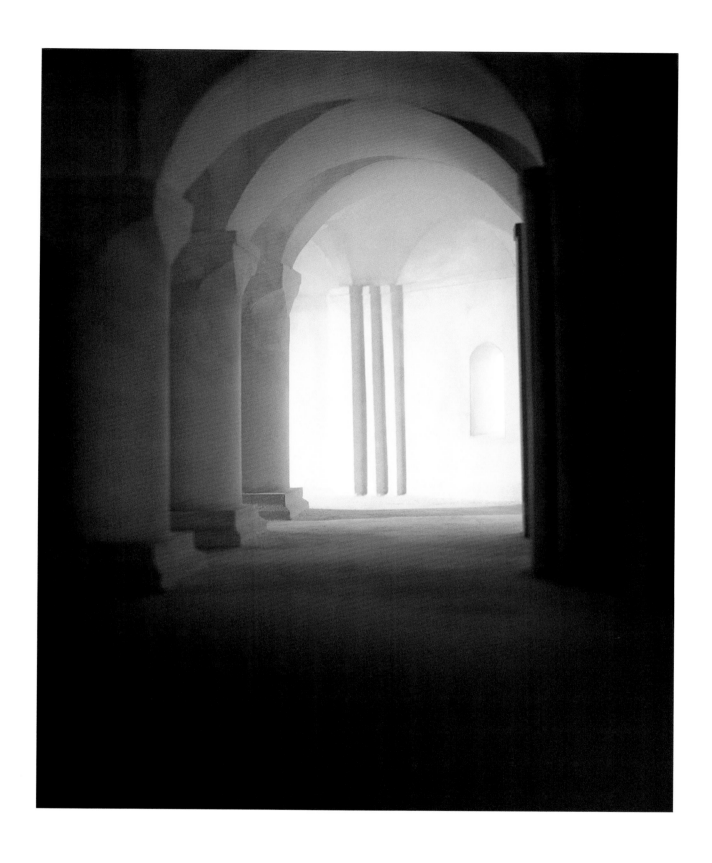

Arcade *1995*

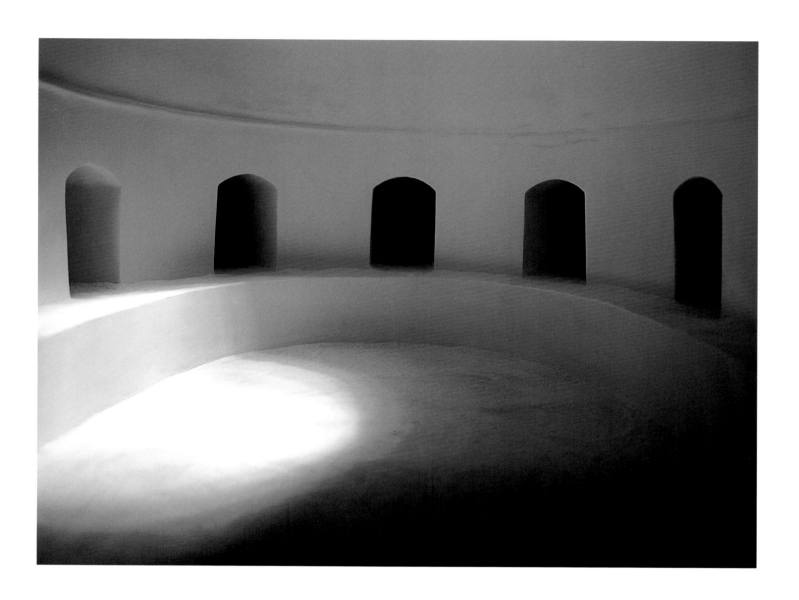

Arena *1995*

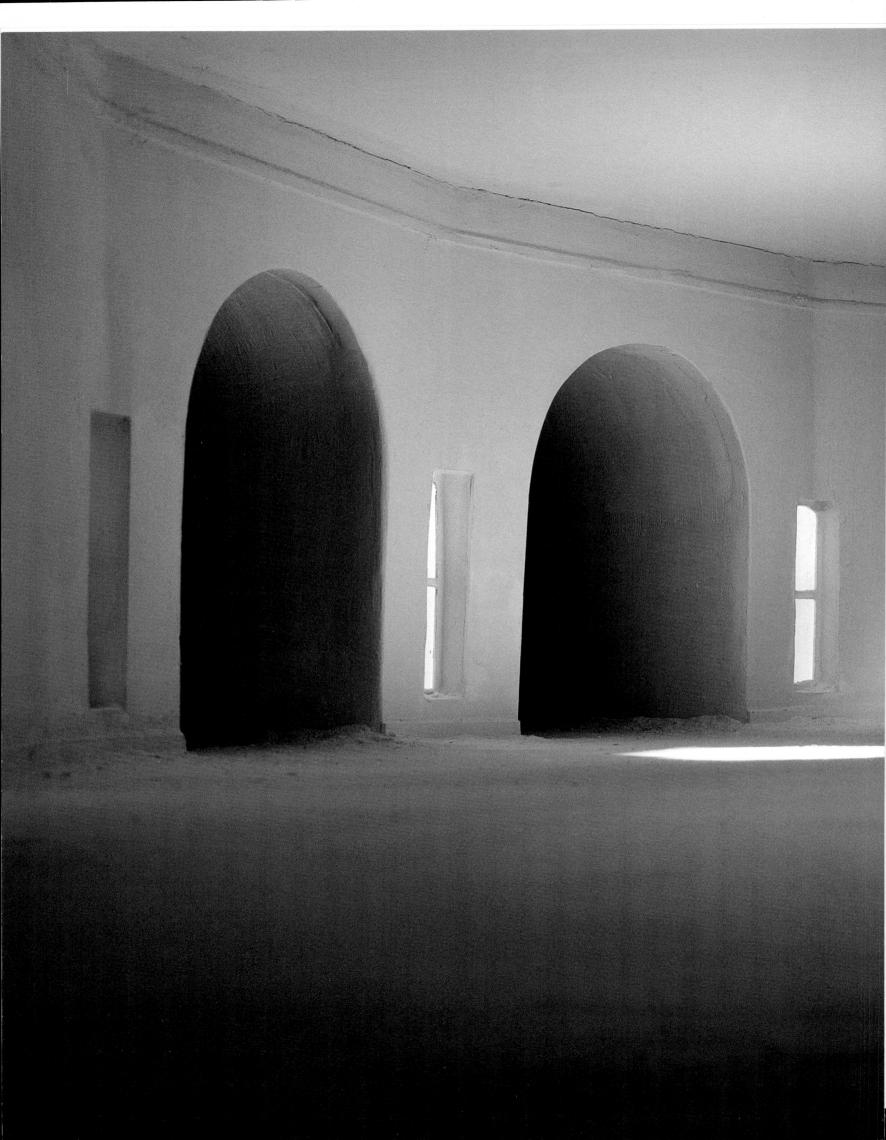

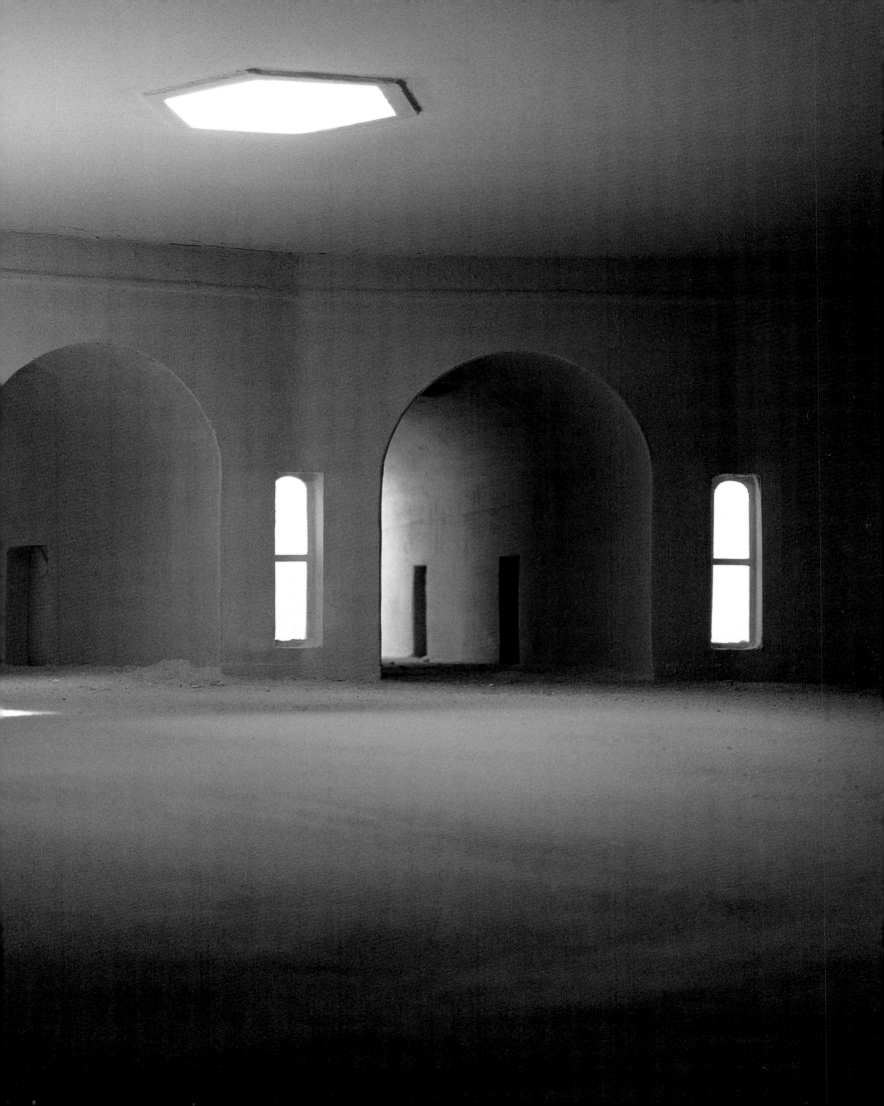

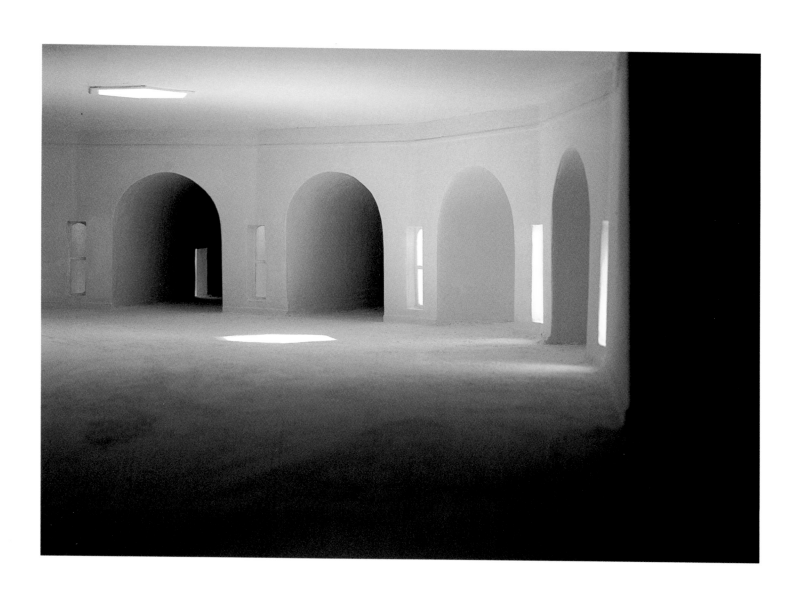

Converging Hallways From Right *1997*

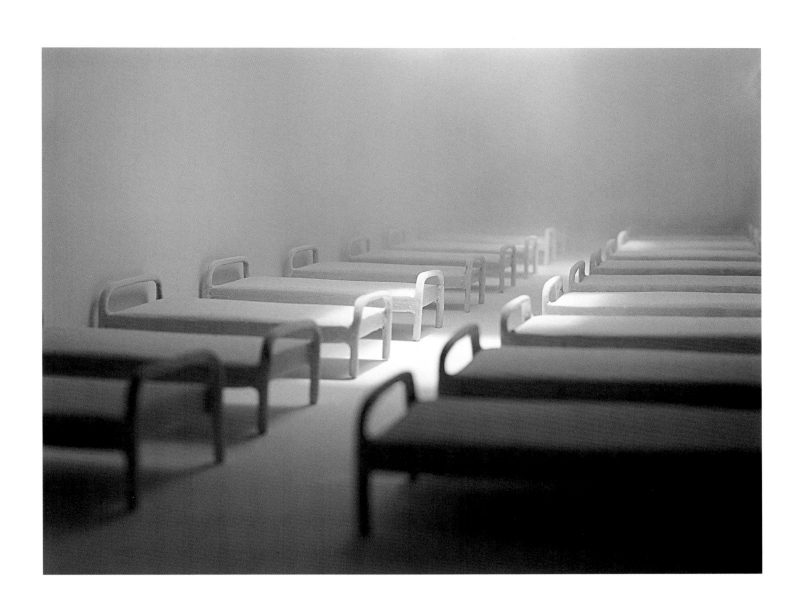

Hospital *1997*

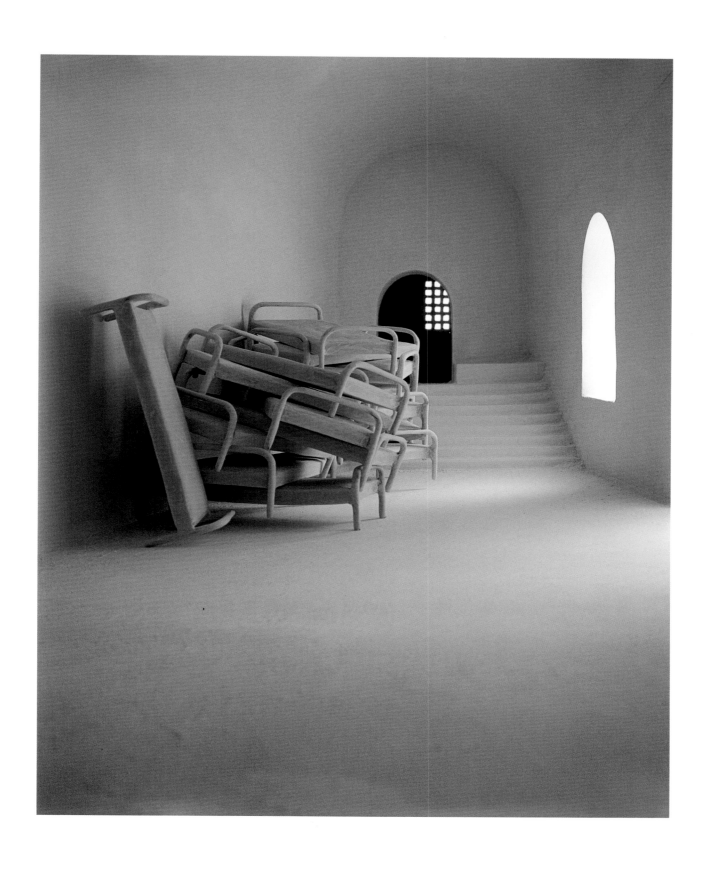

Tall Stack of Beds *1997*

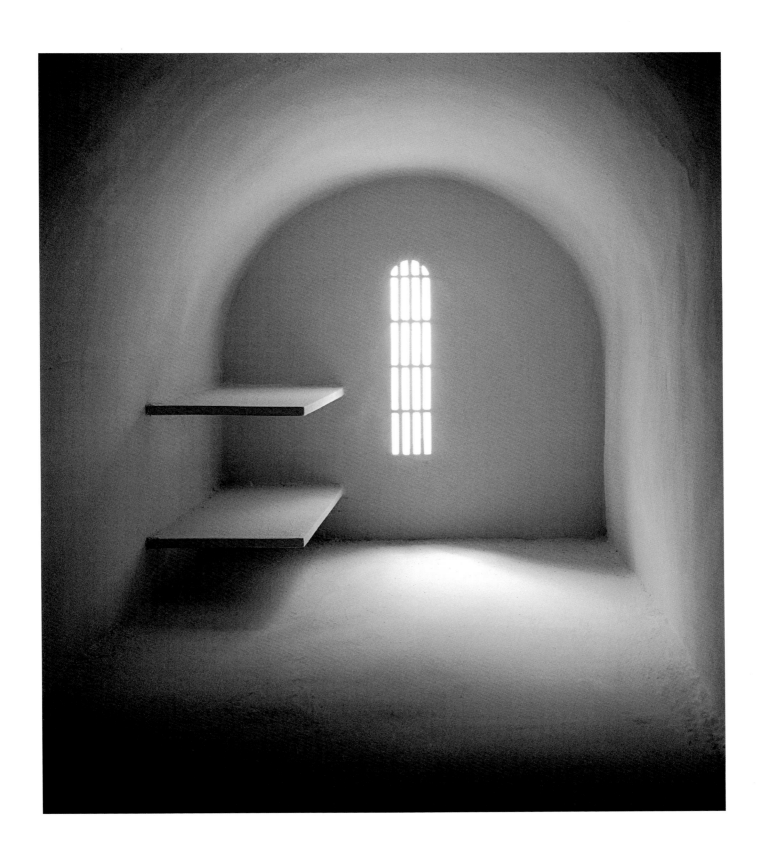

Two Bunk Cell *1998*

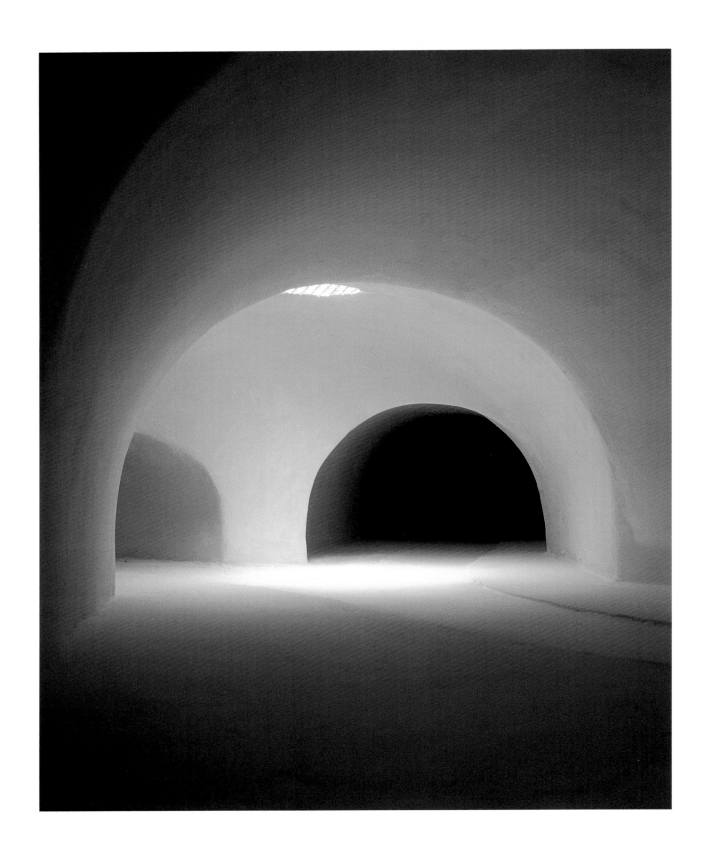

Two Tunnels from Left (Vertical) *1998*

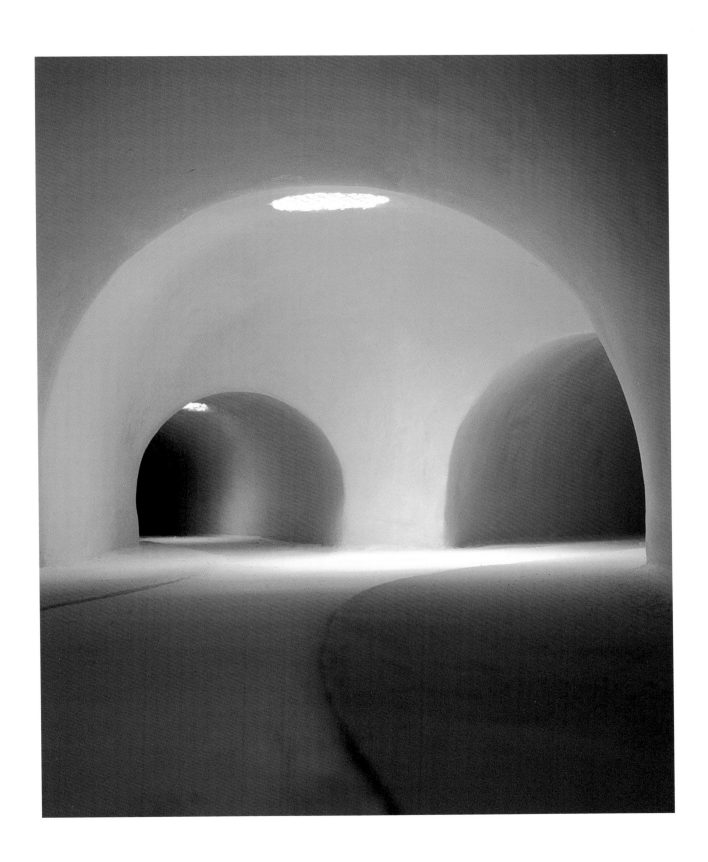

Two Tunnels from Right (Vertical) *1998*

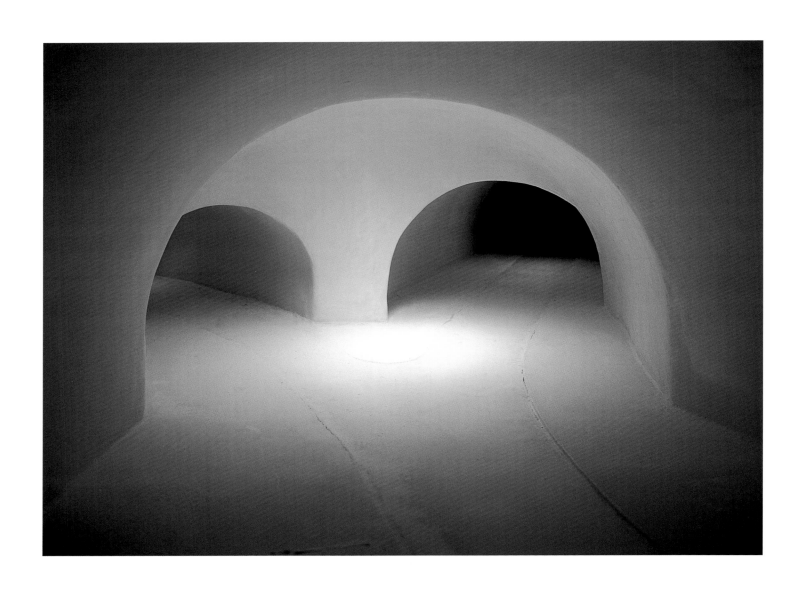

Two Tunnels from Left (Horizontal) *1998*

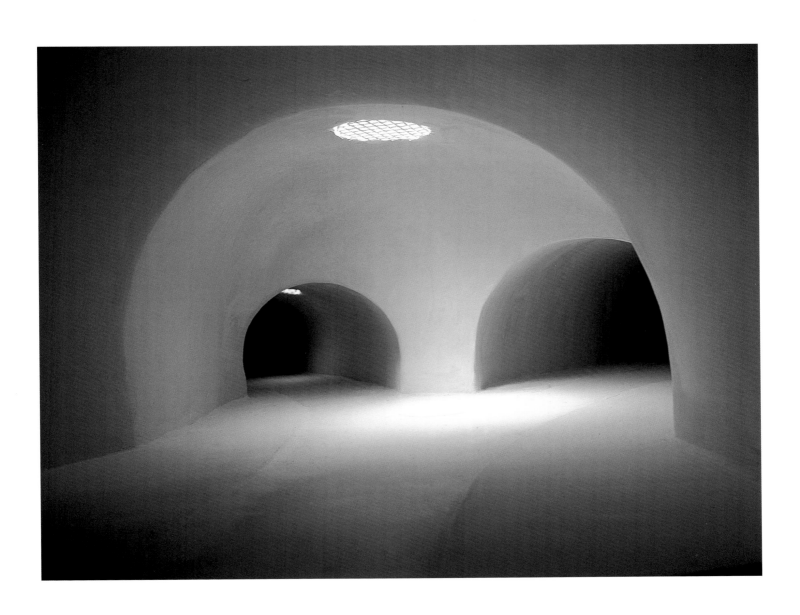

Two Tunnels from Right (Horizontal) *1998*

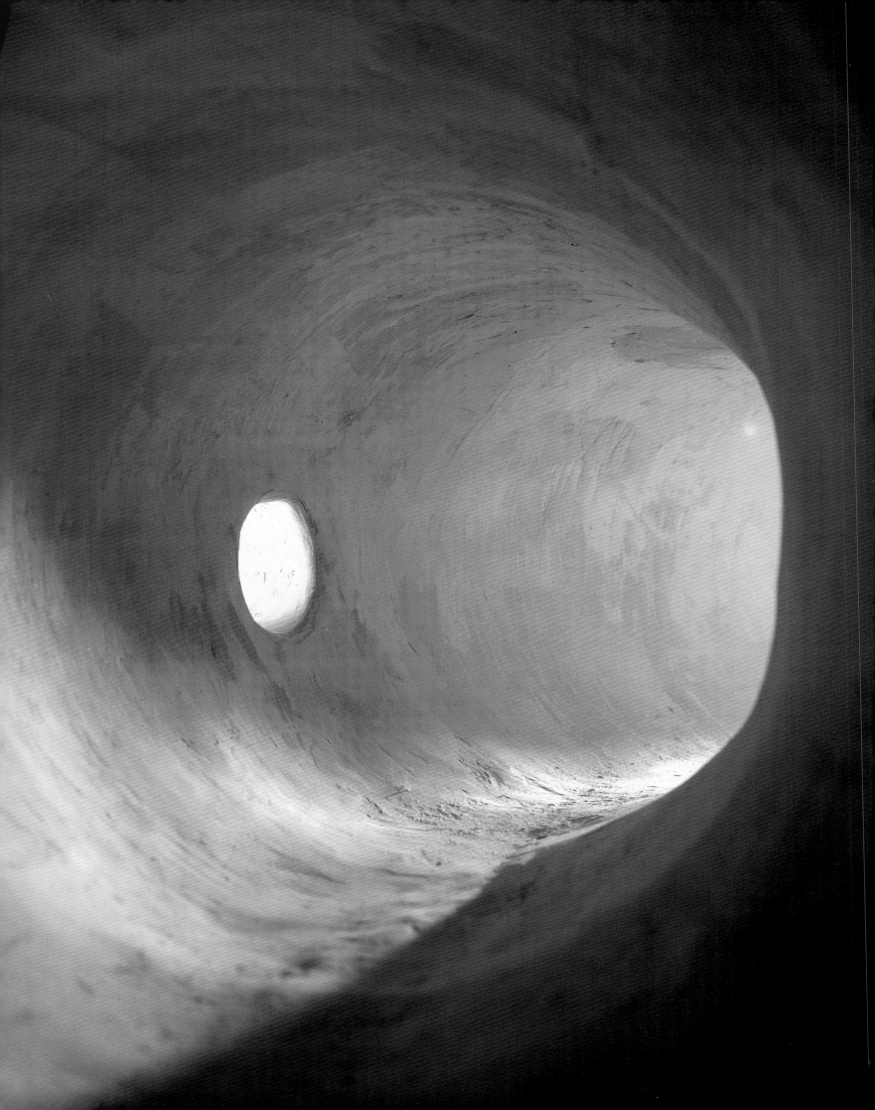

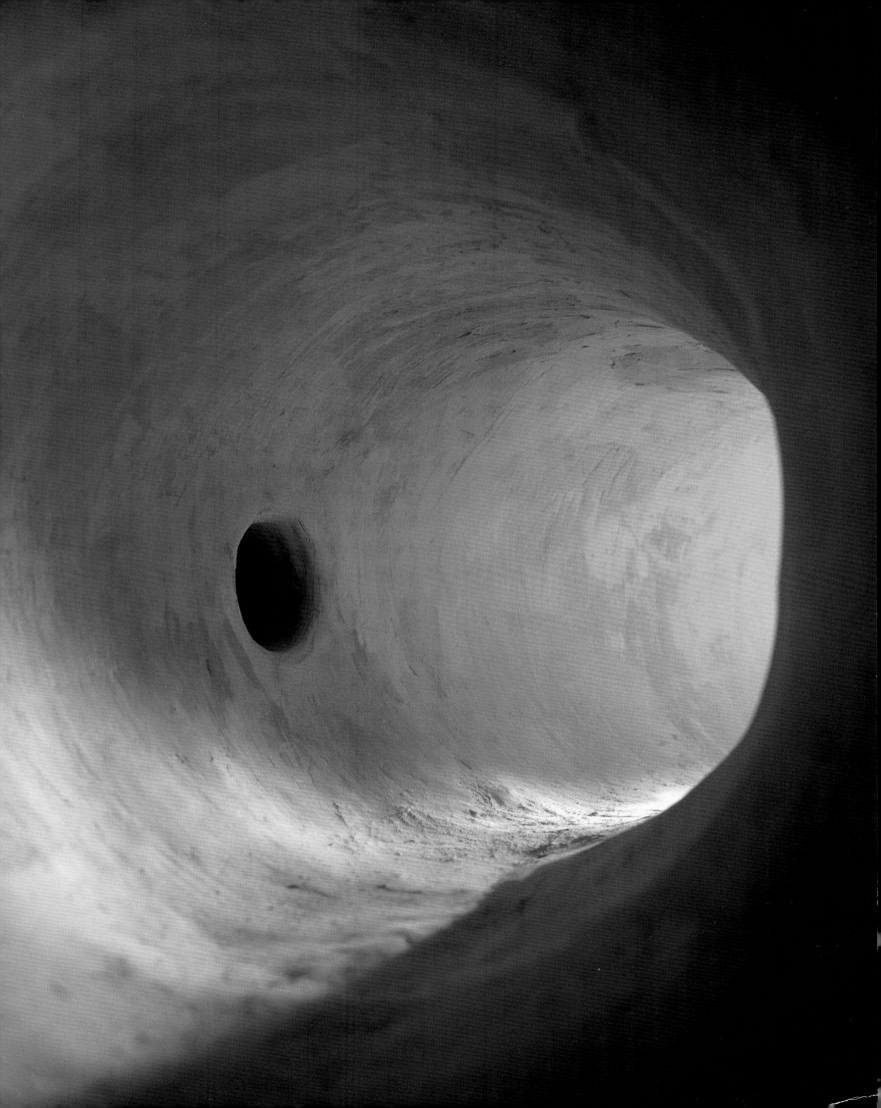

p. 140
Tunnel with Bright Hole *1998*

p. 141
Tunnel with Dark Hole *1998*

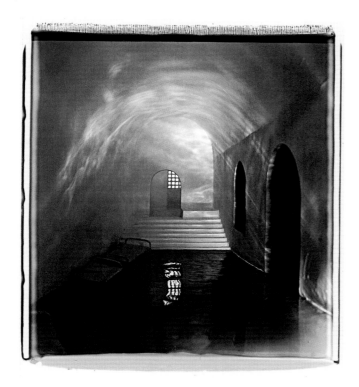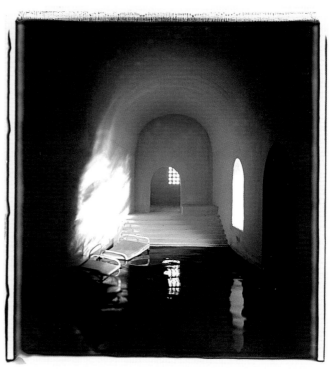

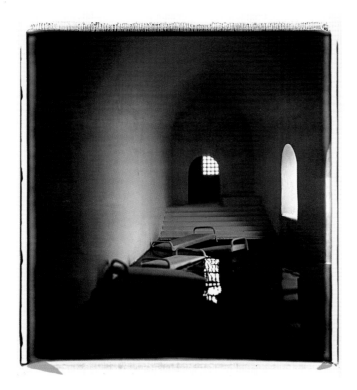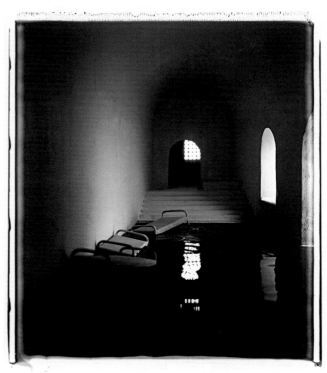

Untitled *1998-99*

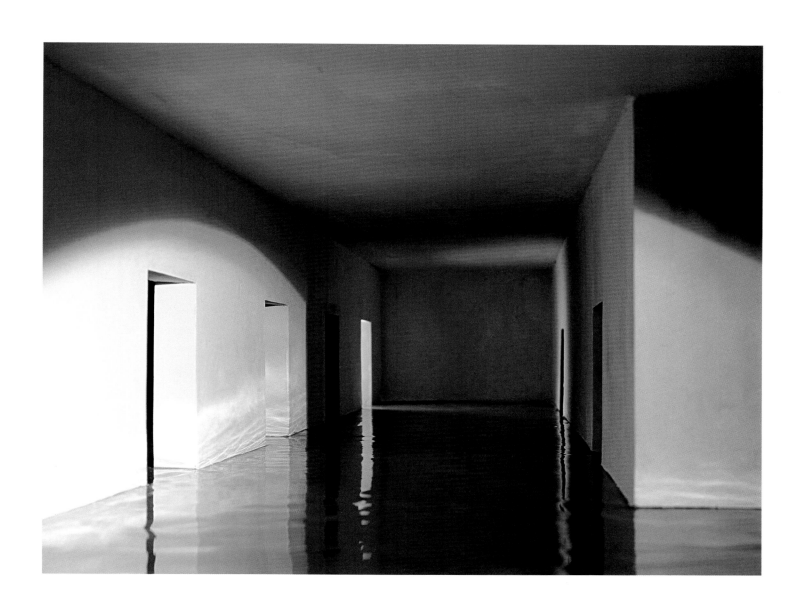

Flooded Hallway *1998-99*

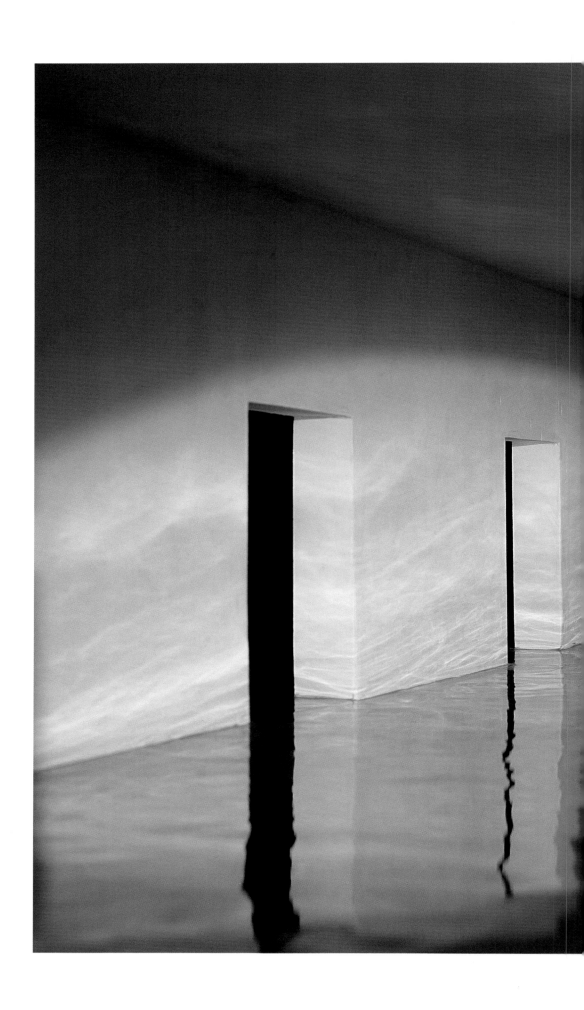

Flooded Hallway from Right *1999*

146

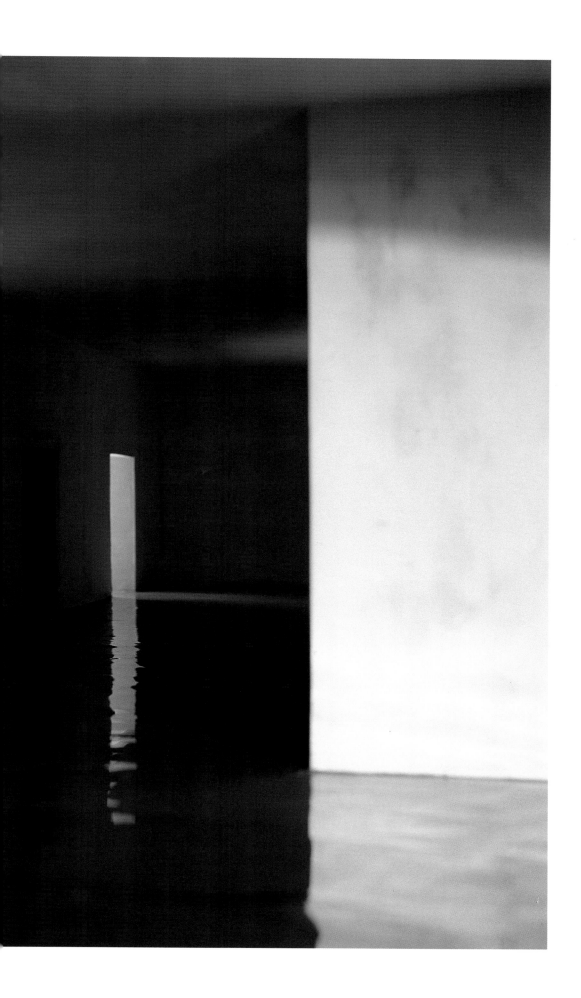

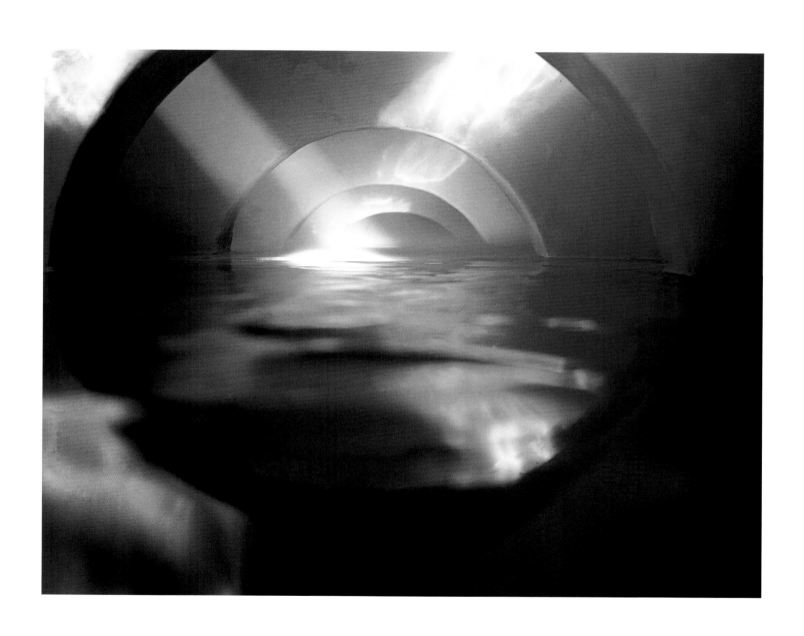

Four Flooded Arches from Center with Fog *1999*

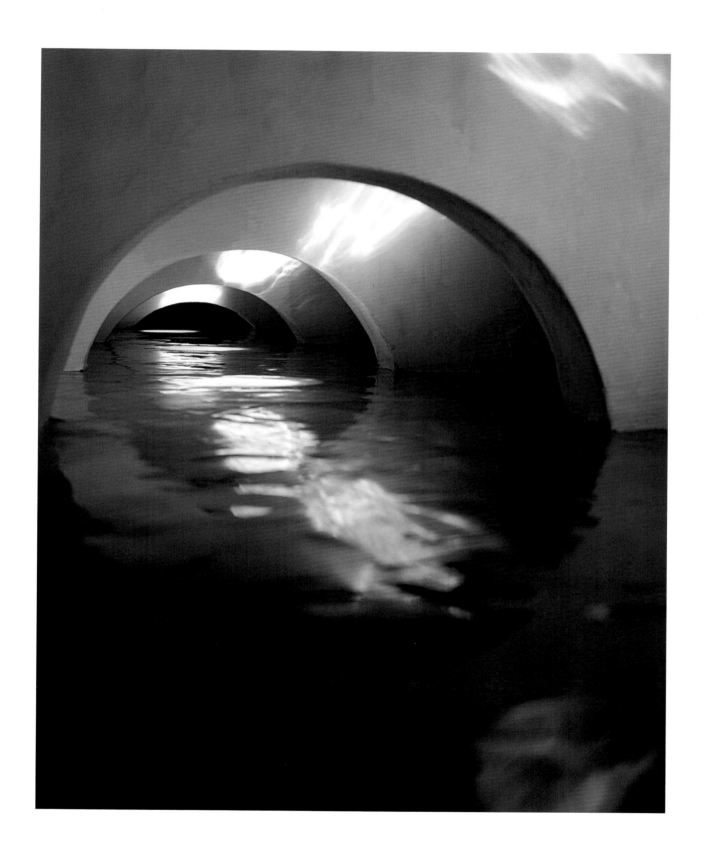

Four Flooded Arches from Left *1999*

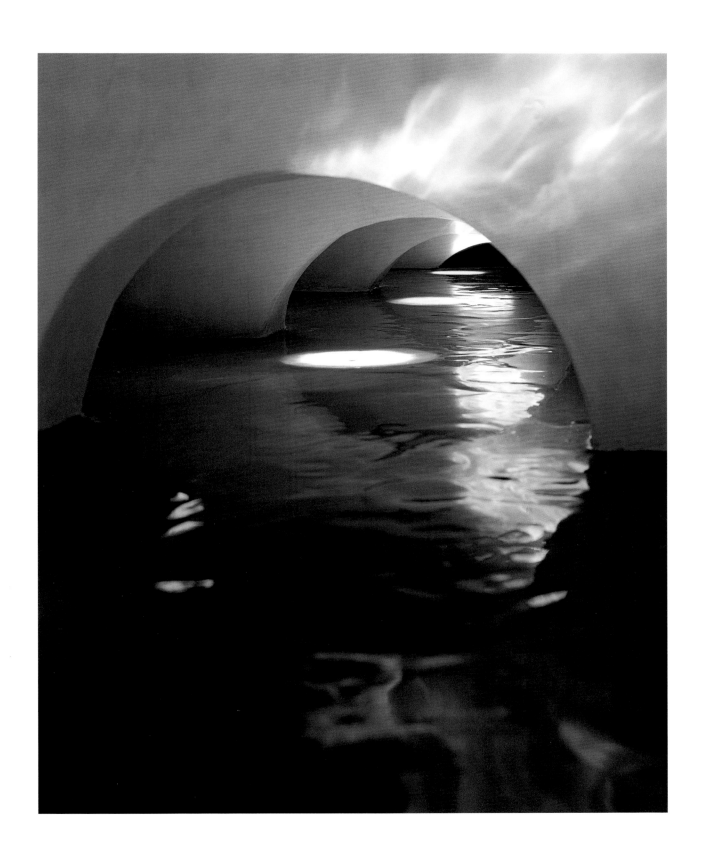

Four Flooded Arches from Right *1999*

Four Flooded Arches from Right With Fog *1999*

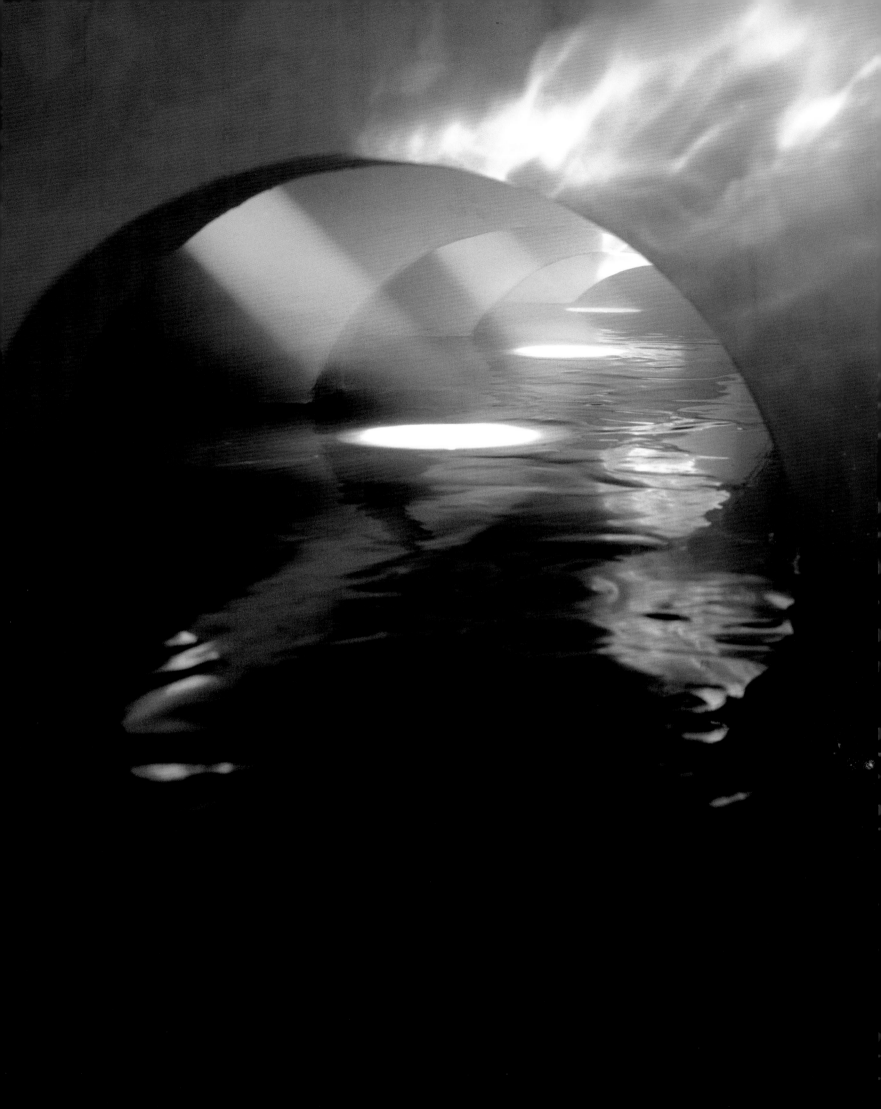

Blue Hallway *2000*

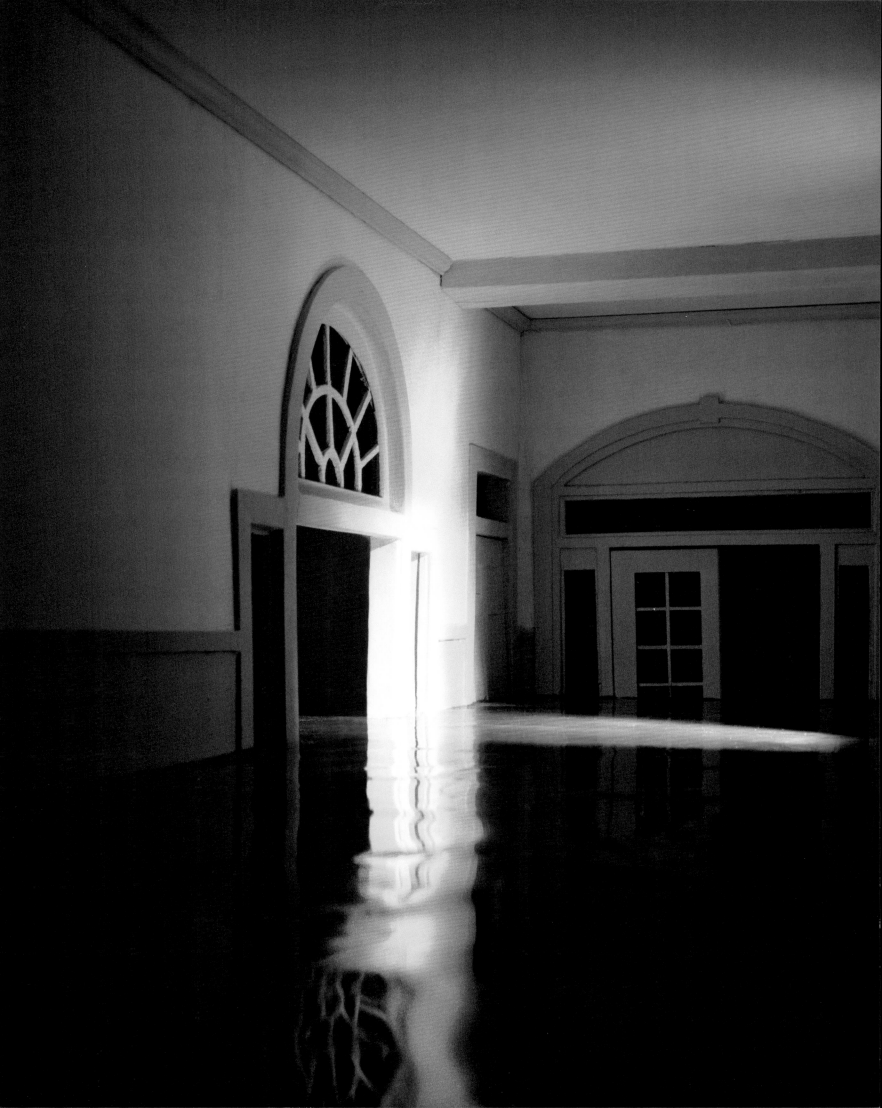

Pink Hallway #3 *2000*

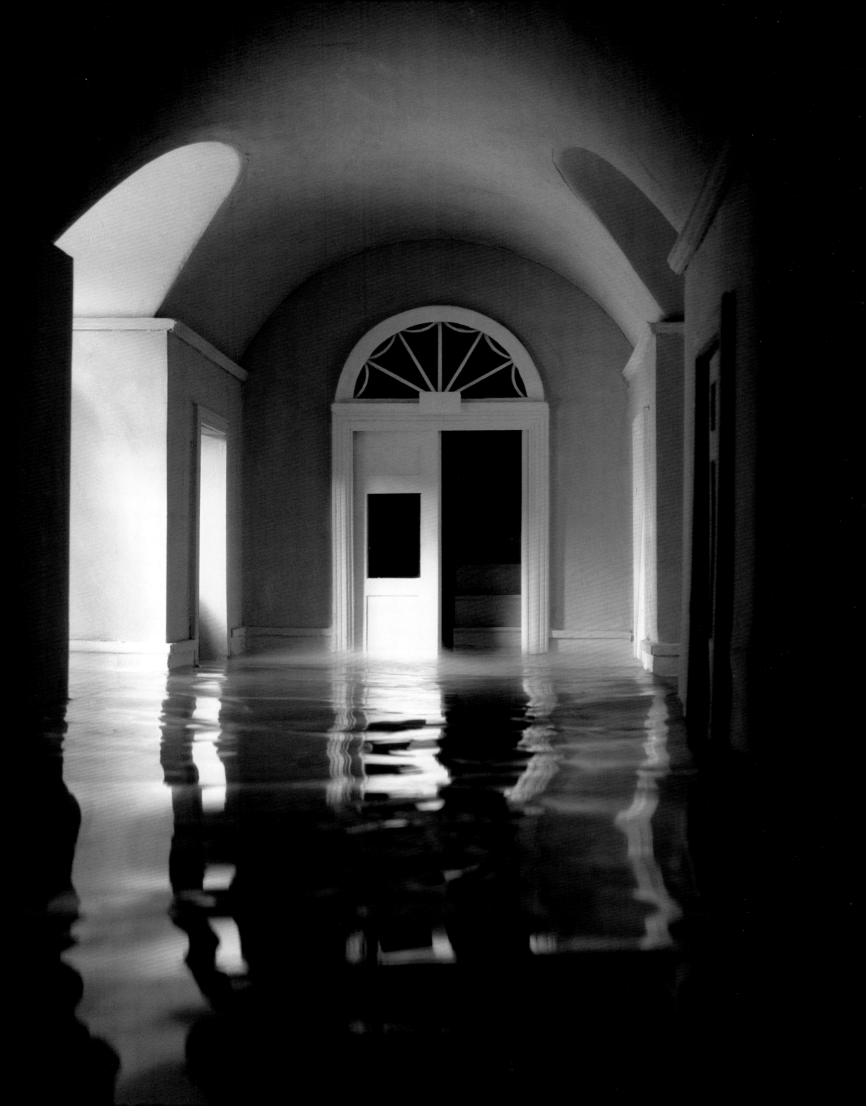

Pink Hallway #2 *2000*

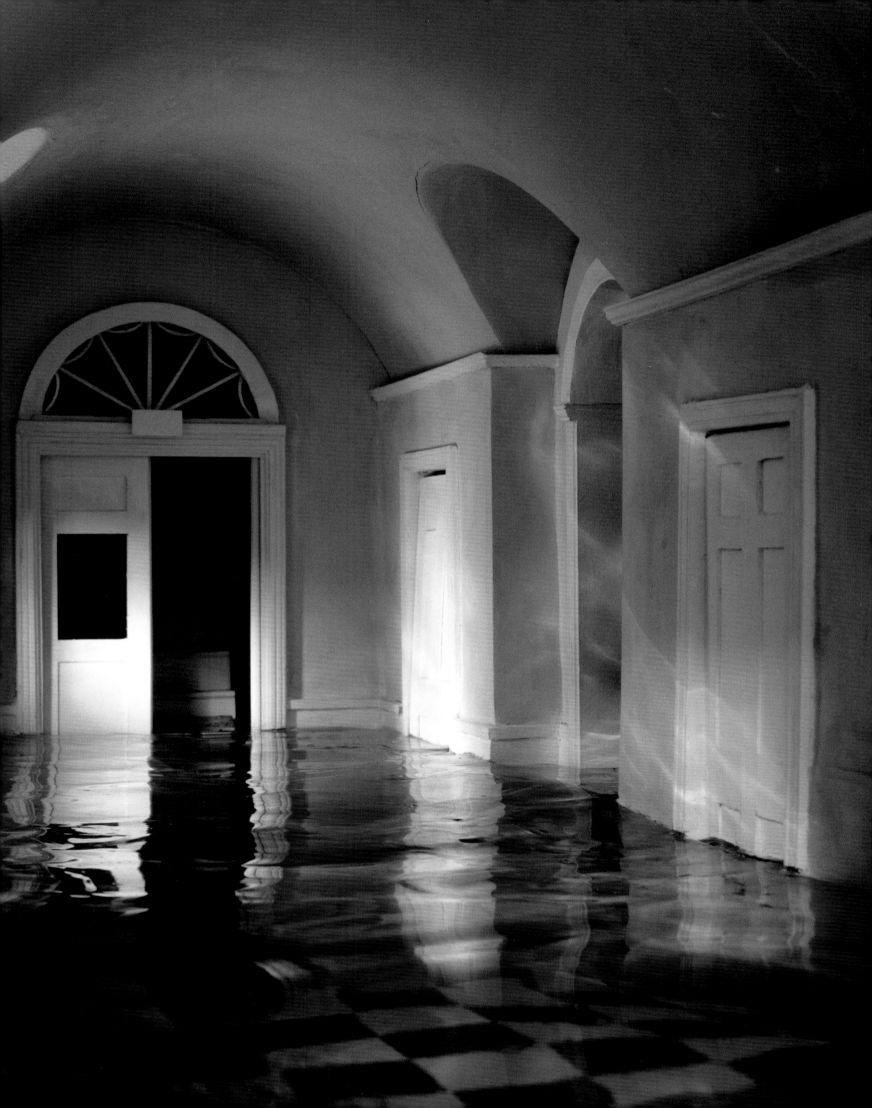

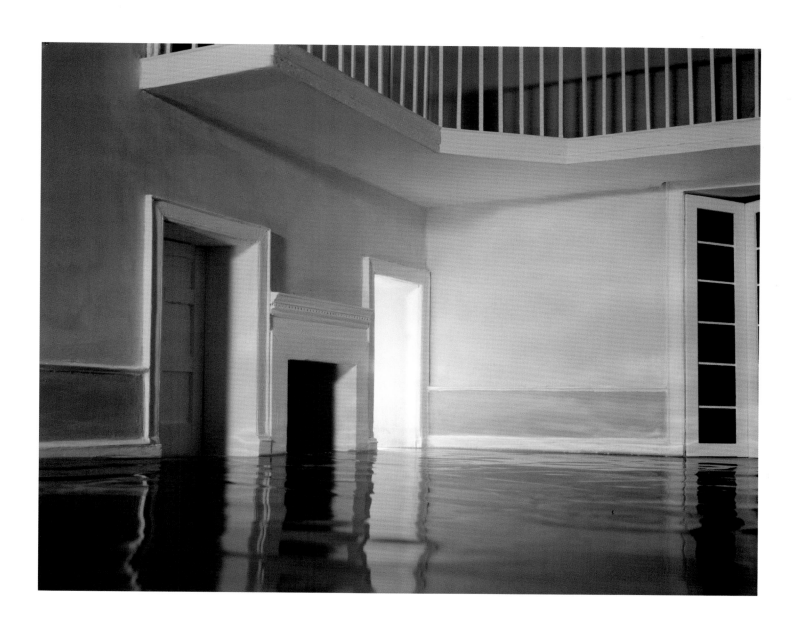

Monticello #2 *2001*

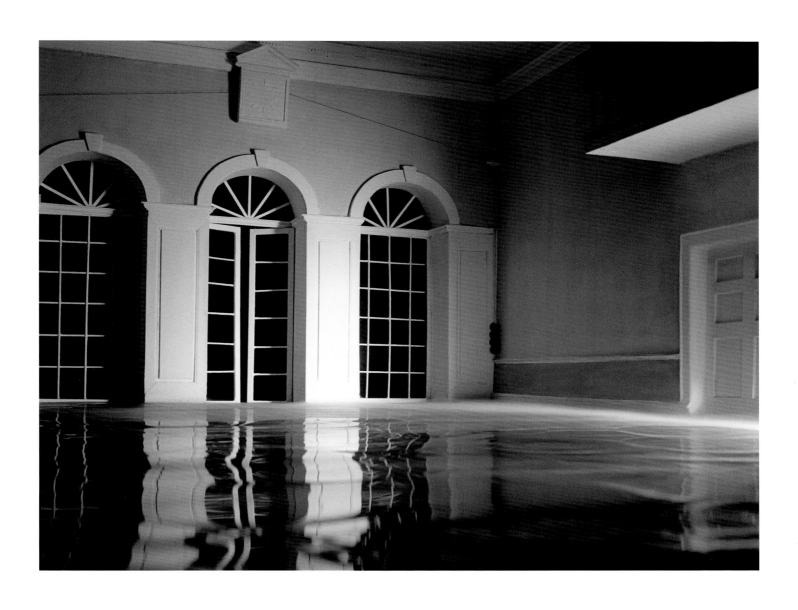

Monticello #3 *2001*

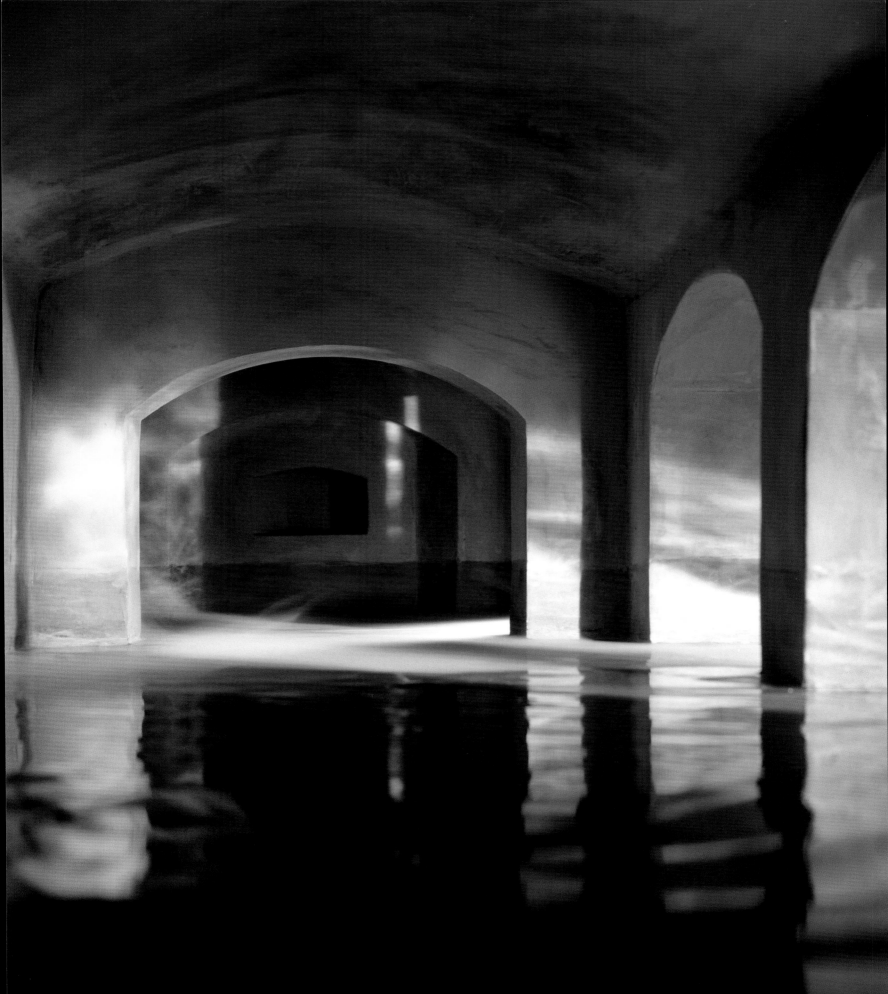

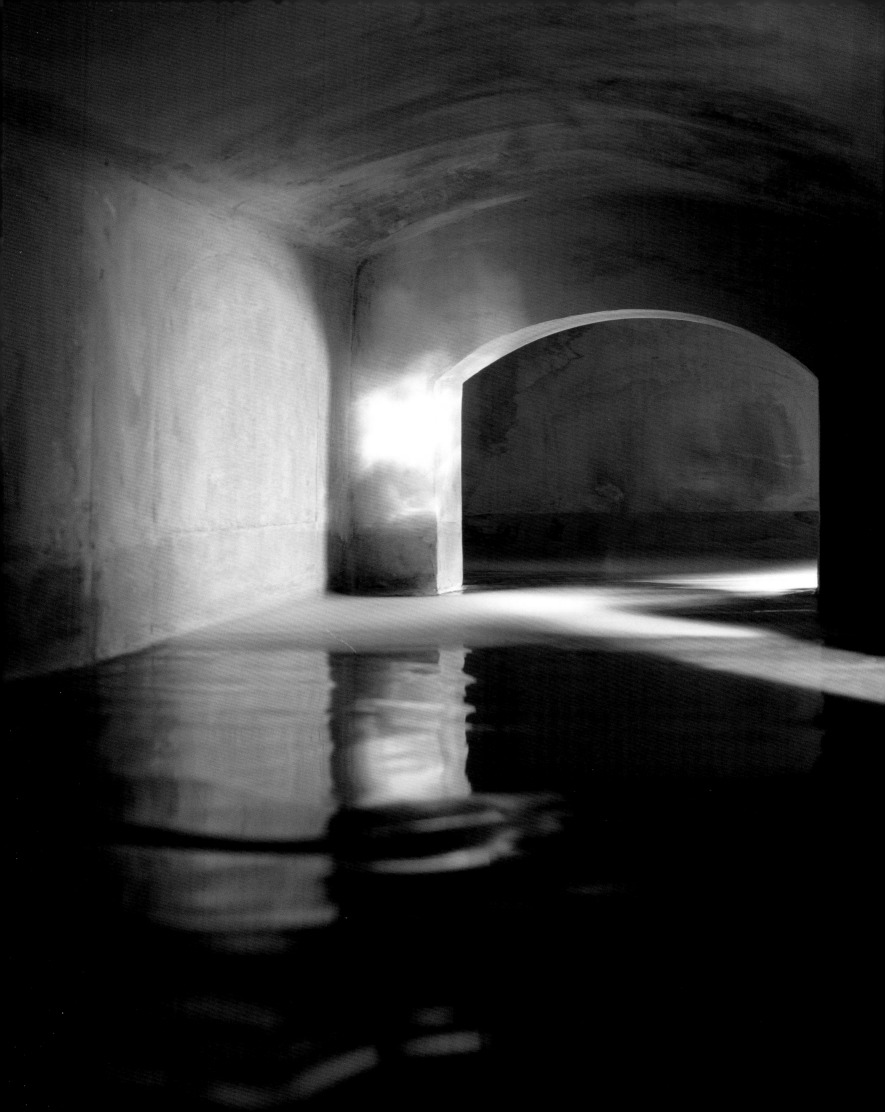

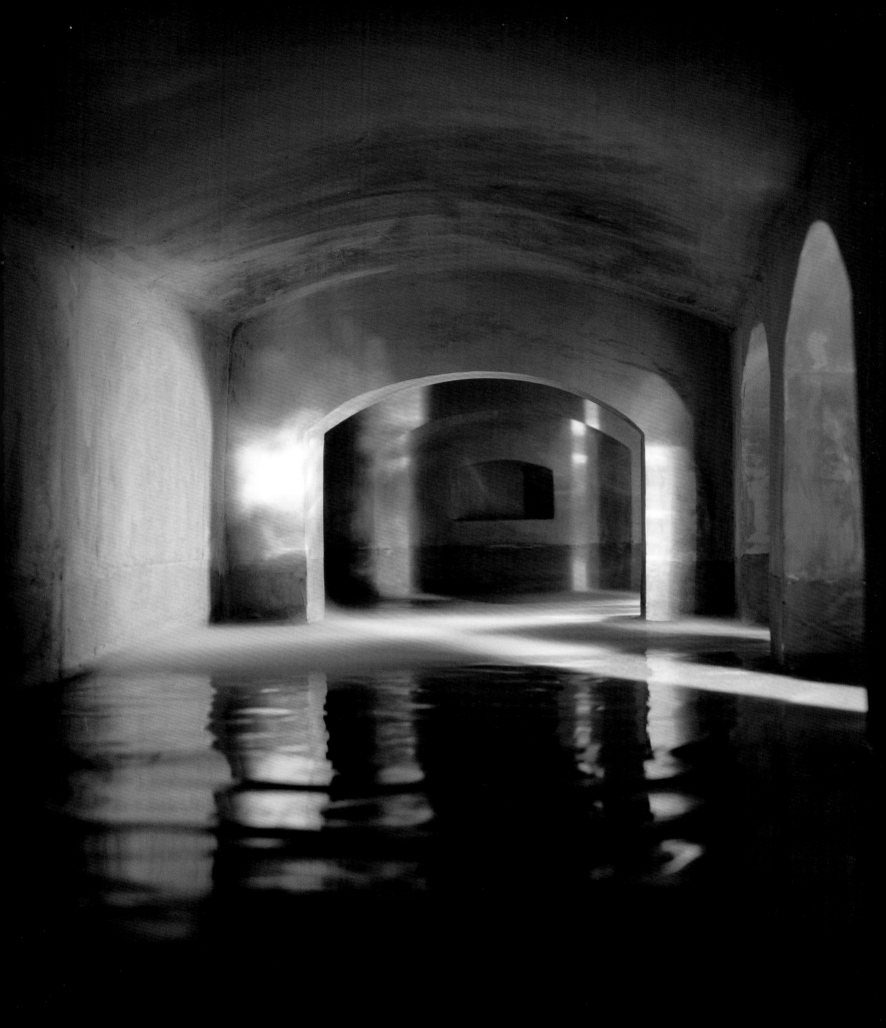

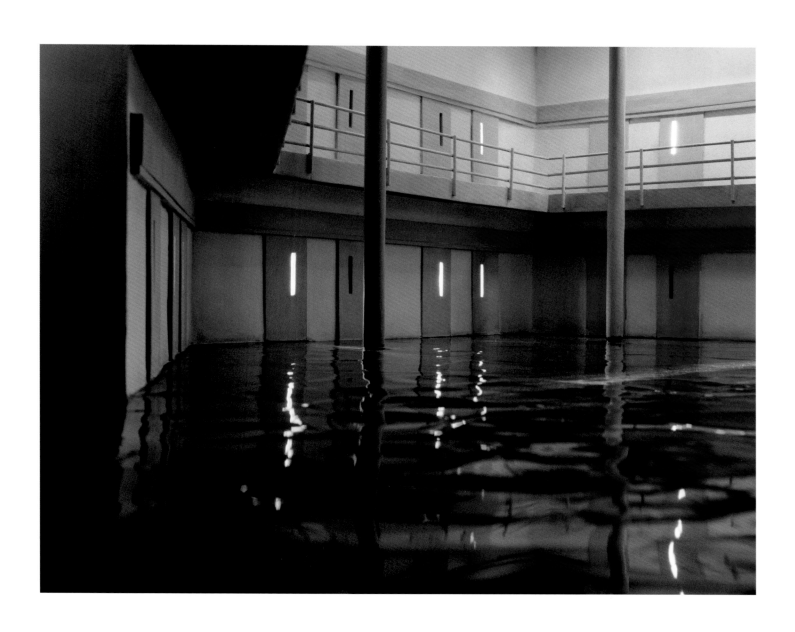

Wichita Falls *2001*

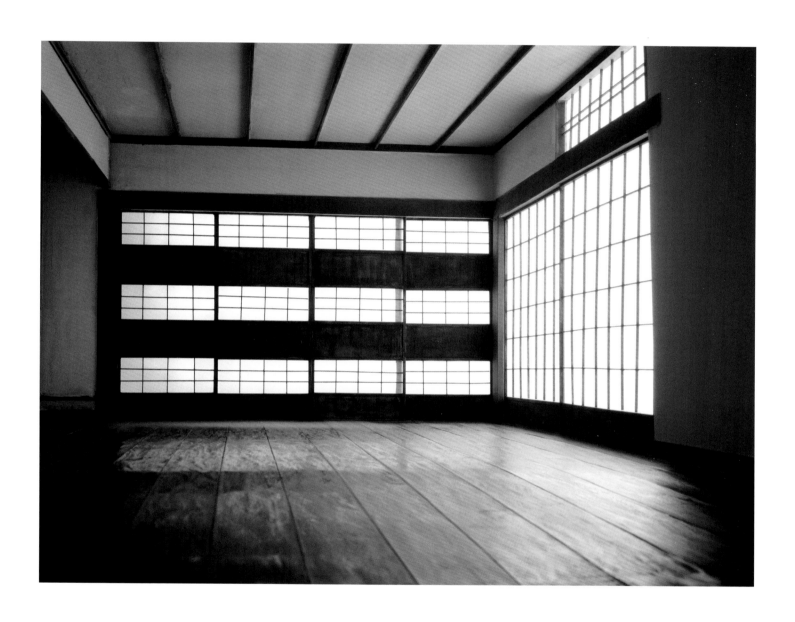

Parlor *2001*

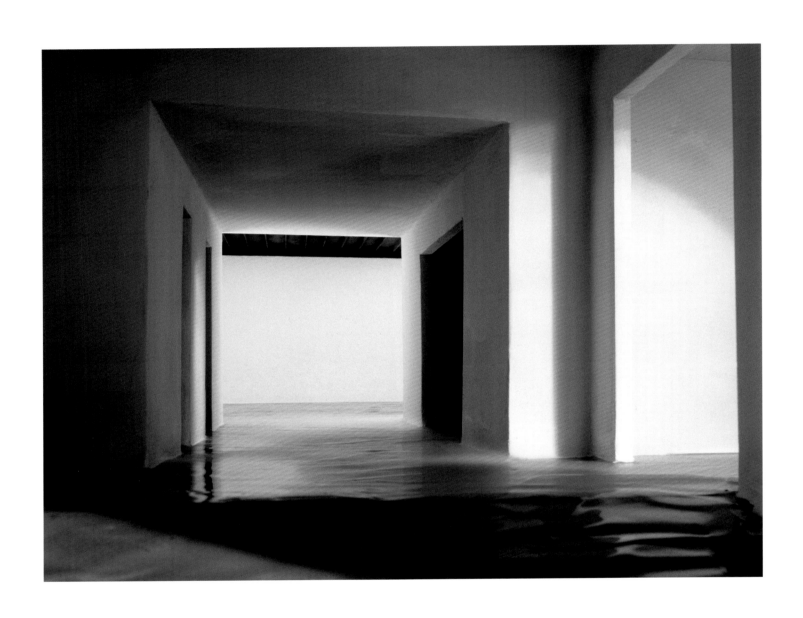

Gallery *2001*

LIST OF WORKS

Bacillus Pestis (to be looked at while listening to "Scenes from Childhood," section 3 "Catch me" by Robert Schumann), 1976
silver print
10x8 inches
edition of 10
p. 40

Fan as Eudemonist: Relaxing after an Exhausting Day at the Beach, 1975
silver print
10x8 inches
edition of 10
p. 41

Furnace With Flame, 1976
silver print
10x8 inches
edition of 10
p. 42

Fork in the Refrigerator, 1975
silver print
10x8 inches
edition of 10
p. 43

Finding a Shiny New Copy of my Father's circa 1933 Boy Scout Scarf in a New Jersey Dormitory Lobby, 1976-77
silver print
16x20 inches
edition of 10
p. 45

Bed Upturning its Belly at Dawn, 1977
silver print
16x20 inches
edition of 10
p. 47

Storyboard for a Film 1979, Casebebere, 1979
suite of 20 color photographs with text, mounted on board
each photo: 5x7 inches, mounted: 11x14 inches
pp. 48-49
p. 51 (*Storyboard-Sketch*, 1979)

Courtroom, 1979-80
silver print
16x20 inches
edition of 7
p. 53

*Boats**, 1980
silver print
16x20 inches
edition of 7
p. 55

Library I, 1980
silver print
16x20 inches
edition of 7
p. 56

Library II, 1980
silver print
16x20 inches
edition of 7
p. 57

Desert House with Cactus, 1980
silver print
16x20 inches
edition of 7
p. 59

Three Planes, 1982
silver print
16x20 inches
edition of 7
p. 60

Shooting Gallery, 1981
silver print
16x20 inches
edition of 7
p. 61

*Subdivision with Spotlight**, 1982
silver print
16x20 inches
edition of 7
p. 63

*Kitchen Table**, 1982
silver print
16x20 inches
edition of 7
p. 65

*Sutpen's Cave**, 1982
silver print
16x20 inches
edition of 7
p. 67

*Storefront**, 1982
silver print
16x20 inches and 30x40 inches
edition of 7
pp. 68-69

*Street with Pots**, 1983-84
silver print
30x24 inches
edition of 7
p. 71

*Cotton Mill**, 1983
silver print
30x24 inches
edition of 7
p. 73

*Lighthouse**, 1983
silver print
30x24 inches
edition of 7
p. 75

*Winterhouse**, 1984
silver print
14x11 inches, 30x24 inches and 30x40 inches
edition of 7
p. 77

*Arches**, 1985
silver print
16x20 inches and 30x40 inches
edition of 7
pp. 78-79

*Covered Wagons**, 1985
silver print
20x16 inches and 40x30 inches
edition of 7
p. 81

*Western Street**, 1985-86
silver print
16x20 inches and 30x40 inches
edition of 7
p. 83

* these works exist in light box form (most often 50x60 inches and sometimes 30x40 inches)

Needles, 1985
silver prints (diptych)
28x75 inches
edition of 7
p. 84-85

*Empty Bowl with Canopy**, 1989
silver print
40x30 inches
edition of 10
p. 87

*Industry**, 1990
silver print
30x40 inches
edition of 7
p. 89

*Capitol Facade**, 1990
silver print
40x30 inches
edition of 10
p. 91

*Venice Ghetto**, 1991
silver print
40x30 inches
edition of 10
p. 93

*Tenement/Market Place**, 1992
silver print
30x40 inches
edition of 10
p. 95

Panopticon Prison #3, 1993
dye destruction print
40x30 inches
edition of 5
p. 97

Sing Sing, 1992
dye destruction print
30x40 inches and 48x60 inches
edition of 5
pp. 98-99

Prison at Cherry Hill, 1993
dye destruction print
40x30 inches
edition of 5
p. 101

Georgian Jail Cages (Horizontal),
1993
dye destruction print
40x30 inches
edition of 5
p. 103

Prison Cell with Skylight, 1993
dye destruction print
40x30 inches
edition of 5
p. 105

Cell with Toilet, 1993
dye destruction print
40x30 inches
edition of 5
p. 107

A Barrel Vaulted Room, 1994
dye destruction print
30x24 inches and 60x48 inches
edition of 5
p. 109

Asylum, 1994
dye destruction print
24x30 inches and 48x60 inches
edition of 5
p. 110-111

Toilets, 1995
dye destruction print
24x30 inches and 48x60 inches
edition of 5
p. 113

Empty Room, 1994
dye destruction print
48x60 inches
edition of 5
p. 115

Tunnels, 1995
dye destruction print
24x30 inches and 48x60 inches
edition of 5
p. 116-117

Arcade, 1995
dye destruction print
30x24 inches and 60x48 inches
edition of 5
p. 119

Arena, 1995
dye destruction print
24x30 inches and 48x60 inches
edition of 5
p. 121

Nine Alcoves, 1996
dye destruction print
30x30 inches and
48x48 inches
edition of 5
p. 123

Cell with Rubble, 1996
dye destruction print
24x30 inches and
48x60 inches
edition of 5
p. 125

Converging Hallways From Left, 1997
dye destruction print
24x38-1/2 inches and
48x67 inches, edition of 5
86x120 inches (3 panels),
edition of 3
p. 126-127

Converging Hallways from Right,
1997
dye destruction print
24x36 inches and 48x72 inches
edition of 5
p. 129

Hospital, 1997
dye destruction print
24x30 inches and 48x60 inches
edition of 5
p. 131

Tall Stack of Beds, 1997
dye destruction print
30x24 inches and 60x48 inches,
edition of 5
120x95 inches (3 panels),
edition of 3
p. 133

Two Bunk Cell, 1998
dye destruction print mounted on
aluminum
30x24 inches and 60x48 inches
edition of 5
p. 135

Two Tunnels from Left (Vertical),
1998
dye destruction print
30x24 inches and 60x48 inches
edition of 5
p. 136

Two Tunnels from Right (Vertical), 1998
dye destruction print
30x24 inches and 60x48 inches
edition of 5
p. 137

Two Tunnels from Left (Horizontal),
1998
dye destruction print
48x62 inches
edition of 5
p. 138

Two Tunnels from Right (Horizontal),
1998
dye destruction print
48x60 inches
edition of 5
p. 139

Tunnel with Bright Hole, 1998
dye destruction print
40x30 inches
edition of 5
p. 140

Tunnel with Dark Hole, 1998
dye destruction print
40x30 inches
edition of 5
p. 141

Untitled, 1998-99 (unique)
Polaroid photograph
30x22 inches
p. 143 (four images)

Flooded Hallway, 1998-99
dye destruction print
24x30 inches and 48x60 inches,
edition of 5
92x113 inches (3 panels),
edition of 3
p. 145

Flooded Hallway from Right, 1999
dye destruction print
24x30 inches and 48x60 inches
edition of 5
p. 146

*Four Flooded Arches from Center with
Fog*, 1999
digital chromogenic print
24x30 inches and 30x40 inches
edition of 5
p. 149

Four Flooded Arches from Left, 1999
dye destruction print
60x48 inches and 30x24 inches,
edition of 5
96x77 inches (2 panels),
edition of 3
p. 151

Four Flooded Arches from Right, 1999
dye destruction print
60x48 inches
edition of 5
p. 153

*Four Flooded Arches from Right with
Fog*, 1999
dye destruction print
30x24 and 68x40 inches,
edition of 5
96x77 inches (2 panels),
edition of 3
p. 155

Blue Hallway, 2000
digital chromogenic print
60x48 inches, edition of 5
96x77 inches (2 panels),
edition of 3
p. 157

Pink Hallway #3, 2000
digital chromogenic print
24x30 and 60x48 inches, edition of 5
96x77 inches (2 panels),
edition of 3
p. 159

Pink Hallway #2, 2000
digital chromogenic print
30x24 inches and 60x48 inches
edition of 5
p. 161

Monticello #2, 2001
digital chromogenic print
48x60 inches, edition of 5
92x120 inches (3 panels),
edition of 3
p. 163

Monticello #3, 2001
digital chromogenic print
24x30 and 48x60 inches
edition of 5
p. 165

Nevisian Underground #1, 2001
digital chromogenic print
24x30 and 60x48 inches, edition of 5
96x77 inches (2 panels),
edition of 3
p. 167

Nevisian Underground #2, 2001
digital chromogenic print
60x48 inches, edition of 5
96x77 inches (2 panels),
edition of 3
p. 169

Nevisian Underground #3, 2001
digital chromogenic print
60x48 inches, edition of 5
96x77 inches (2 panels),
edition of 3
p. 171

Wichita Falls, 2001
digital chromogenic print
48x60 inches, edition of 5
p. 173

Gallery, 2001
digital chromogenic print
48x60 inches, edition of 5
92x120 inches (3 panels),
edition of 3
p. 174

Parlor, 2001
digital chromogenic print
48x60 inches, edition of 5
92x122 inches (3 panels),
edition of 3
p. 175

APPENDIX

JAMES CASEBERE

1953
born in Lansing, Michigan
lives in New York

EDUCATION

1979
California Institute of Arts, M.F.A.

1977
Whitney Independent Study Program

1976
Minneapolis College of Art and
 Design, B.F.A.

1971-73
Michigan State University

AWARDS

1999
Shortlisted for the Citibank Private
 Bank Photography Prize

1995
John Simon Guggenheim Memorial
 Foundation Grant

1994
New York Foundation for the Arts
 Fellowship

1990
National Endowment for the Arts,
 Visual Arts Fellowship

1989
New York Foundation for the Arts
 Fellowship

1986
National Endowment for the Arts,
 Visual Arts Fellowship

1985
New York Foundation for the Arts
 Fellowship

1982
National Endowment for the Arts,
 Visual Arts Fellowship

1982
New York State Council on the
 Arts: Visual Artists Sponsored
 Project Grant

SELECTED SOLO EXHIBITIONS

2001
Sean Kelly Gallery, New York, NY*
*The Architectural Unconscious: James
 Casebere and Glen Seator*,
 Institute of Contemporary Arts,
 Philadelphia, PA
Gallerie Tanit, Munich, Germany

2000
Lisson Gallery, London, Great Britain
*The Architectural Unconscious: James
 Casebere and Glen Seator*, Addison
 Gallery of American Art, Phillips
 Academy, Andover, MA*
Grant Selwyn, Beverly Hills, CA
*Prison/Dormitory/Dayroom: a
 collaborative project with students
 of S.M.U. at the Mac*, Museum of
 Contemporary Art, Dallas, TX

1999
Asylum, Museum of Modern Art,
 Oxford, England and Centro
 Galego de Arte Contemporanea,
 Santiago de Compostela and
 Sainsbury Centre for Photography,
 Norwich, England*
James Casebere: New Photographs,
 Windows Gallery, Brussels,
 Belgium
*James Casebere: Self Constructed
 Realities: 1975-1990*, Sean Kelly
 Gallery, New York, NY

1998
Sean Kelly Gallery, New York, NY
James Casebere: New Works, Hosfelt
 Gallery, San Francisco, CA
Galerie Tannit, Munich, Germany

1997
Jean Bernier, Athens, Greece
Angel Ho, New York, NY
Windows Gallery, Brussels, Belgium
Site Gallery, Sheffield, Great Britain
Williams College Museum of Art,
 Williamstown, MA

1996
*James Casebere: Model Culture,
 Photographs, 1975-1996*. The
 Ansel Adams Center for

Photography, San Francisco, CA*
Galleria Galliani, Genoa, Italy
Lisson Gallery, London, Great Britain
S.L. Simpson Gallery, Toronto

1995
Michael Klein Gallery, New York, NY

1994
Galleria Galliani, Genoa, Italy
Richard Levy Gallery, Albuquerque,
 NM

1993
Michael Klein Gallery, New York, NY

1991
*Model Fictions: The Photographs of
 James Casebere*, Birmingham
 Museum of Art, Birmingham, AL*
Gallerie Bruges La Morte, Bruges,
 Belgium
James Hockey Gallery, WSCAD,
 Farnham, England*
Michael Klein Gallery, New York, NY*
James Casebere and Tony Oursler
 collaboration, Kunststichting
 Kanaal, Kortrijk, Belgium
Photographic Resource Center,
 Boston University, Boston, MA
The University of Iowa Museum of
 Art, Iowa City, IA*

1990
Galleria Facsimile, Milan, Italy
Museum of Photographic Arts, San
 Diego, CA
Urbi Et Orbi, Paris, France
Vrej Baghoomian Gallery, New
 York, NY

1989
Galerie De Lege Ruimte, Bruges,
 Belgium
Neuberger Museum, State
 University of New York at
 Purchase, Purchase, NY*
The University of South Florida Art
 Museum, Tampa, FL*

1988
Kuhlenschmidt/Simon Gallery, Los
 Angeles, CA
Pennsylvania Station, New York, NY

Casebere in his studio, 2000

1987
303 Gallery, New York, NY
Michael Klein Gallery, New York, NY
Kuhlenschmidt/Simon Gallery, Los
 Angeles, CA

1985
Kuhlenschmidt/Simon Gallery, Los
 Angeles, CA

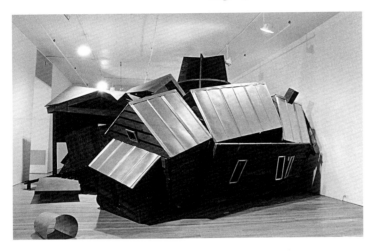

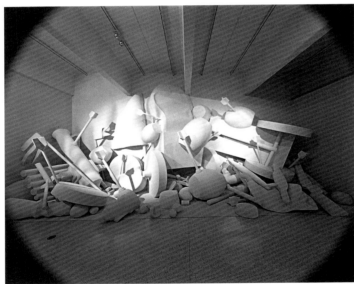

Installation at Vrej Baghoomian, 1990
Gallery, New York City

Installation at Walker Art Center,
Minneapolis, MN, 1987

1981
Franklin Furnace, New York, NY

1979
Artists' Space, New York, NY

SELECTED GROUP EXHIBITIONS

2001
*Rencontres Internationales de la
 Photographie*, Arles, France*
*Photo-Synthesis; Recent Developments
 in Contemporary Photography*,
 curated by Donald Maxwell,
 Camino Real Gallery, Boca Raton,
 FL; will travel to Delaware
 Center for the Contemporary
 Arts, Wilmington, DE*

2000
Art on Paper 2000, Weatherspoon Art
 Gallery, The University of North
 Carolina at Greensboro, NC*
Flash Back, Barbara Farber/La Serre,
 Trets, France
*Open Ends: Architecture Hot and
 Cold, Sets and Situations*, The
 Museum of Modern Art, New
 York, NY*
*Staged and Manipulated:
 Photographic Fictions from St Louis
 Collections*, St Louis Art Museum,
 St. Louis, MO
*Making Pictures: Contemporary
 American Photography*, Asheville
 Art Museum, Asheville, NC
Inside Out: Reality or Fiction? Sean
 Kelly Gallery, New York, NY
*Architectural Constructs in
 Contemporary Photography*, Julie
 Saul Gallery, New York, NY
Supermodel, Massachusetts Museum
 of Contemporary Art, North
 Adams, MA
*Staged: Constructions of Reality in
 Contemporary Photography*,
 Bonakdar Jancou Gallery, NY
*James Casebere, Anna Gaskell, Jitka
 Hanzlova, Tim Macmillan, Tracey
 Moffat, The Citibank Private Bank
 Photography Prize 2000*, The
 Photographer's Gallery, London,
 Great Britian
*The Constructed Real: Photographs of
 non-existent places*, Elias Fine Art,
 Allston, MA
*Insites: Interior Space in Contemporary
 Art*, Whitney Museum of American
 Art at Champion, Stamford, CT*

1999
*Full Exposure: Contemporary
 Photography*, New Jersey Center

Minneapolis College of Art and
 Design, Minneapolis, MN

1984
Diane Brown Gallery, New York,
 NY
Sonnabend Gallery, New York, NY

1983
St. George Ferry Terminal, Staten
 Island, NY

1982
CEPA Gallery, Buffalo, NY
Sonnabend Gallery, New York, NY

for Visual Arts, Summit, NJ
Built, Mark Moore Gallery, Santa
 Monica, CA
*James Casebere, Thomas Struth, Boyd
 Webb, George Lappas, Juan Muñoz,
 Thomas Schütte, Moshekwa Langa,
 Yan Pei-Ming, Cordy Ryman*,
 Bernier/Eliades, Athens, Greece
*Photography: An Expanded View,
 Recent Acquisitions*, The Solomon
 R. Guggenheim Museum, New
 York, NY; traveled to Guggenheim
 Bilbao, Bilbao, Spain
Nature of Light, Contemporary Art
 Museum, Venice, Italy
Blind Spot, Robert Mann Gallery,
 New York, NY
Mumia 911, PPOW, New York, NY
Hindsight, Whitney Museum of
 American Art, New York, NY

1998
Blade Runner, Caren Golden
 Gallery, New York, NY
A Sense of Place, Angles Gallery,
 Santa Monica, CA
Then and Now, Lisson Gallery,
 London, Great Britain
Still…., Laurent Delay Gallery,
 London, Great Britain
*Claustrophobia: Disturbing the
 Domestic in Contemporary Art*,
 Ikon Gallery, Birmingham, Great
 Britain; traveling exhibition
*Where: Allegories of Site in
 Contemporary Art*, Whitney
 Museum of American Art at
 Champion, Stamford, CT
Bathroom, Thomas Healy Gallery,
 New York, NY
PhotoImage: Printmaking 60s to 90s,
 Museum of Fine Arts, Boston,
 MA; traveled to Des Moines Art
 Center, Des Moines, IA*
Internality Externality, Galerie
 Lelong, New York, NY
Jay Gorney Modern Art, New York, NY
Utz, Lennon, Weiner Inc., New
 York, NY
Architectures en Jeux, Frac Centre,
 Orléans, France
Embedded Metaphor, Independent
 Curators Incorporated exhibition
 curated by Nina Felshin; traveling
 exhibition: John and Mabel
 Ringling Museum of Art, Sarasota,
 FL; Western Gallery, Western
 Washington University, Bellingham,
 WA; Bowdoin College Museum of
 Art, Brunswick, ME; Contemporary
 Art Center of Virginia, Virginia
 Beach, VA; Ezra and Cecile Zikha
 Gallery, Wesleyan University,
 Middletown, CT*

1997

Architecture as Metaphor, The Museum of Modern Art, New York, NY

Selections From the Permanent Collection, The Whitney Museum of American Art, New York, NY

Within These Walls, Kettle's Yard, Cambridge, England

Portraits of Interiors, Patricia Faure Gallery, Los Angeles, California, Galerie d'Art Contemporain, Geneva, Switzerland

Making it Real, Independent Curators Incorporated; traveling exhibition: The Aldrich Museum of Contemporary Art, Ridgefield, CT; Kjarvaisstadir, Listastasafn Reykjavikur, The Reykjavik Municipal Art Museum, Reykjavik, Iceland; Portland Museum of Art, Portland, ME; Bayly Art Museum, University of Virginia, Charlottesville, VA; Bakalar Gallery, Massachusetts College of Art, Boston, MA; Emerson Gallery, Hamilton College, Clinton, NY

Elsewhere, The Carnegie Museum of Art, Pittsburgh, PA

A Summer Show, Marian Goodman Gallery, New York, NY

Photographs & Prints, Judy Ann Goldman Fine Art, Boston, MA

The Luminous Image, Alternative Museum, New York, NY

Western Gallery, Western Washington University, Bellingham, WA

1996

This is a Set Up: Fab Photo/Fiction, Bowling Green State University, Bowling Green, OH Galerie H.S. Steinek, Vienna, Austria

New Fall Faculty, Carpenter Center, Harvard University, Harvard, MA

Selections from the Niseson Collection, Los Angeles County Museum of Art, Los Angeles, CA

After Dark: Nocturnal Images, Barbara Mathes Gallery, New York, NY

Embedded Metaphor, Independent Curators Incorporated; traveling exhibition*

The House Transformed, Barbara Mathes Gallery, New York, NY

McDowell Exhibition, Hood Museum of Art, Dartmouth College, Hanover, NH and the Art Gallery at the University of New Hampshire, Durham, NH

Campo, Venice Biennale, Venice, Italy; traveled to Turin, Italy, and Konstmuseum, Malmo, Sweden

1995

4 Photographers, Rena Bransten Gallery, San Francisco, CA

Prison Sentences: The Prison as Site/The Prison as Subject, Eastern State Penitentiary, Philadelphia, PA*

Artistes/Architects, Institute d'Art Contemporain, Villeurbanne, France; traveled to Kunstverein Munich, Munich, Germany; Centre Culturel de Belem, Lisbon, Portugal; Kunsthalle, Vienna, Austria

1994

Building Dwelling Thinking: A Group Exhibition, Lowinsky Gallery, New York, NY

Forecast: Shifts in Direction, Museum of New Mexico, Santa Fe, NM

House Rules, Wexner Center for the Visual Arts, Columbus, OH

Immagini d'Affezione, Castello Monumentale di Lerici, Lerici, Italy

Stilled Pictures-Still Life, Fine Arts Center Galleries, University of Rhode Island, Kingston, RI

The Subject is Architecture, University of New Mexico Art Museum, Albuquerque, NM

1993

American Made: The New Still-Life, Isetan Museum of Art and Hokkaido Obihito Museum of Art, Japan; traveled to the Royal College of Art, London, Great Britain*

Collecting for the 21st Century: Recent Acquisitions and Promised Gifts, The Jewish Museum, New York, NY

Fabricated Realities, Museum of Fine Arts, Houston, TX

From New York: Recent Thinking in Contemporary Photography, Donna Beam Fine Art Gallery, University of Nevada at Las Vegas, Las Vegas, NV*

Kurswechsel, Michael Klein Gallery at Transart Exhibitions, Cologne, Germany

Sampling the Permanent Collection, Museum of Fine Arts, Boston, MA

1992

Interpreting the American Dream, Galerie Eugen Lendl, Graz, Austria; traveled to Galerij James van Damme, Antwerp, Belgium*

More Than One Photography, The Museum of Modern Art, New York, NY

Une seconde pensée du paysage,

Domaine de Kerguehennec, Centre d'Art Contemporain, Locmine, France

1991

1986-1991: 5 Jaar De Lege Ruimte, Galerie de Lege Ruimte, Bruges, Belgium

Constructing Images: Synapse Between Photography and Sculpture, Lieberman & Saul, New York, NY; traveled to Tampa Museum of Art, Tampa, FL; Center for Creative Photography, Tucson, AZ; San Jose Museum of Art, San Jose, CA*

Pleasures and Terrors of Domestic Comfort, The Museum of Modern Art, New York, NY

1990

Anninovanta, Galleria Comunale d'Arte Moderna, Bologna, Italy

Abstraction in Contemporary Photography, Emerson Gallery, Hamilton College and Anderson Gallery, Virginia Commonwealth University, Richmond, VA*

The Liberated Image: Fabricated Photography Since 1970, Tampa Museum of Art, Tampa, FL

Nightlights, APAC Centre d'Art Contemporain, Nevers, France

1989

Altered States, The Harcus Gallery, Boston, MA

Beyond Photography, Krygier Landau Contemporary Art, Santa Monica, CA

New York Artists, Linda Farris Gallery, Seattle, WA

Das Konstruierte Bild. Fotographie- Arrangiert und Inzeniert, Kunstverein München, Munich, Germany; traveled to Kunsthalle Nurnberg, Nurnberg, Germany; Forum Bottcherstrasse, Bremen, Germany; Badischer Kunstverein, Karlsruhe, Germany*

Decisive Monuments, Ehlers Caudill Gallery, Chicago, IL*

Encore II: Celebrating Fifty Years, The Contemporary Arts Center, Cincinnati, OH*

Fauxtography, Art Center College of Art and Design, Pasadena, CA

The Mediated Imagination, Visual Arts Gallery, State University of New York at Purchase, Purchase, NY

Parallel Views, Arti et Amicitiae, Amsterdam, Holland*

The Photography of Invention-American Pictures of the 1980s, National

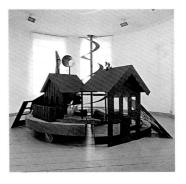

Screw Device
Installation Galerie Bruges La Morte, 1991

Museum of American Art, Washington, DC; traveled to the Walker Art Center, Minneapolis, MN
Suburban Home Life: Plotting the American Dream, Whitney Museum of American Art, New York, NY; traveled to The Whitney at Champion, Stamford, CT*

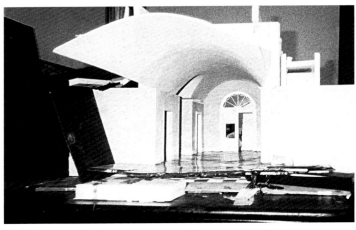

Casebere's Studio, 2000

1988
Complexity and Contradiction, Scott Hanson Gallery, New York, NY*
Fabrication-Staged, Altered and Appropriated Photographs, Sert Gallery, Carpenter Center for the Visual Arts, Harvard University, Harvard, MA
James Casebere, Stephen Prina, Christopher Wool, Robin Lockett Gallery, Chicago, IL
Made In Camera, VAVD Editions, Stockholm, Sweden
Plane Space: Sculptural Form and Photographic Dimensions, The Photographers' Gallery, London, Great Britain
Playing For Real, Toys and Talismans, Southampton City Art Gallery, Southampton; traveled to Ikon

Gallery, Birmingham, and Chapter Arts, Cardiff, Great Britain*

1987
3 Americans, 3 Austrians, Fotogalerie Wien, Vienna, Austria*
This is Not a Photograph: Twenty Years of Large-Scale Photography, 1966-1986, The John and Mable Ringling Museum of Art, Sarasota, FL; traveled to Akron Art Museum, Akron, OH; The Chrysler Museum, Norfolk, VA
Arrangements for the Camera: A View of Contemporary Photography, The Baltimore Museum of Art, Baltimore, MD
Bilder 30, Fotogalerie Wien, Vienna, Austria
CalArts: Skeptical Belief(s), The Renaissance Society, University of Chicago, Chicago, IL; traveled to Newport Harbor Museum, Newport Beach, VA
Cross-References: Sculpture into Photography, Walker Art Center, Minneapolis, MN*
Kunst Mit Photographie, Galerie Ralph Wernicke, Stuttgart, Germany*
Nightfire, De Appel, Amsterdam.
Photography and Art: Interactions Since 1946, Los Angeles County Museum of Art, Los Angeles, CA; traveled to The Fort Lauderdale Museum of Art, Fort Lauderdale, FL; The Queens Museum, Corona Park, NY
The Pride of Symmetry, Galerie Ralph Wernicke, Stuttgart, Germany
Small Wonders, Barry Whistler Gallery, Dallas, TX

1986
The Fairy Tale: Politics, Desire, and Everyday Life, Artists' Space, New York, NY
Foto Cliche, Victoria Miro Gallery, London, Great Britain; Orchard Gallery, Derry, Northern Ireland
James Casebere, Clegg & Guttman, Ken Lum, Galerie Bismarckstrasse, Cologne, Germany
Triennale di Milano, Milan, Italy
Photographic Fictions, The Whitney at Champion, Stamford, CT*
Photographs, 303 Gallery, New York, NY
Picture Perfect, Kuhlenschmidt/ Simon, Los Angeles, CA
The Real Big Picture, The Queens Museum, Corona Park, New York, NY
Signs of the Real, White Columns,

New York, NY
Sonsbeek 86: International Sculpture Exhibition, Arnhem, Holland*
TV Generation, L.A.C.E., Los Angeles, CA

1985
Biennial Exhibition, Whitney Museum of American Art, New York, NY
James Casebere, Jeff Koons, Larry Johnson, 303 Gallery, New York, NY
Rounding Up the Usual Suspects, Fay Gold Gallery, Atlanta, GA

1984
A Decade of New Art, Artists' Space, New York, NY
The Success of Failure, Diane Brown Gallery, New York, NY

1983
Art Park, Lewiston, New York
Artists Use Photography, American Graffiti Gallery, Amsterdam, Holland; Marianne Deson Gallery, Chicago, IL
Images Fabriquées, Centre Georges Pompidou, Paris, France; Museum voor Aktuel Kunst, Hasselt, Belgium*
In Plato's Cave, Marlborough Gallery, New York, NY*

1982
The Fabricated Image, Delahanty Gallery, Dallas, TX
Tableaux: Nine Contemporary Sculptures, The Contemporary Art Center, Cincinnati, OH*

1981
Eight Contemporary Photographers, University of South Florida Art Museum, Tampa, FL
Erweiterete Fotografie, Wiener International Biennale, Vienna, Austria
The Exhibition, California Institute of the Arts, Valencia, CA
Photo, Metro Pictures, New York, NY

1980
Group Show, Annina Nosei Gallery, New York, NY
The Real Estate Show, Co-Lab, New York, NY
The Staged Shot, Delahanty Gallery, Dallas, TX

1979
Fabricated to be Photographed, San Francisco Museum of Modern

Art, San Francisco, CA; traveled
to The University of New
Mexico, Albuquerque, NM;
Albright-Knox Art Gallery,
Buffalo, NY; Newport Harbor Art
Museum, Newport Beach, CA*
*Southern California Invitational/
Photo*, University of Southern
California, Los Angeles, CA

PUBLIC COMMISSIONS

1993
University of Washington, Seattle,
WA. Six light-boxes installed in
bus shelters, commissioned by
Washington State Arts
Commission.

1991
Minnesota History Center, St. Paul,
MN. A group of brass elements
installed in terrazzo floor of
main hall, commissioned by
Minnesota Arts Board and
Minnesota Historical Society.

1990
Kortrijk Station, Kortrijk, Belgium.
Light-boxes installed in
collaboration with Tony Oursler,
commissioned by Kunststichting
Kanaal.

1988
Pennsylvania Station, New York, NY.
Series of 11 light-boxes installed
in station, commissioned by the
Public Art Fund.

1983
Staten Island Ferry Terminal, New
York, NY. A series of light-boxes
installed in the terminal,
sponsored by New State Council
on the Arts, Artists' Sponsored
Project Grant. Art Park,
Lewiston, New York. Light-box
installed in Lewiston Park,
commissioned by Art Park.

1980
New York, NY. Poster project in
Lower Manhattan, sponsored by
Artists' Space.

PUBLIC AND CORPORATE COLLECTIONS

A.T.&T., South Plainfield, NJ
Addison Gallery of American Art,
Phillips Academy, Andover, MA

Albright-Knox Museum, Buffalo, NY
Peter Alger Collection, New York, NY
Allen Memorial Art Museum,
Oberlin, OH
Baltimore Museum of Art,
Baltimore, MD
Big Flower Press, New York, NY
Birmingham Museum of Art,
Birmingham, AL
Brooklyn Museum of Art,
Brooklyn, NY
Carnegie Museum of Art,
Pittsburgh, PA
Capital Group, Los Angeles, CA
Centro Galego Arte
Contemporanea, Santiago de
Compostela, Spain
Chase Manhattan Bank, New York,
NY
Contemporary Art Museum,
University of South Florida,
Tampa, FL
Dallas Museum of Art, Dallas, TX
Davis Museum and Cultural
Center, Wellesley, MA
Disney Collection, New York, NY
Emily Fisher Landau Collection,
New York, NY
Fogg Museum, Harvard University,
Cambridge, MA
Fondazione Sandretto Re
Rebaudengo per l'Arte, Turin, Italy
Fonds National d'Art Contemporain,
Paris, France
General Mills Collection,
Minneapolis, MN
Goetz Collection, Munich, Germany
Goldman Sachs, New York, NY
Solomon R. Guggenheim Museum,
New York, NY
Hallmark Collection, Kansas City, MO
High Museum of Art, Atlanta, GA
Hughes and Luce, L.L.P. Collection,
Dallas, TX
Jewish Museum, New York, NY
Johnson & Johnson, New
Brunswick, NJ
Los Angeles County Museum of
Art, Los Angeles, CA
Metropolitan Museum of Art, New
York, NY
Mukha Museum, Antwerp, Belgium
Museum of Fine Arts, Boston, MA
Museum of Fine Arts, Houston, TX
Museum of Modern Art, New York,
NY
Museum of Modern Art, San
Francisco, CA
National Gallery of Canada,
Ottawa, Ontario, Canada
Neuberger Berman LLC, New York,
NY
Neuberger Museum, State
University of New York at

Purchase, Purchase, NY
Neue Galerie der Stadt Linz, Linz,
Austria
New Orleans Museum of Art, New
Orleans, LA
New School for Social Research,
New York, NY
Pacific Bell Collection, Los Angeles,
CA

Pepsico Collection, Purchase, NY
Progressive Corporation, Cleveland,
OH
Prudential, Newark, NJ
Revco Corporation, New York, NY
San Diego Museum of Contemporary
Art, San Diego, CA
St. Louis Art Museum, St. Louis, MO
Tampa Museum of Art, Tampa, FL
United Yarn Corporation, Wayne, NJ
University Art Museum, University of
New Mexico, Albuquerque, NM
University of Iowa Museum of Art,
Iowa City, IA
Victoria and Albert Museum,
London, England
Walker Art Center, Minneapolis, MN
Whitney Museum of American Art,
New York, NY
Williams College Museum of Art,
Williamstown, MA

Casebere's Studio, 2000

2001

Aletti, Vince. "Spring Arts Preview: Perpetual Motion." *The Village Voice* XLVI, no. 9 (6 March 2001): 88-89.

Bernstein, Fred A. "Quick Learner." *Elle Décor* 12, no. 1 (February-March 2001): 14, 121-129.

"Model Agent: Artist James Casebere Tips the Scale." *V Magazine,* Spring Preview 2001, Volume 9, pp. 17-18.

Hamilton, William L. "Paris as Tomorrowland." *The New York Times,* House & Home, 14 February 2001, pp. F1, F12.

"Media City: On the Newsstand." *New York Post,* 22 January 2001, p. 41.

Princenthal, Nancy. "Artist's Book Beat." *Art on Paper* 5, no. 3 (January-February 2001): 94-95.

Weiss, Susan. "The Architectural Unconscious: James Casebere and Glenn Seator." *Institute of Contemporary Art Newsletter* 1, no. 2 (Spring 2001): 5.

2000

"2000/2001 Museum Preview." *Art in America* 88, no. 8 (August 2000): 39.

Albert, Xiaoming. "Collapsed Interiors." in *Insites: Interior Spaces in Contemporary Art* (New York: Whitney Museum of American Art): 19-20.

Aletti, Vince. "Inside Out: Reality or Fiction?" *The Village Voice* XLV, no. 29 (25 July 2000): 81.

Art on Paper 5, no. 1 (September-October 2000): 72.

Casebere, James. "Maximum-security building Allred Unit prison: Wichita Falls, TX." *Metropolis* (April 2000): 92-99.

"Citibank Photography Prize 2000." *Tema Celeste* (January-February 2000): 107.

"Citibank Prize." *Flash Art* XXXIII, no. 210 (January-February 2000): 44.

Dormir/Sleep. Paris: Coromandel Express.

Drohojowska-Philip, Hunter. "Art and Architecture. Lessons From One Man's Model Society." *Los Angeles*

Times, 21 May 2000, pp. 57-58.

Duehr, Gary. "The Architectural Unconscious: James Casebere and Glen Seator. Addison Gallery, Phillips Academy, Andover, Massachusetts." *Art on Paper* 5, no. 1 (September-October 2000): 84.

Glover, Izi. "James Casebere, Lisson Gallery, London." *Frieze,* no. 52 (May 2000): 115.

Griffin, Tim. "Architectural Constructs in Contemporary Photography." *Time Out New York,* no. 251 (13-20 July 2000): 60.

Johnson, Ken. "Inside Out: Reality or Fiction?" *The New York Times,* 30 June 2000, p. E37.

Loke, Margaret. "Manipulated Images Toy With Facets of What Is." *The New York Times,* 28 July 2000, p. E30.

Oddy, Jason. "A Serious Case of Tunnel Vision." *The Independent,* 28 January 2000.

Riley, Terence. "Architecture Hot and Cold." *MOMA, The Magazine of the Museum of Modern Art* 3, no. 7 (October 2000): 10-11.

Schwendener, Martha. "Inside Out: Reality or Fiction?" *Time Out New York,* no. 252 (20-27 July 2000): 73.

1999

Aletti, Vince. "Photo: James Casebere." *The Village Voice* XLIV, no. 6 (16 February 1999): 88.

Anderson, Cecilia. "Spatial Experience or Spatial Disorientation?" *Katalog: Journal of Photography and Video* (Spring 1999): 26-33.

Arning, Bill. "The Sisters from Another Planet." *Time Out New York* (18 -25 April 1999): 61.

B. D. "James Casebere: Centro de Arte Contemporanea." *Arte y Parte. Nacional Edición* (June 1999): 143.

Bate, David, "James Casebere, Surveillance and Solitude." *Portfolio, The Catalogue of Contemporary Photography in Britain,* no. 29 (June 1999): 4-11 & 50-52.

"Blade Runner at Caren Golden." *Flash Art* XXXII (January-February 1999): 40.

Billingham, John. "Images to Stimulate as Well as to Challenge." *The Oxford Times Weekly,* 29 January 1999.

Buxton, Pamela. "James Casebere." *Building Design-London* (January 1999).

Cameron, Dan. "Camera Chameleon." *Art News* (May 1999): 149.

Cotter, Holland. "James Casebere." *The New York Times,* 12 February 1999, p. E37.

Cotter, Holland. "Art Review: James Casebere." *The New York Times,* 19 February 1999, p. E33.

"Dates: Art." *Blueprint* (February 1999).

Decker, Andrew. "Art's Next Wave." *Cigar Aficionado* (March 1999): 173-182.

Exley, Roy. "James Casebere." *Artpress,* no. 245 (April 1999): 76-77.

Exley, Roy. "Sites of Absence." *Contemporary Visual Arts,* no. 88 (1999): 63-68.

Frankel, David. "James Casebere: New Photographs." *Artforum* XXXVII, no. 5 (January 1999): 52.

"Full Exposure: Contemporary Photography." *Katalog: Journal of Photography and Video* (May 1999).

"James Casebere." *The Architect's Journal* (February 1999).

"James Casebere." *Professional Photographer* (January 1999).

Jenkins, Steven. "Una Conversación con James Casebere." *Arte y Parte,* no. 19 (February-March 1999): 54-66.

Lasky, Julie. "Grand Illusion." *Interiors* (July 1999): 8.

Leach, Ian. "Exhibition Review: Images in Action." *Daily Information,* 26 January 1999.

Lynas, Donna, Michael Tarantino, and Miguel Fernandez-Cid. *James Casebere: Asylum.* Oxford, England: Museum of Modern Art.

McEwen, John. "Unquenchable, Even with a Camera." *Daily Telegraph, London,* January 26, 1999.

"See What Makes James Click." *Oxford Courier,* 15 January 1999.

Smith, Roberta. "When Context

Outshines Content." *The New York Times*, 24 September 1999, p. E31.

Saavedra, Segundo. "Invitación a la Austeridad." *El Periodico Del Arte* (July 1999): 17.

Soyinka, Wole. "The Man that Died." *Transition* 7, no. 3-4 (1999): 389.

1998

Ackley, Clifford. *Photo Image: Printmaking '60s to '90s.* Boston: Museum of Fine Arts.

"Arte Contemporanea." *Tema Celeste*, no. 69-70 (July-September 1998): 68 & 110-111.

Arning, Bill. "Thomas Demand." *Time Out New York* (8-15 October 1998): 62.

Baker, Kenneth. "Photographers' Illusory Truths." *San Francisco Chronicle*, p. C18.

Berke, Deborah and Steven Harris, eds. *Architecture of the Everyday.* Princeton: Princeton Architectural Press.

Blind Spot 12 (1998).

Fox, Catherine. "Mixing it Up in Style." *The Atlanta Journal-Constitution*, 21 August 1998.

Friedman, Ann. "Bedtime Stories: Artists Awaken to Possibilities." *The Bellingham Herald*, p. C1-2.

Houser, Craig and Ellen K. Levy. "James Casebere." *Contemporary Visual Arts*, no. 19 (July 1998): 70.

Hudgens, Andrew. *Babylon in a Jar: New Poems.* New York: Houghton Mifflin. Cover Illustration.

Johnson, Ken. "Art in Review: James Casebere." *The New York Times*, 10 April 1998, p. 39.

"Lofty Vision." *Elle Décor* (August-September 1998): 174-181.

Rian, Jeff. "The Architecture of Memory." *Flash Art* XXXI, no. 203 (November-December 1998): 82-85.

Marger, Mary Ann. "Not So Sweet Dreams." *The New York Times*, Weekend Section, March 1998.

Saint Sauveur, Michele de. "Review: Embedded Metaphor." *New Art Examiner* (March 1998): 43.

Smith, Roberta. "Art in Review: Edwin Zwakman." *The New York Times*, 29 May 1998, p. E38.

Smith, Roberta. "Galleries: Chelsea." *The New York Times*, 18 September 1998, p. E36.

Smith, Roberta. "Thomas Demand." *The New York Times*, 11 September 1998, p. E38.

1997

Berruti, Antonella. "James Casebere."

Juliet Magazine (June 1997): 44-45.

Crump, James. "Solitary Spaces." *Art in America* (October 1997): 56-59.

Dostoevsky, Foyodor. "The Big House." *Aperture* (Fall 1997): 49 & 55.

Exley, Roy. "Constructed Sights; The Domain of Constructed Photography." *Contemporary Visual Arts* (October 1997): 18-25.

Grigg, Jennifer. "Report from London." *Afterimage* 24, no. 4 (January-February 1997): 4.

"Making it Real." *Review* (February 1997): 20.

Marcelis, Bernard. "Galerie Windows." *Artpress* (May 1997).

"Tunnels and Arcade." *Bomb* (Winter 1997): 71 & 80-81.

Zimmer, William. "Life with a Twist: Fiction-Based Photography, Realism in Paint." *The New York Times*, 30 March 1997, p. 12.

1996

Baker, Kenneth. "Large Photographic Vision of Small Worlds." *San Francisco Chronicle*, 3 September 1996.

Batchen, Geoffrey. "James Casebere's Prison Series." *Creative Camera* (June-July 1996): 14-21.

Berger, Maurice, with Andy Grundberg, intro. *James Casebere: Model Culture, Photographs, 1975-1996.* San Francisco: Friends of Photography.

Berger, Maurice. "James Casebere: Solitary Confinement." *See* (Fall 1996): 12-16 & cover.

Bonetti, David. "Bay City Best." *San Francisco Examiner Magazine*, 18 August 1996.

Felshin, Nina. *Embedded Metaphor.* New York: Independent Curators, Inc.

Porges, Maria. "San Francisco Fax." *Art Issues* (October 1996).

1995

Aletti, Vince. "Voice Choices." *The Village Voice* (28 March 1995): 9.

Casebere, James, and Stan Douglas. "Mobius Strip." *Blind Spot*, no. 6 (1995).

Hagen, Charles. "James Casebere." *The New York Times*, 14 April 1995, p. C14.

Johnson, Ken. "James Casebere." *The New York Times*, 14 April 1995, p. C 4.

Prison Sentences: The Prison as Site/ The Prison as Subject. Philadelphia: Eastern State Penitentiary.

Ziolkowski, Thad. "James Casebere, Michael Klein Gallery." *Artforum* (September 1995).

1994

Conti, Viana. "James Casebere." *Flash Art* (March 1994): 45.

Davis, Keith. *An American Century of Photography, From Dry-Plate to Digital, The Hallmark Photography Collection.* New York: Harry N. Abrams Publishers.

Hall, Jacqueline. "New Angles on 'Home': '90s Domestic Spaces Analyzed, Challenged by Varied Ideologies." *Columbus Dispatch*, 18 September 1994.

Hot Off The Press. Santa Fe: University of New Mexico Press, Tamarind Institute.

"House Rules." *Assemblage: MIT Press Journal* (1994).

"James Casebere: Cafeteria and Cell with Toilet." *Print Collector's Newsletter* (1994): 66.

"James Casebere: Silverprints." *Paris Review*, no. 130 (Spring 1994): 229-235.

Luca, Elisabetta. "James Casebere." *Juliet Art Magazine* (June 1994): 45.

Robbins, Mark. "Building like America: making other plans." *Assemblage*, no. 24 (August 1994): 8-11.

Rubenstein, Raphael. "The Art of Imprisonment." *Metropolis* (May 1994): 48.

Ryan, Jeffry. "Twenty One Steps: A New Printmaking Aesthetic."

Seiko, Uyeda. "Quest for Lost Image." *Seven Seas* [Japan] (October 1994): 171-175.

"Wexner Center Presents Social Constructions and Electronic Games by Artists." *Flash Art* (Summer 1994): 35.

1993

Aletti, Vince. "Voice Choices." *The Village Voice* (25 May 1993): C26.

Carroll, Patty. *American Made: The New Still Life.* Tokyo. Japan Art and Culture Association.

Kalina, Richard. "James Casebere at Michael Klein." *Art in America* (October 1993): 127-129.

Lifson, Ben. "A Model Prisoner: James Casebere." *Artforum* (May 1993): 87-89.

McQuaid, Kate. "Asking Why: The MFA's 'Building A Collection' is art that raises questions." *Boston Phoenix*, 19 March 1993, p. 21.

McQuaid, Kate. "Mod Squad." *Boston Phoenix*, 5 February 1993.

Pinchbeck, Daniel. "Openings." *Art & Antiques* (April 1993): 22.

Saltzstein, Katherine. "Breaking out

of the Mold." *Albuquerque Journal*, 25 July 1993, p. F2.

Shefcik, Jerry. *From New York: Recent Thinking In Contemporary Photography*. Las Vegas: Donna Beam Fine Art Gallery University of Nevada, Las Vegas.

Sherman, Mary. "'Building A Collection' at the Museum of Fine Arts." *Boston Herald*, 29 January 1993, p. S4.

1992

Batchen, Geoffrey. "On Post-Photography, Constructing Images: Synapse Between Photography and Sculpture." *Afterimage* 20, no. 3 (October 1992): 17.

Bonetti, David. "Art." *San Francisco Examiner*, 28 August 1992, p. C2.

Casebere, James. "Venice Ghetto." Villa Val Lemme, Capriata d'Orba, Italy.

Loke, Margaret. "Reviews: Constructing Images: Synapse Between Photography and Sculpture at Lieberman & Saul." *Artnews* 91, no. 2 (February 1992): 128.

Mclay, Catherine. "Twice Captured Images: By Lens and Then By Hand."

Robson, Julien. *Interpreting The American Dream*. Graz: Galerie Eugen Lendl.

San Jose Mercury News, 10 July 1992, p. 45.

1991

Coleman, A. D. "When Photos and Sculptures Get Married." *New York Observer*, 11 November 1991.

Conklin, Jo-Ann. *James Casebere*. Iowa City: University of Iowa Museum of Art, Iowa City.

Cross, Andrew, and Stuart Morgan. *James Casebere*. Surrey, Great Britian: James Hockey Gallery, West Surrey College of Art and Design.

Friedman, Ann. "Photographs Mix Ordinary, Eerie." *Birmingham News*, 27 October 1991, pp. 1F & 6F.

Garlake, Margaret. "James Casebere." *Art Monthly* (December 1991): 15-16.

Goldwater, Marge. *James Casebere*. New York: Michael Klein Gallery.

Higuchi, Shoichiro. "James Casebere's Collection of the Memory." *Idea* [Tokyo], no. 226 (1991): 126-129.

"James Casebere: archivaris van Amerikaans industrieel erfgoed." *WB*, 16 May 1991, p. 14.

"James Casebere." *Juliet Art Magazine*, no. 50 (December 1991): 61.

Lambrecht, Luk. "Kunst." *Kaack*, Weekend section, 22 May 1991, p. 18.

Marger, Mary Ann. "Latest In Smart Art." *St. Petersburg Times*, 31 December 1991.

Milani, Joanne. "Photographers Shoot for Depth." *Tampa Tribune*, 6 December 1991.

Nelson, James R. "Casebere Creates Worlds of Emptiness and Artifice." *Birmingham News*, 19 November 1991, p. 4F.

"Photography." *The New Yorker*, (10 June 1991): 18.

Rian, Jeffrey. "James Casebere." *Arts Magazine* (October 1991): 79.

Romano, Gianni. "James Casebere." *Flash Art*, no. 160 (February-March 1991): 86-87.

Schaffner, Ingrid. *Constructing Images*. New York: Lieberman Gallery.

Silver, Joanne. "Architectural Photos Build on Viewer's Experience." *Boston Herald*, 29 March 1991.

Troncy, Eric. "James Casebere." *Metropolis*, no. 2 (1991): 36-37.

Wilner-Stack, Trudy. *Model Fictions. The Photographs of James Casebere*. Birmingham, AL: Birmingham Museum of Art.

Wise, Kelly. "The Juncture of the Real and the Imagined." *Boston Globe*, 16 April 1991.

1990

"Calendar by James Casebere." *Interview* (July 1990).

Christensen, Judith. "Waiting for Life to Happen." *Artweek* (29 November 1990): 13.

Daxland, John. "Sculptures That Force You To Look." *Daily News*, 17 February 1990.

Freudenheim, Susan. "Casebere: Black-and-White and Heartless." *Los Angeles Times*, 27 October 1990.

"Goings On About Town." *The New Yorker* (5 March 1990).

Jarmusch, Ann. "Casebere Show Lights Up Recesses of Mind." *San Diego Tribune*, 26 October 1990, pp. C1 & C6.

Levin, Kim. "Bad Timing." *The Village Voice* (6 March 1990).

Lewis, James. "James Casebere." *Artforum* (May 1990).

Muschamp, Herbert. *Nightlights*. Nevers, France: APAC Centre d'Art Contemporain.

Princenthal, Nancy. "James Casebere at Vrej Baghoomian." *Art in America* (June 1990): 170.

"Voice Choices." *The Village Voice* (6 March 1990).

1989

Encore-Celebrating Fifty Years. Cincinnati: Contemporary Arts Center.

Bayliss, Sarah, Christopher Hoover, and Miwon Kwon. *Suburban Home Life: Tracking the American Dream*. New York: Whitney Museum of American Art.

Grundberg, Andy. *Abstraction in Contemporary Photography*. Emerson Gallery.

Hackett, Regina. "Poker-faced NY pop artists exhibit some staying power." *Seattle Post-Intelligencer*, 21 February 1989.

Hammond, Pamela. "Sculpture." *Artnews* (1989): 178.

Kohler, Michael, ed. *Das Konstruierte Bild*. Munich: Kunstverein Munchen.

Marger, Mary Ann. "University Opens its Doors to the World of Art." *St. Petersburg Times*, 21 January 1989.

Milanti, Joanne. "Avant-Garde Art Finds a Home." *Tampa Tribune*, 20 January 1989, pp. F1-2.

Playing Havoc: Notes on James Casebere's 'Tree Trunk with Broken Bungalow and Shotgun Houses.' Tampa: University of the State of Florida Art Museum, Tampa, FL and Neuberger Museum of Art, State University of New York at Purchase, Purchase.

Roskam, Mathilde. *Parallel Views*. Amsterdam: Arti et Amicitiae.

Sculpture (March-April 1989): 31.

Smith, Roberta. "Charting Traditions of Nontraditional Photography." *The New York Times*.

Steenhuis, Paul. "Droom Spoor." *Brij Nederland* (May 1989).

Steinberg, Janet. "Just Say Faux." *Seattle Weekly* (8 February 1989).

Welles, Elenore. "Beyond Photography." *Artscene* (April 1989): 26.

Westerbeck, Colin. *Decisive Monuments*. Chicago: Ehlers Caudill Gallery Ltd.

Zimmer, William. "Five Photographic Portfolios." *The New York Times*, 16 July 1989.

1988

Block, Valerie. "From One Surreal Landscape to Another." *New York Observer*, 4-11 July 1988.

Cross, Andrew and Helen McNeil. *Playing for Real: Toys and Talismans*. Southampton, England: Southampton City Art Gallery.

Donahue, Marlena. "Reviews: James Casebere." *Los Angeles Times*, 11 March 1988.

Gardner, Colin. "CalArts: Skeptical

Belief(s)." *Artforum* (April 1988): 154.

Gerster, Amy. "Reviews; James Casebere, Kulenschmidt/Simon." *Artforum* (September 1988): 151.

Jones, Amelia. "Connections to the Real." *Artweek* (20 March 1988).

Keonig, Peter. "Exhibition Explores Art of Directorial Photography." *The Enterprise* (1 April 1988): 5a.

Leigh, Christian. *Complexity and Contradiction*. New York: Scott Hanson Gallery.

Rubin, Birgitta. "Med Kameran i Fokus." *DN Pa Stan* (October-November 1988).

Wise, Kelly. "'Fabrications': A Probing, Instructive Exhibit." *Boston Globe,* 5 April 1988, p. 66.

1987

Aletti, Vince. "Photo." *The Village Voice* (3 June 1987).

Bromberg, Craig. "Teaching Tomorrow's Avant-Garde." *Artnews* (September 1987) 100-103.

Casebere, James. "Three Stories," *Blasted Allegories*, ed. Brian Wallis, ed. New York: The New Museum Press.

Currah, Mark. "Reviews-Interim Art; Barbara Ess, James Casebere." *City Limits* (August 1987).

Goldwater, Marge. *Cross References: Sculpture into Photography*. Minneapolis: Walker Art Center and The Museum of Contemporary Art, Chicago.

Grundberg, Andy. "Critics Choices: Photography." *New York Times*, 14 June 1987.

Hart, Claudia. "James Casebere: 303 Gallery, Michael Klein Gallery." *Artscribe International* (September-October 1987): 80-81.

Jurgenssen, Birgit. *3 Americans, 3 Austrians*. Vienna: Fotogalerie Wien.

Kent, Sarah. "New Reviews; Barbara Ess and James Casebere." *Time Out New York* (July 1987): 29.

Kunst Mit Photographie. Stuttgart: Galerie Ralph Werniacke.

Nightfire. Amsterdam: De Appel.

Rubey, Dan. "James Casebere." *Artnews* (November 1987).

Smith, Roberta. "James Casebere." *The New York Times*, 5 June 1987, p. C32.

1986

Bos, Saskia. *Sonsbeek 86: International Sculpture Exhibition*. Arnhem, Holland: Sonsbeek.

Hoy, Ann. *Fabricated Photographs*. New York: Abbeville Press.

Indiana, Gary. "The Death of Photography." *The Village Voice* (30 September 1986).

Javault, Patrick. "Sonsbeek 86: International Sculpture Exhibition." *Art Press* (September 1986).

Langsfield, Wolfgang. "Moderne Kunst im Park." *Süddeutsche Zeitung* (1986).

Photographic Fictions. Stamford, CT: The Whitney at Champion.

Saltz, Jerry. *Beyond Boundaries: New York's New Art*. New York: AlfredVan Der Marck Press.

Verzotti, Giorgio. "Arte Santa." *Domus* (September 1986).

Wallis, Brian, ed. *Rethinking Representation: Art After Modernism*. New York: The New Museum Press.

1985

Brooks, Rosetta. "From the Night of Consumerism to the Dawn of Simulation." *Artforum* (February 1985).

Foster, Hal. *Recodings, Art, Spectacle, Cultural Politics*. Port Townsend, Washington: Bay Press.

Gardner, Colin. "Art: Western Abstract Scenes." *Los Angeles Times*.

Raynor, Vivien. "Fiction: Diane Brown Gallery." *The New York Times*, 23 April 1985.

Russell, John. "Art: Whitney Presents Its Biennial Exhibition." *The New York Times*, 22 March 1985, p. C23.

1984

Hagen, Charles. "Reviews." *Artforum* (Summer 1984).

Levin, Kim. "Immaculate Conceptualist." *The Village Voice* (3 July 1984): 91.

Naef, Weston. "New Trends." *Nippon Press*.

Sayag, Alan. *Images Fabriquées*. Paris: Centre Georges Pompidou.

Zelevansky, Lynn. "James Casebere." *Artnews* (Summer 1984).

1983

Armstrong, Tom. "Independent Study Program, Fifteenth Anniversary." Whitney Museum of American Art, New York.

Foster, Hal. "Uncanny Images." *Art In America* (November 1983): 202-204.

Grundberg, Andy. "Post-Modernists in the Mainstream." *The New York Times*, 20 November 1983, pp. H27 & 43.

Olander, William. "Missing Persons." *Artnews* (February 1983): 112-115.

Solomon-Godeau, Abigail. *In Plato's Cave*. New York: Marlborough Gallery.

1982

Foster, Hal. "Mel Bochner and James Casebere at Sonnabend." *Art in America* (October 1982).

Kamholtz, Jonathan Z. "Assembling Tableaux." *Dialogue Quarterly* (Fall 1982).

Klein, Michael. *Tableaux: Nine Contemporary Sculptures*. Cincinnati: The Contemporary Arts Center.

Miller, John. *Cave Canem: Stories and Pictures by Artists*. New York: Cave Canem Books.

Owens, Craig. "Back to the Studio." *Art in America* (January 1982): 99-107.

Raynor, Vivien. "Mel Bochner and James Casebere at Sonnabend." *The New York Times*, 16 April 1982, p. C22.

Smith, Roberta. "Some Things Old, Some Things New." *The Village Voice* (27 April 1982): 98.

1981

Glueck, Grace. "The Scene from Soho to Tribeca." *The New York Times*, 30 January 1981, p. C19.

1980

Armstrong, Richard. "Review: Fabricated to be Photographed." *Artforum* (February 1980): 106-107.

Fischer, Hal. "Curatorial Constructions." *Afterimage* (March 1980): 7-9.

1979

Coke, Van Deren. *Fabricated to be Photographed*. San Francisco: San Francisco Museum of Modern Art.

Muchnic, Suzanne. "Photography as Art and History." *Los Angeles Times*, 11 March 1979.

Murray, Joan. "Fabricated for the Camera." *Artweek* (8 December 1979): 1 & 11-12.

Porter, Diana. "Photography: The Primacy of Idea." *Artweek* (10 March 1979): 11.

Printed in May 2001
by Leva spa, Milano
for Edizioni Charta
on Gardamatt Art paper by Cartiere de Garda Spa

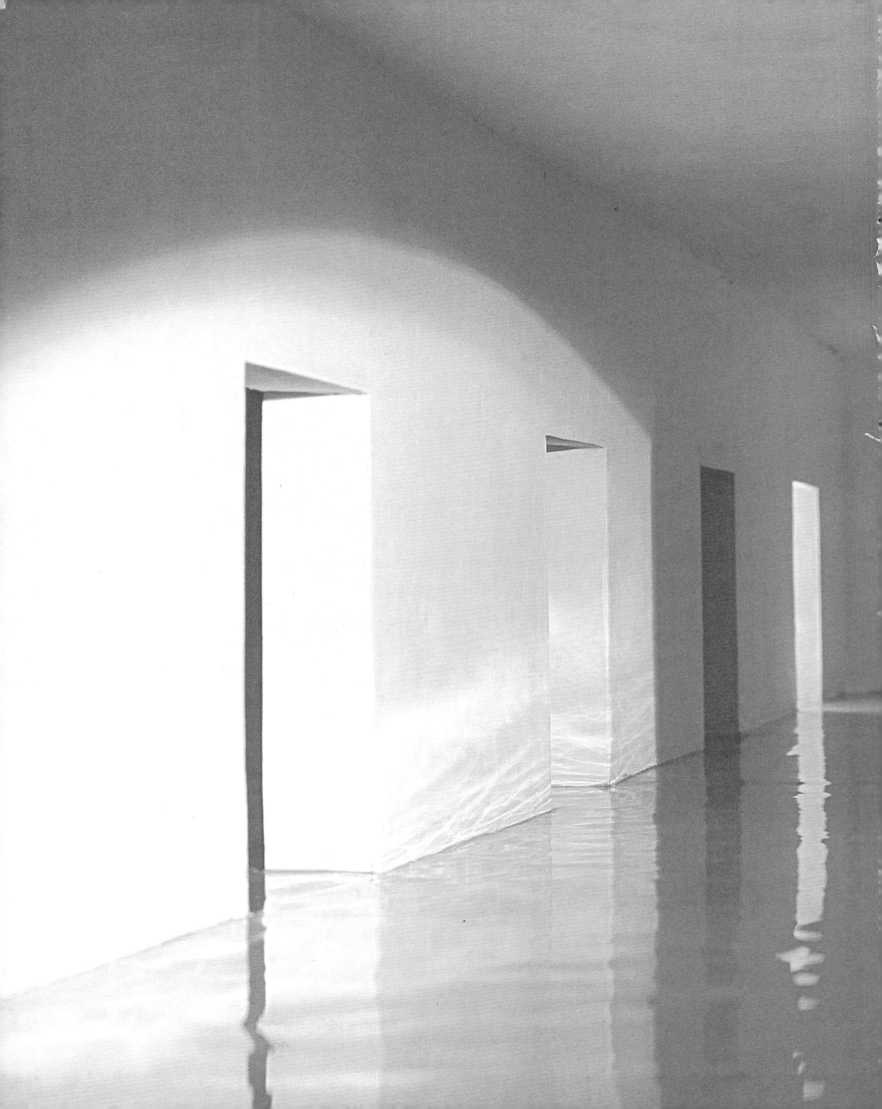